Photographer of the World

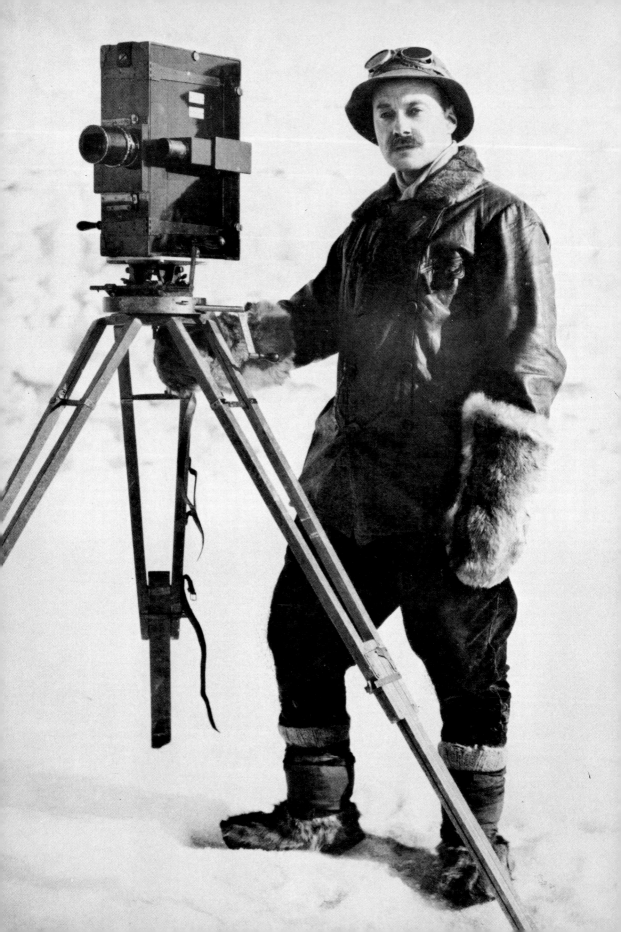

H.J.P. Arnold

Photographer of the World

THE BIOGRAPHY OF HERBERT PONTING

Rutherford • Madison • Teaneck
Fairleigh Dickinson University Press

PHOTOGRAPHER OF THE WORLD. © *H. J. P. Arnold 1969.*
First American edition published 1971 by
Associated University Presses, Inc.,
Cranbury, New Jersey 08512

Library of Congress Catalogue Card Number: 75-156270

ISBN: 0-8386-7959-5

Printed in the United States of America

For Jeanney Ford
who lived to read it

Contents

Illustrations

Preface

IN 1962—the fiftieth anniversary of the death of Captain Scott and his four companions on the return journey from the South Pole—B.B.C. Television presented a commemorative programme, based almost entirely upon the movie and still photography of Herbert Ponting. At that time, Ponting's name meant very little to me. The programme, however, encouraged me to conduct preliminary research, and I found to my surprise that his biography had not been written and that very little had been learned about him beyond a few well-known (and sometimes inaccurate) facts.

The research work spread over six years and now—one book (of a totally different nature), well over 325 letters of enquiry, and thousands of interview car miles later—it is finished. Ponting was not sufficiently famous to have been written about a great deal. Further, many people who knew him are long since dead. Often the trails seemed to peter out, only to be opened again by persistent research or luck.

But no amount of research would have been successful without the generous help of very many people, not only in this country but in the United States and elsewhere. It is not possible to name them all, but I wish to place on record my particular thanks to a small number who put themselves to great trouble to assist me.

The late Mrs. Mildred Organ; Miss Kathleen Organ; Mr. D. A. S. Houghton; Mr. R. D. Houghton; and Mr. A. E. Ponting of San Francisco (Herbert's son)—as members of the family—were able either to speak about Herbert Ponting from personal knowledge or had in their possession documents and scrap-books which were loaned to me and proved to be invaluable. I also owe much to Mrs. Jeanne Ford who, despite ill-health, did not hesitate to go to great lengths to help me with impressions of Ponting during the 1930s, and to search out letters and other documents for me to study. Mr. E. O. Hoppé helped not only by recollecting memories of Ponting at the beginning of the century but also by describing the very atmosphere and practice of photography at the time.

No researcher can succeed without the help of competent and willing librarians, and in Mr. H. G. R. King, of the Scott Polar Research Institute; Mrs. Marjorie Hancock, of the Mitchell Library in Sydney, New South Wales; Mr. G. S. Dugdale (together with Mrs. M. B. Hughes), of the Royal Geographical Society; and Mr. F. W. S. Baguley (Hampshire South-East Regional Librarian), I have been extremely

well served—Mr. Baguley especially being able to fulfil the most difficult of requests with astonishing speed.

The biographer who is writing on a subject associated with photography, and who is an employee of Kodak Limited, is in a most happy situation. Although they should in no way be associated with any errors or omissions in this volume, I must record my thanks to a number of colleagues in the Kodak organisation for their help and encouragement, including Dr. D. A. Spencer, Mr. I. D. Wratten, Dr. L. Mullins, Mr. G. J. Craig, Mr. J. C. Habersberger and Mr. Russell L. Olson.

In addition, the Rev. Dr. George Seaver, Mr. C. H. Dickason, Mrs. D. Irving-Bell and Mr. M. R. D. Foot made contributions to the final result. A considerable debt is owed to the Editor of the *Daily Telegraph*, who, by kindly publishing a letter appealing for information about Herbert Ponting, opened up many new leads.

Permission from the Scott Polar Research Institute to quote from correspondence in the Debenham collection; from the Mitchell Library of Sydney, Australia, to quote from letters to and from Ponting now in its possession; from the Editor of the *British Journal of Photography* to quote from issues published earlier this century; from Gerald Duckworth & Company Limited to quote from Ponting's own account of his time in Antarctica in *The Great White South*; and from J. M. Dent & Sons Limited to quote from *In Lotus-Land Japan*, is gratefully acknowledged.

Finally, I must sympathise with my wife, Audrey, for having to live with my irritability during the incubatory period of yet another book. My thanks go to her, to my six-year-old daughter Ann for keeping quiet (mostly), and to my mother-in-law, Mrs. D. C. Cox, for helping to keep her that way.

H. J. P. A.

Introduction

A LENGTHY news-story appeared in *The Standard* on Friday, 20 October 1911. It had three headlines: 'The Antarctic Rush—Cinematographs of the Scott Expedition —Vivid Record.' The report went on to relate how 'in a cosy little darkened room just off Piccadilly-circus, last evening, a special company of about forty persons sat and watched a small band of men fighting their way over mountains of ice towards the South Pole . . . 3,000 feet of cinematograph film newly arrived from the Scott expedition (were being shown) and something like a sigh escaped the company when the murmur of the reel ceased and the lights went up. . . . The central figure in the room was Mrs. Scott, to whom the pictures had, of course, an interest denied to all others. . . . The films were taken by Mr. H. Ponting, the official photographer of the expedition. . . . No previous Polar expedition has had such "live" chronicles taken of its life among the snows; the present series is marvellously clear and beautifully artistic and the whole story of the expedition from the *Terra Nova*'s departure from New Zealand last year to the beginning of the last stage is told completely.'

The date of the news-story was of major importance, for Captain Scott and his small party were still alive—although they did not have many weeks remaining to them. It was a significant time, too, for Herbert Ponting, since he was at the height of his photographic creativity and achievement. He was born in 1870 and died in 1935—a life spanning the two worlds whose watershed was the Great War. The first of these two worlds saw his greatest successes. The second witnessed little but decline and failure.

1: Sydenhams and Pontings

HERBERT George Ponting was descended from two families of rich West Country heritage, particularly on his mother's side. Mary Sydenham, who married Herbert's father, Francis W. Ponting, on 16 April 1868, at St. Thomas's Church, Salisbury, belonged to stock whose name was first possibly assumed during Norman times by one William de Sideham, and which had in past centuries possessed extensive property in Somerset and Devon.

In 1585 Sir Francis Drake married the reputedly rich and beautiful Elizabeth Sydenham. The family history[1] records a cautionary tale of how Elizabeth was attracted to another suitor—getting as far as the altar with him—but that a cannon-ball fell 'between her and that gallant, effectually preventing the ceremony'. Francis Drake was ever a man of action! But he died in 1596 and Elizabeth lost no time marrying again.

Sydenhams were prominent in the Roundhead cause during the Civil War and one of these was Thomas Sydenham, a doctor who got his B.M. at Wadham College, Oxford, in 1648, after only six months at the University—by order of the Chancellor, and presumably for services rendered to the cause. He did, however, make important contributions in later years to medicine—particularly in the study of epidemic diseases—and earned himself the title 'Father of English Medicine'. Another Sydenham, of the same period—Major George Sydenham—achieved fame in a markedly different manner. Whilst alive he entered into a pact with a friend, with whom he had frequently debated on God and the soul, that whosoever should die first should return and tell the other of his experiences. Major Sydenham is said to have done so at Combe Dulverton, in Somerset, assuring his friend that there was indeed a God—'A just and terrible one'.

According to family tradition, the Pontings were of Huguenot extraction. Herbert's grandfather, Henry Ponting—a Marlborough man—was born in 1822 and was probably the illegitimate son of a Miss Pontin(g), who was at the time a governess to the family of the Marquis of Ailesbury, Warden of the Savernake Forest in Wiltshire. Genealogists are accustomed to frequent claims by descendants that the fathers of illegitimate children in their families were of prominent status in life, but the tale that Henry's father was a Spanish count who was a guest of the Marquis may not have been far from the truth, since it is not too fanciful to distinguish Spanish characteristics in the facial structure of some of the Pontings, and particularly Herbert.

Henry's profession on his marriage-certificate was given as 'sawyer', but he was later described as an agent of the Marquis on the estate. If this was so, it must have been a fairly responsible position. The forest—in East Wiltshire—occupies around four thousand acres, and was given by William the Conqueror to one of his followers as its hereditary warden. At that time it had plenty of game and was regarded as a splendid hunting-ground. In the centuries that followed, the forest was developed by a succession of wardens, with varying application, and in the period before Henry Ponting worked there it had benefited from the attentions of the great tree-planter and planner, Lancelot (Capability) Brown.

Henry Ponting married Ann Collard, of Swindon, in 1842, in the Parish Church of St. Mary, in Marlborough. Ann was the daughter of a local farmer. Judging by the education which the eldest son, Francis—Herbert's father—must have received, the family was obviously not without money. The couple had eight sons and four daughters, born between 1842, when Francis was born, and 1866.[2] Francis's later career in banking was probably aided by experience of his father's work in the management of the estate at Savernake and also by living in Marlborough—the market town for a considerable area.

It did not take Francis Ponting long to make his mark in the world of banking—and at a time of great development in that world. British industrial development in the nineteenth century (and nowhere more so than where the railways were concerned) called for enormous amounts of capital, as it did for continually growing credit and remittance facilities. The first joint stock banks were formed in the 1820s to help meet this need, but by the last quarter of the century it was clear that the provincial joint stock banks could not cope with the continual demands of industry and the growth of international trade. A consolidation movement among the banks developed, which reached its peak in the first two decades of the twentieth century, ultimately resulting in the 'Big Five' as we know them today.

Francis was in the thick of this. He entered the service of the Wilts. and Dorset Banking Company at its head office in Salisbury when he was sixteen. He was there for six or seven years and then went on to gain experience in the Midlands. In 1869 he returned to Salisbury, to become manager of the Hampshire Banking Company's branch there, at the early age of twenty-seven. It was in Salisbury that Herbert was born, on 21 March 1870. Six years later Francis Ponting moved north again, and in 1883 he became General Manager of the Preston Banking Company Limited. The Preston—mainly concerned with financing activities in the cotton industry—prospered under his guidance. In ten years the value of the bank's shares more than trebled and the reserve fund quadrupled in size. In 1894, 'in recognition of his services', the annual meeting of shareholders of the Preston voted him a special gift of one thousand guineas. Shortly after, what is now known as the Midland Bank—

then the London and Midland Bank—was looking for representation in the northern industrial area of Lancashire, and arranged the amalgamation of the Preston within its own organisation.

Francis retired in his early fifties. He survived a major operation for torticollis,[3] even though he needed the continual attentions of a nurse thereafter and had to learn to write with his left hand. He overcame these difficulties splendidly and his private business affairs prospered. The letters and telegrams to and from the City of London flowed freely (one of his younger daughters acting as secretary) and he was also retained as financial adviser to at least one leading industrialist of the day. He was obviously a most capable, not to say brilliant, man in financial matters (which certainly cannot be said for any of his sons), and when he died in 1923 at the age of eighty-one—cared for by nurses and servants and often visited by his children—the gross value of his estate amounted to over £45,000 (£40,000 net), a considerable sum by any standards.

Francis and Mary Ponting had four sons and four daughters—Edith, Herbert, Francis Henry, Alice, Ernest, Ruth, Mildred and Sydenham—born in towns as far apart as Salisbury and Carlisle as the father's banking career progressed. The family occupied at various times large houses at Stanhope Terrace, Hyde Park in London, Watford, Ilkley and Southport. It was at Broom Mount in Southport (which looked out over Hesketh Park and backed on to the sands—an area known later as Millionaires' Row) that Francis died. An idea of the size of the house can be given by its description at the time of the sale—a top floor contained four bedrooms, a box-room and a maids' room, whilst the first floor contained a sitting-room, three bedrooms, a bathroom, a dressing-room and a morning-room, with two cellars and two kitchens on the ground floor.

Family affection for the houses varied. Whilst everybody loved The Manor House, Watford—a beautiful house set in seven acres—the twelve years at Westwood Lodge, Ilkley, were not looked upon with great pleasure, although the youngest girls Ruth and Mildred had a studio there and much enjoyed their art lessons. Francis moved to Ilkley to be near his brother Jim—another banker—who promptly retired and moved his home south to Newbury. It took Francis many years to find a buyer for the large and rambling Lodge. It was the scene of big family Christmas house-parties and, because it was situated on the top of a steep hill, any snow-storms made access difficult. One of the Ilkley railway porters had a favourite saying: 'You'll never get up tonight, sir!' A number of other family stories concern the Lodge and its weather. One tells of a violent storm which broke during dinner, when 'lightning began to play on the steel knives and an extraordinary molten light shone over everything with a very eerie affect'.

In many ways the Ponting family life was typical of the Victorian period. Francis,

the father, was the master and the children had a healthy respect for him. There is one family story of the children breaking a window in the front door and Mary, their mother, getting it repaired before father returned from the office! There is another story of Francis bringing a very rapid halt to a budding romance between Herbert and a local hotelier's daughter—a match of which he did not approve—but he apparently raised no objections to Ernest's liking for a wealthy American girl visiting Ilkley, although the romance came to nothing. The family holidayed on the Isle of Man, and never went to Europe. They were regular but not fanatical church-goers. Herbert had a pleasant light baritone voice; Mildred and Ruth played the mandolin; Alice was an extremely talented pianist and Frank played the banjo. Frequently after dinner in the evenings, Francis would say to his assembled children, 'Now then, orchestra'—and the children were expected to perform, often against their wishes. Bridge and billiards were the two most popular games in the family. The children had enjoyable outings, and one in particular—a visit to the performance of a famous magician in London, which included a brilliant trick with Herbert's handkerchief—greatly impressed the children.

If Francis was master in the Ponting family, he was certainly open to persuasion. In 1898, Edith, the eldest child, married a schoolmaster called Thistlethwaite—a match which Francis had always vowed he would never allow. He was a tolerant man and bore no grudges—for example, when Herbert gave up banking in 1892 there appeared to be no hard feelings. He was generous too. When Herbert went to the United States, he bought a ranch with money given to him by his father. Francis had a realistic appreciation of his children's intellectual capabilities and potential. None of the children was outstanding in this direction, and he did not hesitate to describe the only son who followed him into banking—Frank—as a 'steady plodder'.

No record of Herbert's scholastic achievements has been traced, but they were probably not distinguished. He attended Carlisle and Preston Grammar Schools and later Wellington House College, Leyland. The younger boys—probably because their father's wealth had by then increased—attended the public schools at Uppingham and Tonbridge. Sydenham, the youngest child, tried banking and mining engineering before turning to farming—not very successfully. Ernest became an architect and spent some years in the United States, mostly at his father's expense. Frank joined the Midland Bank and rose no higher than Chief Cashier at its Southport Branch, steadfastly refusing any promotion that could be attributed to family influence. (Boxing and Southport F.C. were his passions. On Saturday mornings he would send the bank junior out for two meat-pies—his pre-match lunch—and a bunch of violets for his button-hole.) All the children, save Alice, who had several unhappy love-affairs, married.

The Pontings may fairly be described as a reasonably happy family—at least in

their early and middle years. Life was made more tolerable by the employment of several maids, a cook (Mary Ponting insisted on first-class cooks), a gardener and a coachman. Employment with the family was appreciated, judging by the longevity of service. Francis shared his time between the office and the family and devoted no time or effort to public or political life. Little detail has survived about Mary Ponting other than her great concern for the running of the household. She is therefore a somewhat shadowy figure but clearly one who received much affection from her children. Life in the family was pleasant and comfortable, if not physically or mentally demanding or stimulating. The library at Broom Mount, which was sold after Francis's death in 1923, consisted of a *Harmsworth Self Educator*, the works of Charlotte Brontë and Charles Dickens, and eight volumes of 'Royal Portraits'.

At eighteen, Herbert tried banking and entered a local branch in Liverpool in 1888. Four years were sufficient to convince him that he did not wish to follow in his father's footsteps and not long after he set out for the West Coast of the United States, assisted by a generous gift from his father. It is evident that Francis was extremely proud of Herbert's achievements in the years that followed. After Herbert's photographic activities in the Russo–Japanese War—which earned him the Japanese medal and diploma known as 'The Imperial Order of the Crown'—his father purchased a very expensive set of books called *Japan's Fight for Freedom*, which remained steadfastly unread by other members of the family. By the time of the Antarctic Expedition in 1910, Herbert was a personality very much in the public eye. His father predictably became prouder still, but some members of the family—save the eldest child, Edith, who was always very close to her brother Herbert—began to tire a little of living in their brother's shadow. In post-Antarctic days neighbours of the family home at Southport—and particularly young people—regarded Herbert, by then the 'Great Photographer', with awe.

Thus, although Herbert rejected banking, he did so with his father's spiritual and practical blessing, and there was no family quarrel of any kind. In later years he visited and stayed with his mother and father quite frequently. Indeed, a photograph (Plate 3) taken in 1899 shows four generations of Pontings—Henry, Francis, Herbert and his son A.E. ('Dick'), who was born in London in that year. Herbert also wrote as frequently as he could from all corners of the world when he was on his trips. Mary died in 1919, and when Francis was taken seriously ill in 1923, Herbert rushed to his bedside to give some blood, but in vain.

And what of photography? Herbert left for the United States in 1893 or 1894 and there is no indication that he was seriously interested in photography before that date. In later years he described how he felt his first passing interest in photography at around 1890, but it was not until 1900 in America that his serious application began. The ten years or so after 1900 were to be the most productive and eventful of his life.

1. Dr. G. F. Sydenham: *History of the Sydenham Family*. Published privately in 1928.

2. Henry, his wife Ann and his son Charles Edwin—an architect of considerable achievement—were buried in the Churchyard at Cadley, in the Savernake Forest.

3. Torticollis: Wry-neck or twisted neck. The condition, which can be constant or intermittent and in which the person is not able to look forward, is due to irritation or shortening of the neck muscles on one side. In the light of present-day knowledge, his condition might in fact have been a cervical disc protrusion—a 'slipped disc' of the neck.

2: America and beyond

HERBERT Ponting arrived on the West Coast of America during the period of the legendary 'gay nineties' of old San Francisco. In fact, the period of 1893–4 was anything but gay for many Americans. In 1893 there had been a massive financial collapse, the like of which was not to be seen again until 1929. The stock-market crashed, banks and mines closed, and there was an army of unemployed, leading in 1894 to a march of desperate unemployed workers on Washington. Relations between bosses and the new immigrant labourer from Poland, Greece, Italy and elsewhere were never worse. Farmers did not escape and were faced with intense competition from the Canadian Prairies, from Argentina, and from Australia. But all this did not stop the United States emerging as the foremost industrial power in the world, and in the 1890s she even launched herself on the imperialist trail, for example fighting 'a splendid little war' (to quote one government official) against Spain over Cuba and the Philippines. In 1901 America once again witnessed the assassination of a president, this time William McKinley.

The West Coast suffered badly from the 1893 crash but it quickly recovered. No doubt Ponting—later to become an experienced traveller of the world—sampled the attractions of San Francisco, and there was much to interest a handsome bachelor. San Francisco was the 'Paris of America', where it was alleged that no gentleman ordered anything with dinner save champagne.[1] Families whose power was based on fortunes made from gold- and silver-mining lived in massive mansions on Nob Hill, though the whole state of California was effectively ruled by the 'railway kings' of the Southern Pacific Railway. Californians claimed to have the biggest of everything (save for 'Little Egypt', the famous oriental dancer!), and during the period that Ponting was there, they had the world heavyweight champion, Jim Corbett, Jack London was writing his famous stories of the Far North, Sousa led his band and a young girl called Isadora Duncan was teaching dancing and doubtless aiming to become the greatest dancer in the world. It was the hey-day of the bicycle, when horse-carriages were limited to twenty miles per hour, but when the automobile had already made its appearance—and there were to be twenty of them in San Francisco by 1900.

This was only one side of the picture—the gay, cosmopolitan, music and drama-loving side. On the other were the large red-light districts, gambling and opium dens,

and, most of all, the Barbary Coast. This was the side of San Francisco which gave birth to such words as 'hoodlum' and 'to Shanghai', even if the artistic side of the town could claim birth of such words as 'blurb'! Rudyard Kipling had quite definite views: . . . 'a mad city, inhabited by perfectly insane people whose women are of a remarkable beauty.'

Although perhaps he may not even have heard of the man, Ponting certainly had an excellent photographic example to follow in California—the work of Arnold Genthe, a German who reached California about the same time. He achieved fame as a portraitist but his best work was done during forays into Chinatown, where he used a camera small enough to be kept out of sight until the moment of exposure. He waited hours for the right situation (as Ponting was to do in later years) and his photographs created a sensation when published after the 1906 great fire of San Francisco had destroyed the entire district. During that fire, Genthe was out in the streets recording the spreading flames and the fleeing refugees.

Ponting, arriving with an unknown though doubtless considerable amount of paternal money in his pocket, purchased a fruit farm at Auburn—a town some miles to the north-east of San Francisco beyond the state capital of Sacramento. The ranch was described as 'a great English settlement' and, indeed, the towns of Auburn and nearby Newcastle contained many English people. (A book published in England in 1913 paid tribute to the many 'adventurous English' who emigrated to California in its early years but also noted the 'antipathy towards England which lurks in every (native) Westerner's heart'. Paradoxically, the author went on to record the extreme popularity of a wide range of goods 'Made in Britain'.[2])

Besides ranching, Ponting invested with partners in gold-mining and, for some time, worked a successful pocket in the area of Forestville, on the American River. It was not long before he married—and married well. His bride was a pretty and popular girl in her late twenties. Mary Biddle Elliott was the daughter of Washington Lafayette Elliott (his father was a close friend of *the* Lafayette), a General in the U.S. Army who had fought in the Civil War and had been in command of the Presidio or Army H.Q. in San Francisco. Mary's middle name was in honour of her mother's family, which was prominent in the State of Pennsylvania.

The marriage took place on 5 June 1895, and a local unidentified paper recorded 'a wedding of real interest' at the First Presbyterian Church in San Francisco. 'In the fashionable set, few families are better known than the Elliotts and fewer still enjoy a higher degree of esteem. The bride is the daughter of the late General Washington L. Elliott and her uncle was Commodore Denman who achieved distinction in many naval battles. . . . Mr. Ponting is a resident of Auburn, where he owns a large ranch. . . . She wore the inevitable white silk, but it was garnished by a quantity of rare old lace, an heirloom in the Biddle family. . . . '

A daughter, Mildred, was born at Auburn in January 1897. But the ranch got into financial difficulties and, toward the end of 1898, the family left for London, where the second child, 'Dick', was born in March 1899. Ponting was to display his financial ineptitude time and time again, but—to be fair to him—the Californian episodes may not have been entirely his fault. At the turn of the century in California, the cynical Englishman Arthur T. Johnson criticised the wealth of crooked real-estate agents ready to sell ranches at the drop of the proverbial hat. 'Now if this prospective buyer is a "genu-wine sucker" . . . he will probably fall into the baited trap so cunningly laid for him, and, at the end be glad to purchase his liberty with his bottom dollar.'[3]

After about nine months in London, the Pontings returned to a new home in Sausalito, just across the Golden Gate from San Francisco. It is not clear at which stage the gold-mine project collapsed, but it did—after a great deal of money had been invested in the attempt to find new and productive pockets.[4]

In 1904 the family moved again, this time to a $4,500 three-storeyed home near the young University of California. But, by this time, photography was already prominent in Ponting's life.

According to his own account, he took up photography seriously in 1900. 'Then I had to stereograph everything I could. The beautiful stereoscopic process had a hold of me [which] . . . got stronger and stronger.'[5] If his later life is any guide, Ponting would have devoted great time, study and energy towards conquering the techniques of this form of photography—in which two simultaneous photographs are taken of a scene, from viewpoints separated by the same distance as a pair of eyes. The resulting photos are looked at through a suitable stereoscopic viewer which produces a '3-D' effect. The typical way of taking the photos was—and still is—by a camera with two taking lenses.

By chance, a professional photographer was commissioned to illustrate the area of California where Ponting was living, and asked his advice on where the most promising pictures were to be taken. Ponting did so, with an expert eye for a scene which impressed the professional. At the same time, Ponting showed some of his own negatives and the professional was even more impressed. He was advised to try his pictures in competitions and also to send a selection to one of the companies specialising in making pictures for the stereoscope, which was enjoying one of its periodic bouts of popularity. The advice was followed—with spectacular results. In 1900, a 'telephotograph' of San Francisco Bay shot from his home at Sausalito was submitted in a competition organised by the lens manufacturers Bausch & Lomb—and won 'the world's prize'. In the same year, Ponting shot a superb picture of 'Mules at a Californian Round-up'. This was enlarged from the 5 in. × 4 in. negative as a print 6 feet long, and featured in the centre of the Kodak exhibit at that year's World's Fair at St. Louis (Plate 13).

The approach to the stereo company was successful, too. In a typically casual manner, Ponting later related how storage of all his stereo negatives was a problem. He submitted them to the publishers and 'I was so staggered by the prices offered that I thought this method was the best way of "scrapping" negatives I had ever known, and as often as I could I sent others along'. Within a few months, an invitation arrived to go to New York (all expenses paid) to talk business.

This was the beginning of more than a decade of globe-trotting. In 1901 he went on a tour of the Far East on behalf of the magazine *Leslie's Weekly* and The Universal Photo Art Co. of Philadelphia. Not long after his return, Underwood & Underwood—another major publisher of stereo photographs—commissioned him to go to Japan, and he also took many photographs in Korea and Manchuria. Then, when the Russo-Japanese War broke out in 1904, he was accredited as a war photographer to the First Japanese Army in Manchuria, working for *Harper's Weekly* and H. C. White & Co. It is impossible to establish the precise chronology of his travels after the Russo-Japanese War ended in 1905, but he was certainly in China and India in 1906–7, and back in Europe, taking mountain photographs in Switzerland and France, in 1908.

Spain, Portugal, Russia, France, Java and Burma were other countries to which he was sent on assignment, and the list of magazines and periodicals in which his photographs and also his articles appeared in England and America was impressive. It included *Harper's, Century, World's Work, Strand, Wide World, Metropolitan, Cosmopolitan, Sunset, Pearson's, Leslie's Weekly, Sphere, Illustrated London News,* and *Graphic*. His work was featured in *L'Illustration* and other continental weeklies, and he was a particularly frequent contributor to *Country Life*.

The attempt to assess Ponting's work during this period is difficult on two counts. Since he was working for agencies his pictures frequently had agency credits and not personal credits. Thus, while today a shrewd guess can be made as to the authorship of photographs—particularly as Ponting's style developed—there are many question-marks. Similarly, he contributed to so many magazines that it is almost certain that only a comparatively small proportion of the total output has been traced and examined. Nonetheless, the attempt at such an assessment must be made, preceded by a brief description of the state and technique of photography during this period.

What was the nature of the world of photography which confronted Ponting around 1900? The industry was introducing major technical innovations with impressive frequency, but the typical professional probably remained true to the time-honoured pattern of the past few decades. He used a large-format camera ('howitzers' was how one famous photographer described them) which took glass plates. If he was really a large-format man he would prefer 10 in. × 12 in. glass plates or even larger. If he was somewhat more daring, he might have been using a smaller-format camera, perhaps taking plates $3\frac{1}{4}$ in. × $4\frac{1}{4}$ in. The plates were much less sensitive to light than today's

24

films, thus necessitating long exposures. The emulsion of the plates was orthochromatic (that is, not sensitive to the orange and red section of the spectrum) and development was by inspection. Enlarging was the exception and printing was often done using daylight and by contact—hence the frequent need for large negatives. According to preference, the photographer would be making albumen prints (steadily going out of fashion at Ponting's time but still favoured by some), in which paper was coated with a thin film of egg-white before it was sensitised by a solution of silver nitrate; or possibly the very expensive platinotype prints—using platinum—that yielded deliciously deep blacks but which were soon to be replaced by the cheaper palladium (palladiotype) prints during World War I; or maybe carbon prints, which were Ponting's speciality. The skilled man would pride himself on his ability to gauge the exposure required and might get angry if it was suggested that he should use the then equivalent of the modern exposure meter—the actinometer. Ponting, however, was not too proud to use it—'and vast as his experience is, he is not above using an actinometer to measure his light speed whenever he has any doubt'.[6]

But if this was the somewhat conservative world of the professional or serious photographer in the early 1900s, things were changing—to a considerable degree both stimulated by and causing the mushrooming popularity of 'snapshotting', with camera clubs and photographic magazines springing up all over the place. In 1900, for example, it has been estimated that there were 4,000,000 camera owners and 256 photographic clubs in Britain.[7] The American, George Eastman, had launched his first roll-film camera, and a new film on thin cellulose nitrate base (due to become the less inflammable cellulose acetate in due course), a dozen years or so before. In the early 1890s daylight-loading film-rolls were introduced, and Hurter and Driffield had already published the results of their scientific investigations into emulsion characteristics, which were of major importance to later progress. The number of genuine hand-cameras—as distinct from the gimmicks of the 1880s—was increasing, and the first 35 mm. still-camera was only a few years away. The far-easier-to-use chlorobromide, silver bromide and silver chloride types of photographic papers—essentially like those used today—had already been announced, and were steadily to remove most others from the market-place. In 1906 the British company of Wratten & Wainwright introduced panchromatic plates—that is plates with emulsion sensitive to all the visible colours of the spectrum—although they were not to become really popular until later.

In 1907 the Lumière brothers in France introduced the Autochrome Plate for colour photography, in which a panchromatic emulsion layer was exposed through a screen formed of a mixture of starch grains dyed in the primary colours of red, blue and green—the result being viewed through the same screen. Of this system, the *British Journal of Photography* of 3 January 1908 wrote: 'There can be no doubt that

the photographic event of the year, and one which will have an influence on the immediate future of photography, has been the introduction of the Lumière Autochrome Plate, and the consequent indulgence, on the part of the veriest tyro in the use of the camera in colour photography.' Other colour processes appeared in due course —the first 'Kodachrome' film in 1914, for example[8]—but it was not until 1935 that the real breakthrough was to come.

So it was indeed a time of fast, technical progress. But arguments about the nature of photography, and in particular its relationship with the painter's art, also flowed quickly and freely. Some years before Ponting took up photography, the vitriolic Dr. P. H. Emerson in England had been attacking in scathing terms those photographers who did nothing but record artificial, staged scenes in the studio. The school of photographers who produced vast combination prints from as many as thirty negatives on the one hand and those on the other who strove to reproduce the style of the impressionist painters or of other schools of painters inevitably evoked a response from photographers of the genius of Alfred Stieglitz, who believed that photography existed in its own right and on its own terms, and that effective pictures existed everywhere in everyday life. George Bernard Shaw—an extremely keen photographer—was active in the debates around the turn of the century. In an inimitably waspish way, he wrote: 'I greatly prefer the photographers who value themselves as being photographers, and aim at a characteristically photographic technique instead of a sham brush and pencil one. . . . As to the painters and their fanciers, I snort defiance at them; their day of daubs is over.'

There is little evidence that Ponting had much time for these doctrinaire arguments. In a typical manner, he was probably too busy exhaustively learning the techniques of his new trade, and—once he had set out on his travels—too busy working on his various commissions. Besides, he was never one for intellectual debates.

If the photographic world both technically and artistically was in ferment, it was also a risky world upon which Ponting had launched himself. One man who became a photographer at the same time and who was to become a famous portraitist (and who also came from a banking family) later wrote that there were large numbers of itinerant photographers 'little better than tramps', walking the countryside soliciting sittings from villagers. 'Photography was still in the outer suburbs of the professions, and my father, a banker, was reluctant to see me embark on a career which seemed to have little but the hazardous to recommend it.'[9] When this photographer—the famous E. O. Hoppé—decided to take up portrait photography just after getting married, he was faced with a major family row, and was told: 'You are mad to think of becoming a photographer . . . jeopardising security for a wild-goose chase. You ought to show a little more sense of responsibility.'[10] Fortunately, such advice was rejected by Hoppé and—if it were ever proffered to him—by Ponting as well.

The earliest Ponting article of any note was published in *Navy and Army Illustrated*, on 8 December 1900. It was entitled 'The Training of Army Horses'. Describing the breaking-in of wild horses and mules for the German Army in China—a subject about which he obviously knew a great deal—Ponting wrote well, and included were some excellent action-shots. Masquerading under the title 'Awaiting the Kaiser's Orders' was the famous photograph better known as 'Mules at a Californian Round-up'.

From this time on, sometimes with both articles and photographs, but more frequently with photographs only, Ponting dealt with a vast number of subjects. In *Country Life* of 12 December 1908, he wrote eruditely—if ponderously—on the superb workmanship of the decoration on Japanese swords (one example was 'worth as much as a crack six-cylinder motor-car'). In the same magazine, in September 1907, he wrote an article on the Ming tombs of Peking. In *Wonders of the World*, around this period, his photographs were frequently used to illustrate articles by others—and his coverage of Burma, India, Japan and China was a particularly fruitful source of such photographs.

Over these early years of the century, a pattern can be discerned in Ponting's written and photographic work for the magazines. Photographically, there was much extremely competent *record* work for the agencies—for example, panoramic views of Port Arthur and of Mukden at the time of the Russo–Japanese War—which occasionally rose to even greater heights, as in the burning of the Hindu dead on the Ganges at Benares. There was also frequent and extremely capable *pictorial* photography which also rose—though even more often than in the case of the record work—to greater heights. For example, in the pages of the *Wonders of the World* a superb shot of Kangchenjunga taken from Darjeeling with a long-focus lens gave an almost unbelievable impression of depth and power, while choice of viewpoint and lighting yielded photographs of the Great Wall of China which had surely never been seen before.[11] There had been many photographs of the tombs and monuments of the Indian emperors before, but it took a Ponting to isolate the splendour of Mogul Emperor Akbar's tomb by shooting it through the fine, marble lattices of the mausoleum, leading attention powerfully to the tomb itself (Plates 32, 34 and 39).

In his 'pen and picture' articles, Ponting quickly achieved a very successful formula. He researched his subject well (from Tibetan prayer-wheels to the habits of alligators) and wrote a mixture of potted history, travelogue and romance illustrated by his own photographic work. Most of this material was not truly memorable but was clearly well-suited to the requirements of the editors and thus to the readers of the day. He never claimed to be much of a writer and was certainly not when he was philosophising or expounding on an abstruse subject in a verbose and pedantic manner. However, when recording action (for example, in the case of a photographic mission) his writing improved. In the middle of 1907, he recorded in *Country Life* his

attempts at photographing the alligators kept by a Maharajah in a lake near Calcutta. The 'muggers' were enticed from the lake by meat:

'Others now began to appear on the surface and were lured ashore by similar means. I was busy photographing each specimen as he emerged from the water. By means of a pair of 8 inch lenses on a stereoscopic camera, I was able to keep at a safe distance and yet secure fair-sized portraits of them. They were easily alarmed by any sudden movement and would rush off into safety again; but the tasty scraps were irresistible. . . . It was not easy, however, to get the brutes on to the high and dry ground. They preferred to remain on the safe side of the water's edge where their powerful tails could help them manœuvre even more rapidly than was possible on the hard surface. There was no running or hurrying about them unless alarmed. They appeared to be most sluggish brutes; the instant they were frightened at anything they would swing round and rush back to safety with the speed of which I have already spoken....

'The Indians repeatedly warned me not to approach too near; but thinking the muggers were as much afraid of me as I of them, I became foolishly bold, and in the end had nearly cause to rue my enthusiasm. I was intently centring one on the ground glass, with my eyes well down into the hood of my reflex, when I thoughtlessly stepped back a few paces, quite forgetting that there was another ten-footer close behind me. Suddenly there was a fearful snort, the Indians yelled, there was a patter of feet, and without turning to look I took a leap and then ran. I was not a fraction of a second too soon, for the brute's jaws came together with a loud snap that fairly made my blood chill, as I realised that only my leap had saved me from being badly mangled, or, as would more probably have been the case, set upon by the lot of them and dragged into the lake' (Plate 38).

Although obviously not intended for publication, a letter which Ponting wrote to his parents from India on 18 February 1906 reveals his narrative capability. He was writing about Benares, the sacred city of the Hindus—a subject that was later to form part of one of his lectures in the Antarctic and to greatly impress his Polar colleagues:

'Sunrise was accompanied by much ringing of bells and the prayers of the multitude were as the roaring of the sea, and even my boatmen as they rowed chanted now and again the long drawn out sacred syllable "Awm". On the terraces of the temples and palaces, monkeys jibbered at each other and hawks and vultures were waiting for the refuse from the pyres. As the great sun rose on the opposite side of the river, a sight of the most sickly horror began—the burning of the dead. This ghastly spectacle needs a Zola to paint it in prose.

'The bodies, swathed in thin cloth—white for men and red for women—were

brought to the water's edge and bathed in the river; some were even bathed before the breath had left their bodies; then the wood pyres were arranged and on each a corpse was placed. A relative applied the torch, sometimes a tiny boy to the pyre of his mother or a son to the pyre of his father; sometimes a father applied the fire to the body of his son; or sometimes a poor weeping half-fainting little child shrieking with terror . . . lit the fire under the still warm body of his father who had died but an hour or so ago.

'The horror of it all! A whole morning from sunrise to noon, I watched the sickening spectacle fascinated with its horror and the desire to illustrate it all. Around me were old people on beds, brought to the holy riverside to die, shaking at their last gasp and close beside them the corpse burners served the hissing crackling fires.

'At the end of each little pyre, the feet and head stuck out so that each body was first consumed in the middle. Then, as the fire burned low, the Domra (or corpse burners) prodded the corpses with long poles and bent and poked and beat them into the hottest parts of the fires. They broke the bodies in two, and they smashed in the skulls so that they would burn the better, and when the fire burned out before the corpse was much more than charred, as was often the case with those whose relatives could not afford sufficient fuel, they rolled the blackened trunks into the river where some sank and some floated downstream past the crowd of bathers, and some floated in amongst the boats and one I saw float to the water's edge and I turned away sickened at the sight of a lean cur tearing out its heart.

'All day long, from daylight to dark, a steady stream of bodies flowed to the burning ghats and all day the smoky air was rent with the wailing of the women, the chanting of the pall bearers and the crackling of the pyres.

'The poor were borne on a single pole to which the hands and feet were tied, sometimes not even a shroud covering the bodies, whilst the corpse of a rich woman [was] laid in a bamboo cradle decorated with fruit and was borne by many bearers and accompanied by much beating of tomtoms and cymbals. Whilst the corpse was being purified in the holy river, into which a sewer belched the city's filth not 6 feet away, the Domra refreshed themselves with the fruit on the catafalque and a young father came bearing the body of his baby in his arms and cast it into the sacred waters.

'Ever and again a great kite swooped down from one of the palace towers and snatched a piece of flesh from the stream, and on the other side of the river vultures waited for the bodies of cattle and the corpses of those for whom no pyre could be afforded. I made a photograph of some hundreds of these foul creatures tearing a corpse to pieces and another picture showed the skeleton picked clean of every shred of flesh.

'Benares, the Mecca of the Hindus—where all who can come to die—beautiful as it is in the changing lights of early day; replete as it is in picturesque charm and

colour; graceful as are its minarets and magnificent as are its buildings, will always remain in my memory as a place of untold horror.

'After this fearful place, how beautiful and glorious is Agra. Of Agra it seems to me I could never tire, for surely the brain of man never conceived more perfect buildings than are here. Of them all, the tomb of Itamu Daulah and the Taj Mahal are the loveliest, the latter probably the most perfect structure which ever graced the face of mother earth.

'This exquisite thing—beautiful as a dream—a creation of marble inlaid with agate, cornelian, coral, jasper, turquoise, malachite, lazulite and other rare stones seems too perfect to be real. I cannot attempt to describe it, no words could do it justice and to tell of its history would be to recount a love tale which has been told again and again and again. I have brought all the skill I can command to show in my pictures something of its ethereal beauty, but how can I ever tell you of that sainted chamber in which rest the bodies of Shah Jehan and his Persian queen? How can I attempt to describe the delicate beauty of that trelissed marble screen, inlaid with precious stones, which girdles the tombs? How can I speak of those pierced marble windows which temper the fierce Indian sunlight to a soft gloom? And how can I convey to you the slightest idea of the wondrous echoes which the slightest whisper awakes? A Mahomedan chanted a long note in a high tenor. Ah! the beauty of that sound. It filled the whole chamber with a clamour of music and set the air waves ringing. It lingered on the marble pavement and sprang from wall to wall. It surged through and through the marble tracery, and ascending higher and higher in a slow quavering dimuendo, it fled, many seconds later, murmuring through the marble windows above.

'To describe the beauteous Taj is beyond me. One must see it for oneself. The tomb of Itamu Daulah is so exquisitely embellished with marble tracery that I can only compare it to a delicately carved ivory jewel casket inlaid with gems. For beauty of design this building, to me, stands second to none that I have ever seen. Not even the Taj Mahal can eclipse this beautiful lace-like thing. But the two are so different in design that they do not vie with each other. Each of its kind is supreme and each is perfect.

'But even beauteous Agra has its horrors. I was wandering along the other side of the river where no one but artists and photographers and other queer people ever think of going. They were burning the body of a woman on the sand and on the banks there were many skeletons. I was making a sunset picture of the Taj Mahal across the Jumna river. A kite flew overhead bearing something large and strange-looking in its talons. It alighted a hundred yards away. Curious to know what its prey was, I ran and frightened the bird away and found the body of a baby which it had just begun to devour.

30

'I told you I expected to find India a melancholy land. But oh the picturesqueness of it all. It is a paradise to me' (Plates 33, 35, 36 and 37).

It was undoubtedly the Russo–Japanese war which was the biggest single event affecting Ponting's work in the pre-Antarctic period—and the war needs setting in its context. As the nineteenth century moved towards its close, Japan attempted to expand in China and, in 1895, the Southern Manchurian port of Port Arthur was ceded to it by the Chinese Government. However, largely as a result of Russian pressure, Japan was later forced to give up Port Arthur, and Russia herself took it over as an ice-free port in 1898. Russia also had eyes on expansion in Korea. In 1902, however, Japan and the United Kingdom signed a treaty, the most important aspect of which was that, if Japan went to war with Russia, Great Britain would support Japan if any other European power attempted to join in on Russia's side. In fact, this agreement made a Russo–Japanese war almost inevitable—despite continued negotiations between the two countries in 1903. In February 1904 the Japanese attacked the Russian fleet in Port Arthur (before any declaration of war) and one of the bloodiest struggles to that date began. Naval power played an important part but the main action on land was the drive of the Japanese armies—under the command of Marshal Oyama (Plate 15)—out of Korea and into Manchuria. The fall of Port Arthur to the Japanese army; the battle of Mukden (with about 60,000 casualties on each side); and the sea-battle of Tshushima brought Japan victory, and the defeat of Russia was to have an effect on its internal history, being a critical factor in the Revolution of 1905.

Ponting, as already indicated, was touring the area before hostilities began. When the war started he was attached to the Japanese First Army in Manchuria, under General Kuroki. The lot of the western war correspondent or photographer on the Japanese side at this time was not a particularly productive one. While the Japanese were the height of civility, they placed severe restrictions on the movements of correspondents and kept their plans very secret.[12] Correspondents were not even allowed to inspect Japanese guns, magazines and store depots. Thus, while there were photographs of the front from the Russian side, such photographs from the other side were extremely rare.

There is no indication that Ponting escaped from this general Japanese policy, though there was one report of his being allowed to spend three days on the half-sunken Russian warships in Port Arthur a few *months* after the fall of the fortress. There was another story of the co-operative Japanese officers staging a bayonet-charge up a hill so that Ponting could photograph the awesome spectacle—an objective which was somewhat spoiled by the apparent amusement of the Japanese other ranks at such a ludicrous performance, resulting in an inability to make the appropriately fierce faces.

If they did not see much of the actual war, the correspondents were extremely well-received by the Japanese. Ponting had a number of formal meetings with the Japanese supreme commanders and was on good terms with them (Plate 6). He visited individual high officers and his knowledge of Japanese history and customs was a great asset. And if he learned little of the higher strategy of the war, at least he discovered that one of the generals had a good luck mascot in the shape of an extremely attractive doll!

The West Coast of America sent a number of war correspondents and photographers to the area—one of whom was Jack London—and Ponting was always included with them as a 'Californian'. He was high in the regard of his colleagues, as was shown by an article written about the Californian correspondents in the Russo-Japanese War by one of their number, Edwin Emerson—who had been one of Roosevelt's Rough Riders in Cuba during the war of 1898, and who continued to lead a very active life during the Russo-Japanese War. In the magazine *Sunset*, in October 1905, Emerson referred to Ponting as 'the foremost war photographer in the Far East . . . Ponting is the man, whose exclusive photographs of Port Arthur, Mukden, Manchuria, Korea and the hostile war fleets in eastern waters were published broadcast by Underwood and Underwood at the outset of the war. Ponting was the only one who had the gumption to travel through these regions on the eve of the outbreak of hostilities, photographing everything of warlike interest in spite of frequent arrests and danger of prolonged military imprisonment. When war broke out, his unsurpassed stereoscopic pictures of the most important places and men in the theatre of war, were in such demand that the publishers cleared many thousands of dollars, the reproductions appearing in American and European publications. . . .'

After repeating praise of Ponting's work and how it rivalled the work of the best and renowned war photographers, Emerson continued: 'When I first met Ponting in the Far East, he was perched on a high ladder in the midst of a surging mob on the principal square in Tokyo taking photographs of a public reception given by Admiral Togo. Someone nearly upset the ladder. I caught it as it swayed and steadied it. Ponting merely glanced down for an instant and said, "Thank you, sir". Later, when I was more formally introduced to him, he told me that he had got so used to being upset with his camera that the danger of such an accident had ceased to have the thrill of novelty.

'When I left the Far East, Ponting was just setting out again for the front in Manchuria. The last news I have of him is a quaint photograph he sent me showing him asleep in the temporary quarters of the war correspondents with Kuroki's Army in an ancient Chinese temple. He did not write who took this photograph. I am probably right, though, in presuming that he took it himself. No other war photographer, with the Japanese Army, could turn out so good a piece of work.' (And, incidentally, it was a sign of the future that in *Harper's Weekly* for 17 September 1904,

photographic coverage of the Russo–Japanese war which was almost certainly executed by Ponting should appear just a few pages away from an article titled 'The Story of The New Farthest South'—an account of the 'Discovery Expedition' to Antarctica by Captain Scott.)

As Ponting's name became wider known, his work extended beyond magazine articles. In 1905 (the same year as he was elected a Fellow of the Royal Geographical Society) twenty-five of his best Japanese photographs were published in Tokyo and London in *Fuji-san*, and, later, fifty more varied views appeared in *Japanese Studies*. Later still, a volume of *Camera Pictures of the Far East* was published. Some of the individual photographs could be purchased, and prices of between two guineas and three guineas were being quoted for prints around 20 in. × 16 in. in size.

The small books of photographs were well received. *The Sphere*, for example, wrote: 'A wonderful series of photographs. Mr. Ponting is not only great in his photographic technique, but he has a fine artistic instinct—a rare combination.' Another critic, Captain F. Brinkley, an author of many works on Japanese art, wrote of *Japanese Studies* in the *Japan Mail*: 'It seems altogether a misnomer to apply the name photograph to these exquisite reflections on Nature's graces. They are quite free from the objectionable characteristics which belong to the ordinary photograph: offensive fidelity, mechanical accuracy and exclusion of all appeal to the imagination. Indeed, they seem to us to rank even higher than pictures, for the subjective element is supplied by a subtle choice of aspect, and there is a mystery of aerial perspective such as a painter's brush could not produce, or at any rate, has not yet produced. What strikes us notably in the landscapes is the cloud effect—the last thing one would be disposed to look for in a photograph. But, in truth, it is difficult to indicate any feature deserving exclusive praise.'

However, when an exhibition of Ponting's work was held by the *British Journal of Photography* at its Wellington Street offices in London in the spring of 1908, and a set of prints included later that year at the annual Royal Photographic Society Exhibition, there were some—if inadequately developed—criticisms. His R.P.S. exhibition prints were praised for perfect technique ('a clever photographer') but an item in the *British Journal of Photography* of 18 September 1908 commented that the photographs carried 'the mind back to the photographic exhibitions of 15 years ago . . . and one realises . . . how far pictorial photography has advanced during the past few years . . . the work was not done chiefly from a pictorial point of view'.

Such comment had little practical effect on Ponting—though he answered the critics when he wished to—and his photographs were displayed at conversaziones of the Royal Institution, at the Canadian National Exhibition of 1909 and at the 1909 Dresden International Exhibition. The last was the most ambitious and comprehensive exhibition of photography held up to that date, and has probably never been

equalled since. One of the British selectors, or 'commissioners', for Dresden was E. O. Hoppé, who was already well on the way to becoming Britain's foremost portraitist. An Austrian by birth, he had arrived in England a few years after Ponting had left for the United States.

Hoppé invited Ponting to submit some of his Far Eastern prints for the Dresden Exhibition. He did so and sent twelve of his Japanese photographs, printed by the carbon process up to a size of about 60 in. × 40 in.[13] Hoppé recorded later that he had never seen such print sizes: 'They were exquisite and beautiful, and the cost must have been very high. They also required enormous negatives.' Ponting had his reward, for the photographs were well received. The King of Saxony bought six of the photographs, and the publicity no doubt played some part in supporting Ponting's claims for final selection for the Antarctic expedition.

Although as photographers they were concerned with greatly different subjects, Ponting and Hoppé enjoyed a friendship of several years. First at Margravine Gardens, and then at Millais House in London, where he had a studio, Hoppé provided a meeting-point for young and struggling artists of all descriptions. His Thursday evening get-togethers became famous and the visitors included Homes, Editor of *The Studio*, Mackintosh, the Scots painter, Epstein, Violet Hunt (granddaughter of Ford Maddox Brown), and Caruso sang for them on one occasion. The circle was typical of its kind: its members argued endlessly, remade the world, and had musical interludes. Hoppé and Ponting both played the guitar together and Ponting occasionally sang. Ponting, according to Hoppé, fitted easily into the circle even though the others did not get to know him well and he did not enter into any close relationships. He talked extensively about his travels and was a good raconteur of stories and jokes—frequently making slightly acid asides. Hoppé's lasting impression was of a perfectionist, who was his own fiercest critic but not particularly gracious towards criticism from others—a person who, in the view of this man who was afterwards to photograph everybody of importance in society from George Bernard Shaw to King George V, was the '*supreme* pictorial reporter with a superb technique' (Plate 18).

Ponting attended the Thursday evening circle until a few months before he left for Antarctica in 1910. Thereafter, attempts by Hoppé to re-establish contact were unsuccessful—a situation for which no easy explanation could be found. Hoppé and his wife often talked about Ponting and wondered about his background. They noticed that he never talked about a family, were puzzled about it and speculated as to the reason.

Unknown to them, Ponting was, of course, married, but his marriage had been the one major casualty of this period of his success.

Around 1905 or 1906 he returned to the home in Berkeley and reputedly told Mary,

his wife, that as an artist marriage was a millstone round his neck and that he could not be tied down by family responsibilities. He left the family and never returned. His daughter Mildred was about nine years old and his son 'Dick' seven years (Plate 5). That Herbert was so involved with his photography that it amounted to an obsession or a fanaticism on his part is indisputable. Whether this was the genuine or main cause of the breakdown of his marriage—an artistic renunciation of his wife— is not clear. No evidence of the personal relationship between him and Mary Ponting has survived and the children were too young to have any clear impressions. Whilst Herbert made many friends and was an excellent conversationalist and a pleasant companion, he never—either before 1906 or subsequently—made deep intimate friendships and very rarely took people into his confidence. Thus, once he had left the United States for good and returned to England, very few people knew that he was a married man. He was at heart, to use an American term, a 'loner'—although, judging from his later life, there is no evidence that Ponting was anything but healthily heterosexual in his attitude to the opposite sex. Maybe the Californian experience of those years had some effect on Ponting's decision. That other English visitor to California, Arthur T. Johnson, devoted some pages to the 'instability of the home' in California, and wrote: 'It can scarcely be wondered at, therefore, that a man who is a speculator at heart and a vagrant by circumstances, is liable to be bored by what is known as home-life . . . the home becomes a mere name, and he scrambles through life in the razzle-dazzle of the streets, the restaurant, and the hotel. Why, to him, the vision of a faithful wife darning socks over an evening fire is unthinkable. It would drive him to drink, or send him reeling to a typewriter or a telephone bell for company.'[14]

Be that as it may, Ponting not only left the young family on its own but later carried his alienation from his wife to the extent of specifically excluding her from his will: 'I declare that in no circumstances is my wife, whom I have not seen for upwards of 30 years, to receive any benefit from my estate.' (The children did figure, however.) Mary received some support payments from Ponting's father until the time of his death in 1923, and (possibly) part of Ponting's pay while he was at the South Pole. When Herbert died in 1935 Mary wrote in her notebook: 'The book is closed.' She survived him for only five years. There was never a divorce, only separation. Mary was prepared for divorce but Herbert refused, possibly because he may have feared the financial settlement he might have had to make.

Ponting received little sympathy from his family. His father Francis, as just indicated, helped Mary in the most practical way possible and also sent his youngest daughter Mildred to stay with her for some months in 1906. He was also consulted by Mary on the best way out of the mess. Herbert was quite emotional at this time, telling his father that he was a desperate man and was 'ready for the river'. He criticised

Mary too for misleading him about her age—she was around four years older. This emotional, over-dramatic outlook was to be continued in later years. Shortly before going to the Antarctic in 1910, he sent a message to his two children—who were in Europe—that he wished to see them before he left. They came to London but found a note at his hotel saying that he had already left, 'because he felt that if he again saw his children, it might deter his ambition to leave on this hazardous trip'. Later still, when he entered a period of acute depression and ill-health in the 1930s, he lamented to a friend, how 'I could be walking down Oxford Street, past my son and he not recognise me'—a throwback to the day in an earlier year of the century when he returned to California from one of his world trips, only to be met at his front door by a son who did not recognise him and who called to Mary Ponting that there was a man at the door 'who said he was his father'.

It is one thing to be a 'loner' when fit, active and in one's prime. It is quite different when one's strength is failing through ill-health and age and one's ultimate hopes and dreams have been dashed—whatever have been the successes along the way. This was what was to befall Herbert Ponting—but not before he met his greatest challenge and achieved his greatest success.

1. Two fascinating accounts of San Francisco at the turn of the century are *Bay Window Bohemia*, by Oscar Lewis (Doubleday & Co., 1956), and *Champagne Days of San Francisco*, by Evelyn Wells (Doubleday & Co., 1947).
2. Arthur T. Johnson: *California : An Englishman's Impressions of The Golden State*, p. 35. Stanley Paul.
3. Ibid, p. 52.
4. Ponting, as in all things, went very thoroughly into the techniques of anything he took up. In his book *In Lotus-Land Japan* (p. 83), he related the legend of how a Buddhist saint carved an immense face of the god Jizo on a wall of rock in one night. He commented: 'I did a little figuring on this achievement, and estimated that if two good Californian miners had worked, with the assistance of modern explosives, in blasting out the rock alone, without attempting any carving, they would have well-earned good wages if they had completed the work in a week.'
5. *The Weekly Press*, 23 November 1910. Ponting was later awarded a medal by the famous Dr. P. H. Emerson for *Artistic Stereoscopic Photography*.
6. *The Weekly Press*, 23 November 1910.
7. H. & A. Gernsheim: *A Concise History of Photography*. Thames & Hudson, 1965. See also Beaumont Newhall's excellent *History of Photography*. Museum of Modern Art, New York, 1964.
8. This was a two-colour process greatly different from today's 'Kodachrome' film.
9. E. O. Hoppé: *Hundred Thousand Exposures*. The Focal Press, 1945.
10. Ibid.
11. 'I had to live for three days in a little Chinese hostel filled with Mongolian muleteers and camel-drivers before the conditions were suitable for making an exposure' (*Weekly Post*, 23 November 1910).
12. The then Lieutenant-General Sir Ian Hamilton, in his book on the Russo–Japanese War (*A Staff Officer's Scrapbook*, Edward Arnold, 1906), recorded the correspondents' extreme dismay at this Japanese policy. He also had to struggle hard before he was allowed near the action.

13. The carbon process was greatly favoured at this time for exhibition purposes and the best portraiture. Carbon tissue—paper coated with a layer of carbon or coloured pigment in gelatine—was sensitised and exposed. The exposed gelatine became insoluble in water, but the unexposed or still soluble gelatine was removed by rinsing in warm water. The resulting range of tones was very wide and the prints made in a number of colours.

14. California: *An Englishman's Impressions of the Golden State*, p. 70.

3: The first book

In the years before 1910, then, Ponting's life had been extremely full and productive and he had firmly established himself as a photographer whose work was in demand. Also—as already indicated—he was a man who had a good news sense. In the middle of 1910, as he was preparing for the Antarctic Expedition, Ponting's first book, *In Lotus-Land Japan*, was published by Macmillan & Co. The timing was either very shrewdly chosen or was a most happy coincidence. He wrote later:

'June 1st, the date of the departure of the Expedition from London, was also a memorable day in another respect for me. It was the day on which my book, *In Lotus-Land*—a record of my travels in Japan, on which I had been working for the last six months—was published. Before leaving for the docks, I eagerly opened the parcel that had just arrived, and with no little pleasure contemplated the dozen volumes; the handsome embossed covers of red and gold; the large, clear print and margins wide, and the hundred or more full-page plates, each a triumph of the printer's art, that nestled among the neat, clean pages of the text. The publishers had sumptuously produced the work, and they could not have chosen a more auspicious day on which to offer it to the world.'[1]

There is little doubt that Ponting's appointment to the Scott Expedition helped to direct attention to the book, as did the staging at the same time of a Japanese–British Exhibition at Shepherd's Bush, to which he contributed some of his prints. Be that as it may, the book gathered together in one place sufficient words and pictures to provide a reasonably comprehensive impression of the man and his photography up to 1910.

Japan had long ceased to be a country of the mysterious east. Indeed, in the last years of the nineteenth century and in the early twentieth century, the flow of travel and other books about the country closely resembled the flood of books about Russia and the other communist countries in the period after 1945—and the general quality appears to have been as abysmal. Tourist trade was building up and, in a review of *In Lotus-Land*, the critic of the *Northern Whig* noted:

'Nowadays hosts of globe-trotters storm through it (Japan) as through a larger and

more varied Blackpool, bidding it stand and deliver its secrets before the challenge of their loaded kodaks [*sic*]. . . .'

Ponting certainly could not be accused of any superficiality. Material for the book was collected over a number of visits to Japan—probably concentrated in the years 1902–5—and he eventually reached the stage where he could converse simply in Japanese. He described the book as a 'guide book for the traveller', written by somebody whose camera and notebook had been his inseparable companions in many foreign lands. Guide book it certainly was, and in the best sense of that description. His typical thoroughness, his preparedness to concentrate firmly on a subject which had captured his imagination, his powers of observation were revealed on every page. (At one point, he refused to believe the measurements of the statue of the Daibutsu or Great Buddha at Amida as given in a book sold by the priests, since a photograph 'made with a sixteen inch lens from a distance of fifty yards, so that there is no distortion' proved them incorrect!) He gathered together an account of Japan's early history, its customs, its religions, its art, peoples, and habits which could not be comprehensive but was an excellent primer for the intending, sophisticated visitor.

The standpoint of the book was a clear one. Ponting was a fervent admirer of the Japanese people and—even more—of their country: 'A beautiful country' . . . 'one of the most delightful of holiday lands.' The three aspects of Japan which most intrigued him—the countryside and particularly Mount Fuji, its women, and its craftsmen and artists—figured prominently in the hundred or so photographs which were included.

While viewed from the hindsight of sixty years later (and in particular the events of the Second World War), Ponting's overwhelming enthusiasm for the Japanese may seem overdone, he could be critical. He was appalled by the attitude of the Japanese to the aborigines of Japan, the Ainu; he faithfully recorded what must have been an unpleasant experience when arrested by soldiers for photographing in a restricted area; and he had no hesitation in castigating one hotel as being one of the most extortionate in the land, and of complaining how prices were rising as a result of the growing tourist trade. The criticism, nevertheless, tended to be muted, and the book was overwhelmingly a tribute to Japan and the Japanese—and particularly the women, with their pervading influence on Japanese life. Since he wrote the book at a time when criticism of Japan had entered a debunking stage, Ponting's attitude was probably a useful attempt at balancing the picture, even if some critics of the time, who were favourably inclined towards the book, found it hard to accept such statements as: 'Never in history did foeman have a kinder and more generous adversary than did Russia in that struggle (the Russo–Japanese War). . . .'[2]

In the first edition of *In Lotus-Land*, Ponting apologised for the 'letterpress' and commented that the text had been written around his photographs at the suggestion

40

of friends. Many of the reviews which appeared in 1910 stated that there was no need for such modesty and that the writing stood on its own merits. His prose was typical of the times in which he wrote, and to the reader of the 1970s is often much too flowery and verbose. The reader begins to tire of repeated descriptions of Japanese girls as 'the daintiest little maidens', and when phrases such as 'a poem in greens of every shade'; (of a mountain) 'in gracious mood' or 'black and frowning'; 'soft balmy air'; 'snowy billows'; 'kindly nature'; 'gauzy cascades' and 'white-robed waterfalls' follow fast one upon another. But, as argued in the previous chapter, given the right type of subject, Ponting could write a passage which almost had the strength of the natural powers he was describing—as when he recorded a descent down the Katsura-Gawa Rapids:

'The captain never glanced behind him; he knew his men too well. Each was ready at his post, with pole poised in hand, and each knew the spot for which to aim. It seemed we must inevitably be dashed to pieces as the boulder raced towards us, but, just as the crash was imminent, Naojiro's pole flew out into a tiny hole in the slippery boulder's side. Simultaneously three other poles darted out as well. There was a jerk, a momentary vision of four figures putting forth their utmost strength and bending with all their strength against the rock, and the swirling waters rose level with the starboard gunwale, as for an instant our speed was checked, and the boiling current banked up against the boat. But it was only for a moment. The helmsman swung the stern round, and the great ungainly craft, grazing the boulder as it did so, took the curve and sprang over the waterfall like a fish'[3] (Plate 21).

Ponting's attitude in the book was serious throughout, and it underlines that a sense of humour was not a marked characteristic—something which was to be revealed more clearly in the Antarctic. He made brave if laboured attempts at a few amusing asides but rarely did they succeed. Those who in later years have struggled through the 'English' of a Japanese camera instruction leaflet will doubtless appreciate, however, Ponting's story of a notice in an electric car which read: 'Parsons infected, intoxicated or lunatics will not be allowed, children without attender too.'

But if he did not have much of a sense of humour, Ponting *was* the complete globe-trotter. He could compare the track up a hill called Kagozaka with the Mount Tamalpais Railway in California or the line up the Himalayan foothills to Darjeeling. A mountain called Myojin-yama was compared with the Gornergrat in Switzerland, Le Brevant in France or Yosemite Point in California. The great bell of the Chio-in temple reminded him of others in Russia, Burma, Peking and Korea.

He could take most events in his stride too. The mixed bathing in Japan—'the nude is seen but not noticed . . .'—scarcely caused one Ponting eyelid to flutter, even when

he was participating! And like the professional globe-trotter he was, he had an utter contempt for the antics of amateur tourists—whether it was the destruction of property to secure mementos or trampling over a Buddha statue for photographs to be taken.

On the various ascents of the Japanese mountains, he revealed his climbing background, though on one occasion he appeared to be somewhat irresponsible in attempting an untried way down Mount Fuji with inadequate preparation, and on another in letting his delight at the view to be seen at the top of Fuji's crater get the better of his caution and lead to an incident where, engulfed in cloud, he could have died of exposure.

Unlike in his account of the Antarctic Expedition in *The Great White South*, Ponting had comparatively little to say in this first book about photographic techniques or activities. But what he did write was a sign of things to come—and emphasised his thoroughness and patience in securing the photographs he wanted, no matter how long he had to wait. 'Many happy days I spent with my camera in this lovely spot; but not until three years later, and after I had tramped the fourteen miles to Nakano-kura-toge and back more than a dozen times, and waited patiently for many an hour, was I able to take the photograph of "Fuji and Kaia Grass". Sometimes, when the mountain was clear, there would be too much wind, and the grass was blown about so violently as to render the making of the desired picture impossible. And sometimes, the grass would be still but Fuji obscured by cloud. At last, however, the long awaited moment really came. The mountain was clear; for a few brief seconds the grass was still, and during them I secured the coveted picture—which depicts the mountain in early winter'[4] (Plate 28). (His camera was probably stopped down to as much as f/64 to get both the grass and mountain sharp, and this would have demanded a long exposure; a filter was also used.)

In another passage, he described how four porters were needed to carry his photographic kit and luggage, 'and there was but a small basket of the latter', whilst with the photographer's eye he commented a little later that: 'The site of every cottage among these hills and dales seemed to have been chosen only after mature and careful consideration with a view to securing the best and most artistic effect. Each little humble dwelling stood just where it ought; were it moved either to left or right the picture would be marred.'[5]

Securing another picture—which necessitated the blocking of a road, whilst 'a good deal of time passed'—led to a brush with the police and a fine, of 6s.! On yet another occasion, he risked his life to get the shot he wanted—something that was to occur in Antarctica. He was in the crater area of the 8,280-ft. volcano Asama-yama when it became particularly active:

'Great black whorls of smoke belched from the crater, being emitted with such force

42

and volume that they were pushed far back into the teeth of the wind; and several times we had to retreat quickly as they bellied out toward us. They rose to the heavens in writhing convolutions, and from the centre of the mass billows of snow white steam puffed out, and bulged beyond the smoke. And as white and black rose higher and higher in turn, they mingled with each other, and soared up to the skies in a gradually diffusing pillar of grey, which was tilted northwards by the wind and borne off rapidly into the clouds above.

'Here was a wonderful chance to secure a unique photograph, but on looking round for the coolies, I saw them madly rushing down the mountainside with my cameras as fast as legs could carry them. Realising that if I did not stop them I should miss the chance of a lifetime to get a picture at the lip of a volcano in the state of violent activity, I ran after them, calling to them to stop. The guide shouted back that we should all be killed if we did, and they continued their rush down the mountainside faster than ever. They raced over the smooth ash and leapt over stones like deer, regardless of the damage such a pace might do to my apparatus, which was packed to suit a more sober gait. Failing to check them with my shouts, I ran after them, and, being unencumbered, soon overhauled the man with my hand camera. Quickly unlashing the camera from his pack, I returned with another and older coolie—who had stopped at my bidding—to the crater's lip, and there hastily I took some snap-shots, and then rewarded the old fellow with a substantial gratuity, much to his satisfaction.'[6]

As indicated in the previous chapter, a large number of Ponting's photographs of Asian countries had already appeared in a variety of publications, and collections of his Japanese pictures had also been produced. *In Lotus-Land Japan* was reviewed widely—from the *London and China Telegraph* to the *Scotsman*; from the *Daily Telegraph* to *The Ladies' Field*; from *Photography* to the *Wigan Observer* and *The Hardware Trade Journal*! In all, Ponting's comment in the introduction to the new and revised edition of the book in 1922 was fair: '. . . the book was received with unanimous and generous approval by the Press.' The *Standard* recorded that, 'As an artist of the camera he is unrivalled'; the *Yorkshire Post* stated, 'among the best results by camera we have ever seen'; while *Photography* noted that the book contained '. . . over a hundred of the most admirable photographs', and praised his photographic technique, which yielded the kind of photography which did not leave the viewer '. . . as ignorant of the appearance of the things they represent as we were before we saw the photographs'—a reference to the popular printing manipulations of the time. The *Daily Mirror* and the *Civil Service Gazette*—surely strange companions—were the only journals which made a feature of Ponting's references to mixed bathing in Japan!

The standard of photography in the book, examined after the passing of decades, was uneven. Technically, the quality was as impeccable as it ever was and was to be. The tonal range of the prints was superb and indicated excellently exposed and processed negatives, whilst some of the shots which were taken indoors showed that Ponting was a complete master of available light photography. He was extremely proud of his photographic essays of Mount Fuji and he wrote in the introduction to the 1922 edition:

'Some of the writer's original studies, and more particularly those of Mount Fuji, have been copied by Japanese photographers, and by artists and craftsmen working in various metals and textiles. Lest, therefore, there be any who question the origin of these photographs, an extract is appended from a review which appeared in one of the newspapers of Japan when the author's Fuji-san was first published.'[7]

He had reason to be proud, and it is easy to see in the numerous photographs of Mount Fuji the precursors of the studies that were to follow of Mount Erebus and the Lister Range in Antarctica. Ponting sought different views and different conditions with a doggedness which deserved the results he frequently obtained—and it is scenic photographs which are undoubtedly the greatest strength of *In Lotus-Land* as they were to be in Antarctica. He had a feeling for the moods of mountains which has rarely if ever been equalled since—Japan, Antarctica, the Alps, they were all recorded with an unswerving skill (Plates 25, 26, 27, 28 and 29).

There was one other feature of the photographs in *In Lotus-Land* which was also carried over into the Antarctic work. Ponting never regarded himself as a portraitist, but he not infrequently took photographs of men—sometimes in the style of a portrait and at other times showing them at work—which were of great power and which were fine character-studies. There were a number of these in the Japanese book, in particular those depicting the craftsmen of Kyoto—men for whom Ponting had tremendous respect (Plates 19 and 20). He hated imitation in any shape or form and regarded originality as being one of the greatest characteristics of the best Japanese artists and craftsmen. In the famous Kinkosan workshop, however, he recorded how he found his Fuji photographs being copied on to tea-plates:

'I felt that the only attitude to adopt in the circumstances was one of "Shikata ga nai" (it can't be helped), and to comfort myself with the solace that imitation is the sincerest form of flattery.'[8]

There is no doubt what was the most disappointing feature of *In Lotus-Land*. Although it may be surprising—given Ponting's attitude to Japanese womanhood

44

(or because of it?)—the many photographs of Japanese girls and women, whether as main subjects or as foreground interest, were with few exceptions contrived, uninspired and absolutely predictable. The technical skill was still there and the prints were needle-sharp, with a full range of tones and usually divided into the classical proportions. The element that was absent was some sign of imagination and of life. Ponting's later attempts at portraits of women were also unhappy, and the conclusion must be that he was always a good and frequently superb photographer of nature and of men, but rarely of women. Photographs of Japanese women in traditional costume and in garden settings were common postcard subjects of the time, and it may be that Ponting could not sufficiently remove these stereotyped images from his mind.[9] The occasional photograph of a Japanese girl that was of some merit in the book was usually an available light shot and therefore not in one of the traditional poses (Plates 22 and 31 are two examples of exceptions).

Despite this, few contemporaries of Ponting found any fault though it is a relief to the biographer to find that the *Illustrated London News*, while bestowing general praise upon the book, commented that the eight colour shots in it (most of them of women) were 'conventional and of little worth'. The book sold well and went through two editions before being revised and published again in 1922.

Ponting's Japanese photography was later to have a use which he could not have foreseen when he was engaged upon it. In his diary for 29 May 1911 in Antarctica, Scott wrote:

'Tonight Ponting gave us a charming lecture on Japan with wonderful illustrations of his own. He is happiest in his descriptions of the artistic side of people, with which he is in fullest sympathy. So he took us to see the flower pageants. The joyful festivals of the cherry-blossom, the wistaria, the iris and chrysanthemum . . . and the paths about the lotus gardens, where mankind meditated in solemn mood. We had pictures, too, of Nikko and its beauties, of Temples and great Buddhas. Then, in more touristy strain, of volcanos and their craters, waterfalls and river gorges, tiny tree-clad islets, that feature of Japan—baths and their bathers, Ainos and so on. His descriptions were well given and we all of us thoroughly enjoyed our evening.'[10]

The last sentence of a review of *In Lotus-Land*, which appeared in the *Geographical Journal* in September 1910, read:

'The British Antarctic Expedition should be well served by the camera in Mr. Ponting's hands.' It was.

1. *The Great White South*, p. 5. Gerald Duckworth, 1921.
2. *In Lotus-Land Japan*, p. 38, 1922 edition. J. M. Dent & Sons.
3. Ibid, page 258.
4. Ibid, p. 107.
5. Ibid, p. 118.
6. Ibid, pp. 289–90.
7. Ibid, p. vi.
8. Ibid, p. 232.
9. To be fair to Ponting, these unfavourable impressions could stem from the viewer's lack of knowledge of Japanese customs and attitudes. Defending his concentration on lotus gardens, for example, he wrote in 1908: 'Many of my photographs have a deeper meaning than the untravelled will perceive' (*British Journal of Photography*, 23 October 1908).
10. Quoted in *The Great White South*, pp. ix–x.

4:The Great White Silence

BY 1909—when Robert Scott was selecting the men to accompany him on his second Antarctic Expedition—Herbert Ponting was already a famous (and perhaps the most famous) out-door photographer. But it was his previous travels with Cecil Meares that probably made the offer of the photographic specialist's post on the expedition a certainty.

Ponting, who was *en route* for India, first met Meares in November 1905, on a steamer going from Yokohama to Shanghai. Meares was as travelled as Ponting, if not more so. He had spent years in India and some periods in Siberia and Kamchatka —speaking Hindustani and Russian as a result. Since Meares was in need of a holiday after experiencing an unpleasant time in the Russo–Japanese War, he accompanied Ponting as his interpreter for six months during a visit to Burma, India and Ceylon. During their time together, Meares spoke of his desire to go on a polar trip, and his enthusiasm imbued Ponting—with his experience of mountaineering and mountaineering photography—with the same spirit. The interest was deepened when Ponting read Scott's *The Voyage of the Discovery* during a trip across Russia in 1907. When Scott began to form his party, Meares offered his services as transport officer. He was accepted, and relieved Scott of the entire burden of arranging the supply of the Siberian dogs and ponies which were to be taken on the polar trip—and was in charge of the dogs in the South.

Ponting made Scott's acquaintance through Meares. Their first meeting took place in the autumn of 1909, when Ponting was already planning a two-year photographic tour of the Empire under contract to the Northcliffe Press:

'But I was drawn strongly to the famous explorer at my first meeting with him. His trim athletic figure; the determined face; the clear blue eyes, with their sincere, searching gaze; the simple, direct speech, and earnest manner; the quiet *force* of the man—all drew me to him irresistibly. During this, our first interview, he talked with such fervour of his forthcoming journey; of the lure of the southernmost seas; of the mystery of the Great Ice Barrier; of the grandeur of Erebus and the Western Mountains, and of the marvels of the animal life around the Pole, that I warmed to his enthusiasm. He told me of his plans for scientific research—for geology, zoology, biology, meteorology, physiography, and for photography. . . .

'. . . when Scott finally stated that he considered photography was of such importance in exploration that it was his intention to make a special department of the art, and he asked if I would like to take charge of that part of the enterprise, though I asked for a day to think the matter over, I had already made up my mind that I would go if equitable arrangements could be made.

'The next day I told Captain Scott of the alternative plan which I had had under consideration. Just, and willing to look at all sides, as later I always found him to be, he expressed the opinion that, with such an interesting prospect before me, it might be foolish to abandon it in order to embark upon an adventure fraught with such risks as a Polar expedition. I told him that all my previous travels had been made in the interests of geography; that I felt this was a chance, such as never would come to me again, to turn the experience that I had gained to some permanent benefit to science, and that I was convinced that if I went, and were given a free hand to utilise my experience as I thought best, the photographic results might prove to be not only of great educational value, but a valuable asset to the enterprise. He seemed pleased and thanked me for taking this view, and then and there it was decided that I should throw in my lot with the Expedition.'[1]

Ponting's pay was to be £5 per week, compared with £4 per week paid to the members of Dr. E. Wilson's scientific staff of the expedition.

Herbert Ponting could not be regarded as the first specialist photographer accompanying an exploration party. Such photographers (some of them veterans of the Civil War) had accompanied government expeditions of exploration to the Western Frontier of the United States in the 1860s and the 1870s, for example. Photographs of far-off places in the world, taken by inveterate travellers, were by no means infrequent at the middle of the nineteenth century. But Ponting was undoubtedly the first *specialist* still and movie photographer to go to a *polar* region.

Photography, had, of course, been practised in these areas for some years, photographs having been taken in the Arctic at least as early as 1858. The Belgica Expedition of 1897 to the Antarctic had a surgeon/photographer. Photographs were taken during the Scott Expedition to the Antarctic in 1901 to 1904, and during Shackleton's Expedition of 1907 to 1909—but the main work of illustration fell upon 'artists'. The Danmark Expedition to Greenland in 1907 produced some 1,500 photographs and the trip of the *Le Pourquoi-Pas?* to the Antarctic in 1908 to 1910, under the leadership of Dr. Jean Charcot, had the benefit of 'a huge and well-fitted photographic laboratory'.[2] But again—there was no specialist photographer, Monsieur A. Senouque being in charge of magnetic studies as well as photography. The resulting photographs were not good, displaying extreme contrast and lack of tonal range, were not well composed,

48

and demanded much of the retoucher's art when they were published in book form. Senouque tried cinematography but unsuccessfully:

'I did not make any suitable movie films. The camera was very cumbersome. It never worked well because the films were always jamming.'

Ponting was to change this picture dramatically—but also to be followed shortly afterwards by another first-class specialist in the Antarctic. This was the Australian Frank Hurley, who accompanied Sir Douglas Mawson's Expedition of 1911 to 1914, and Sir Ernest Shackleton's Expedition of 1914 to 1917. Hurley was a good deal younger than Ponting and far less experienced, but he was to do excellent work and ultimately to make six trips to the Antarctic, going on to spend a lifetime in photography which took in war photography during the two world wars, and many extremely successful films and books. Ponting told a friend in 1930: '[Hurley] is a "crackerjack" with the camera.' Nonetheless, in 1910 Ponting was the master:

'[He was] doing beautiful work. . . . He was considered to be the greatest outdoor cameraman in the world.'[3]

Ponting started making his preparations in January 1910. He had been given virtually *carte blanche* by Captain Scott to ensure that the photographic record of the expedition would be complete—a delicious position in which to be, and one which Ponting accepted with customary thoroughness. The movie record was of special importance. Ponting noted in an interview at the time that there had been excellent books written on Antarctic expeditions, but that 'The fascination of a moving, living picture is irresistible. That is where the cinematograph scores. It will practically bring the Antarctic itself before the public's eyes. The cinematograph is undoubtedly one of the greatest educators of the century. . . .'[4]

He was, however, still comparatively inexperienced in movie photography, so he turned to one of the manufacturing specialists of the day, Arthur S. Newman, who was in due course to become a firm friend. Newman later recalled:

'When he arranged to go with the Scott Expedition to the South Pole as official photographer, he came to me and said that as the kinematograph was well established, he wished to take a kine camera as part of his equipment, but as he was quite ignorant of the particular methods used, he desired me to tell him all I was able, and together we took many films and developed them, had them printed or printed them ourselves, and studied the projected results. He was exceedingly severe in his criticism of the results.

'His great objection to the pictures then being shown at the picture theatres, was the fact that the movements of people and animals were not natural, and I made several comparative exposures to prove why the general trend of animated subjects was jerky and stilted.

'When the results satisfied him in this particular, he took up kinematography with enthusiasm, and from that time his still camera took a second place in his ideas. . . .

'He was a great experimenter and would always try out any idea before condemning it. I have made many appliances for him, some which I knew could be of small value. When I tried to dissuade him from proceeding to spend money on what I considered a useless idea, he would say "Well! You may be right, but I still want to try it out".'[5]

Ponting took two movie-cameras with him. One was a Newman–Sinclair, adapted from one of that company's No. 3 models. He told the *British Journal of Photography* in an article published on 3 June 1910: '[It] is provided with a number of quite new features. The film boxes are placed side by side, and an immense saving of space so effected, whilst focussing is done by a reflex attachment which does not in any way interfere with the use of the film. The reflex mirror and ground glass drop into place when required and are instantly removable. The actual focus is obtained on the ground glass, not on the film, and the instrument is fitted with an f/3.5 Tessar.' He also took a J. A. Prestwich camera, which is now at the Science Museum in London, together with one of Ponting's still cameras from the Antarctic Expedition. The Prestwich camera (which is the one shown in the well-known photograph of Ponting in polar kit standing by a tripod with camera in position) had film-spools enclosed in detachable cases which fitted inside the camera above and below the central viewfinder tube. Each spool-case was fitted with a sliding metal cut-off to permit loading in daylight. He probably took two kinds of 35-mm. movie film with him but subsequently he only referred to Eastman film which, he wrote, 'never failed to yield the finest possible results'.[6] A Newman–Sinclair cinematograph film developing-machine was also taken.

For still work, a number of cameras were selected. These included some Newman & Guardia 'Sibyl' ¼-plate models with f/4.5 Tessar lenses. These were specially intended for use by the sledging parties since they were made from metal and thus light and strong. Ponting's own most frequently used camera was one of his own design—a 7 in. × 5 in. reflex, which he described as a '*multum in parvo*', since it could accommodate lenses from a focal length of 6 in. up to 40 in., and could be adapted for use as a stereo camera. A Sanger-Shepherd camera, capable of a 5-ft. extension, was selected for photomicrographic work of specimens, and a 150-in. lens was taken for the telephotography, which was a Ponting speciality. ('The only way to obtain a true idea of a mountain summit is to telephotograph it from a distance of some miles.')[7] Roll-films, Eastman 'Seed' Plates and Paget Plates were taken, all of which were to be

50

developed in Burroughs Wellcome Tabloid 'Rytol' Developer—the *British Journal of Photography* later explaining: 'Ordinary stock solutions would appear to be almost an impossibility on account of the difficulty of avoiding crystallising of the salts through the variation in temperature.'[8] The Lumière brothers in France supplied colour-plates and Ponting took a selection of the colour screens (or filters) which he almost always used for his scenic shots. A projection lantern was another item also taken.

The equipment was comprehensive enough to deal with everything likely to be encountered from scientific photography to the pictorial. The *West Australian* of 12 October 1910 had some reason for claiming that it was 'the most perfect photographic equipment ever devised', and the *British Journal of Photography* for noting (more circumspectly) that it was an outfit 'the like of which has probably never before been brought together'.[9] Second-in-command of the expedition, the then Lieutenant E. R. G. R. Evans, put it in blunter terms: 'A colossal photographic outfit.'

The Expedition's ship, the *Terra Nova*, left London Docks in June 1910 for the trip to Australia and New Zealand. Ponting—like Scott—travelled later by passenger ship, and he arrived in New Zealand at the end of October, a few days before the *Terra Nova*. He was soon to have a shock. Some of the photographic apparatus sent out in the *Terra Nova* had been damaged by sea-water leaking into the cases. 'Consequently almost every hour of my stay in New Zealand was fully occupied, with the help of a clever mechanic, in putting these things right. Had we not been able to repair the damage my hopes would have been well nigh crushed at the outset, for I should not have been able to accomplish more than a small part of the work that I had planned.'[10]

Ponting was obviously much in demand at this time for interviews, and his photograph—particularly one showing him wearing a very jaunty boater—was often to be seen in the newspapers.

The expedition set sail from New Zealand on 29 November 1910. Since for the duration of the trip and for some time thereafter the ship would be the whole world of the Expedition, Ponting had ensured the provision of a darkroom: 'It was 6 feet long, 4½ feet wide, and 8 feet high. A lead-covered bench, 18 inches wide, ran the length of the apartment, in the middle of which was a deep lead-lined sink, and on each side of the sink there were cupboards under the bench. Water was laid on from an iron tank, fixed under the roof, which was filled periodically until all such arrangements were finally rendered ineffective by the frost. There was a ruby-glass scuttle, or porthole, over the sink; and a window—protected by shutters and iron bars—which could easily be darkened, looked out astern. Three tiers of shelves ran round three sides of the room, with guard-rails to prevent anything from falling off, and on these and in the cupboards I was able to store an incredible quantity of gear; all plates, films, etc., being in hermetically-sealed tin cases.'[11]

With the ship heading for the 'Furious Fifties' and the 'Shrieking Sixties', rough weather was encountered almost immediately. Ponting suffered badly from seasickness, and moved from the crowded cabins to his darkroom, where there was more room. He persevered with his photography, one splendid shot being taken from the rigging of the *Terra Nova* in a Force Ten gale (Plate 46). Captain Scott in his diary recorded a delightful scene: 'Ponting cannot face meals but sticks to his work. . . . I am told that he posed several groups before the cinematograph, though obliged repeatedly to retire to the ship's side. Yesterday he was developing plates with the developing dish in one hand and an ordinary basin in the other!'[12]

Ponting was hurt during one storm—but was far more worried about his equipment: 'Each time a heavy sea came aboard, a stream of water spurted through the chinks of the door, which fitted badly; and this was added to by the water that periodically dribbled through the mushroom ventilator in the roof, so that the floor quickly became awash. All my valuable and indispensable apparatus was kept either on the shelves, or hung by hooks to the roof; but the cupboards were crammed with various stores, which I had hurriedly to restow as soon as the ship began to heel over, leaving the lower compartments empty. As the sill of the door was a foot high, the water was prevented from escaping, and my "lab" was on the lee side. Consequently, as the list became greater, but for almost ceaseless baling from the floor to the sink, day and night, the water would have been nearly a yard deep in the cupboards. I had taken all possible care to make things fast and shipshape before leaving port; thanks to this precaution, and to the fact that all perishable supplies had been stored in hermetically-sealed cases, my gear sustained little serious damage.'[13] It was typical of Ponting's single-mindedness that he should have been safeguarding his apparatus and supplies at a time when all the crew members were fighting desperately to save the very ship, loaded as it was with a vast amount of supplies which presented the gravest of difficulties to those sailing the vessel.

Ten days out from New Zealand they encountered their first iceberg: 'In all my travels in more than thirty lands I had seen nothing so simply magnificent as this stupendous work of Nature. The grandest and most beautiful monuments raised by human hands had not inspired me with such a feeling of awe as I experienced on meeting with this first Antarctic iceberg. It was flat as a table; about eighty feet in height, and a mile or more long. Its vertical cliffs were seamed with fissures, and near the water line the great mass was pitted with caverns into which the waves rushed and foamed, or, dashing against the cliffs, rose with a roar, far up the perpendicular precipices.'[14]

On 10 December 1910, the ship crossed the Antarctic Circle and was soon surrounded with icefloes. Ponting described in light vein the first visit by Adélie penguins: 'A touring party next appeared. I assume they must have been a tourist band on

pleasure bent, because at this time of the year all serious minded Adélies would be attending to their young ones. These, I took it, were carefree individuals, unhampered by such responsibilities, and out to see the world. This contingent popped up several floes away, just as the ship was brought to a stop by heavy pack. They advanced in double file, extended formation; some sliding along on their bellies, whilst others waddled on their hind legs, which are at the extremity of their bodies. By this I do not mean to suggest that they possessed more than the orthodox biped equipment; but it comes naturally to use the expression "hind legs" when referring to penguins, because when they toboggan, or slide along on their bellies, they use their flippers as well as their legs as a means of propulsion, and appear to be going on all fours. Having arrived close to the ship's quarter, they closed up their ranks, and entered upon a pow-wow of a serious nature, of which it was evident that the ship was the subject.

'Someone tossed a potato on to the ice, an act which was productive of much excitement among our visitors, and the confab at once became of a more animated tone. The vegetable was at first regarded with suspicion, until one individual, bolder than the rest, decided to investigate; whereupon the whole company followed suit, each in turn closely scrutinising the strange object, with much expression of opinion in the nature of raucous, crow-like squawks. One after the other they eyed it critically and tested it with their beaks, lifting it and letting it drop, and then repeating the process, as though estimating its weight. Whilst each in turn examined it, the others solemnly looked on, passing remarks at appropriate intervals. Then one would try to make off with it, but the others followed and made him drop it. Finally, apparently finding the presence of such a strange object in such a place inexplicable, they camped around it and went to sleep. When they woke up, they all regarded the tuber with the same surprise and curiosity as before, and began their examination all over again.'[15]

But the icebergs continued to fascinate Ponting most, and he began to develop a modest expertise. 'This berg was a remarkably picturesque and interesting sight for it was already midway on its journey to decay. The process of erosion affects no two bergs alike. As, in course of time, the submarine portion becomes worn away by the currents, the centre of gravity changes; the berg tilts and finally turns over. Then the wildest efforts of imagination would fail to conceive the fantastic shapes which sometimes emerge to view as the formerly submerged portion of the ice island rises to the surface. This berg had obviously tilted, exposing a large water-worn section at one end, whilst the list had caused the whole upper portion to slide off, leaving several large masses behind, ready at any moment to gravitate into the sea. It had likely enough spent more than one season drifting amidst the floes since starting on its northward way; but the next swell it encountered would send it thundering into a thousand fragments.

'Like many others, this berg was the subject of much interesting discussion by our scientists, some maintaining that it was not a Barrier berg, but had parted from some pressure-tortured land glacier. From such differences of opinion amongst our experts —some of whom had not previously visited these regions—one gathered that their hypotheses were frequently founded on speculation, the most plausible theory being that accepted. Sound as their arguments always were, and advanced with a sincerity that no one could question, yet there often remained a doubt; thus one learned to form one's own theories about such things. I had formed my own idea about this berg before hearing the controversy which it excited, and I felt that I was progressing in Polar lore when both Captain Scott and Dr. Wilson pronounced themselves to be of the same opinion—that it was a Barrier berg. The picturesque ruin crept up to within half a mile of us, and provided material for some striking photographs and sketches.'[16]

But Ponting was not merely passive in his photography. He was determined to get some shots of the *Terra Nova* crashing through the icefloes. Some planks were rigged up, 'extending ten feet from the starboard side of the fo'c'sle, to the end of which I fixed the kinematograph with its tilting-table. Spreadeagling myself on the end of these planks, I had a field of view clear under the overhanging prow. As the ship bumped into the floes, I hung on as best I could, and with one arm clung tightly to my precious camera lest it should break loose and fall into the sea, whilst with the other hand I turned the handle. Fortunately no mishap occurred; and the result— showing the iron-shod stem of the ship splitting and rending the broken ice into the foaming sea—proved to be one of the most thrilling of all the moving-picture records of the Expedition.'[17] (Ponting was absolutely right in his observation because this sequence was one of the most popular when the *Terra Nova* brought the first batch of films back in 1911 (Plate 8).)

Suitable periods of weather and thus of lighting conditions were seized with alacrity by Ponting: 'The evening before Christmas again found the road closed to us by heavy pack, after having worked our way some sixty miles southward during the preceding five days. At night the sun was warm and bright, and there was not a breath of wind astir. It may seem strange that I should write of the sun shining at night, but we had now been fourteen days in the regions of constant summer daylight, day and night. I stayed up until long after midnight, busy with my cameras on the lovely effects of light and shadow created by the sunbeams as they played amongst the icefloes.

'It had been a source of great disappointment to me that the skies had been dull and overcast during the greater part of our progress through the pack—rendering photography of much of the finest ice scenery futile. In cloudy weather the icefields appeared blank and featureless, no matter how broken up they were; but a shaft of

54

sunlight falling on the uneven surfaces instantly transformed desolation into entrancing beauty. No precious hour of sunshine could therefore be wasted—whichever of the twenty-four it might be.'[18]

On a number of occasions the cumbersome nature of his equipment defeated the photographer. Shortly after Christmas the *Terra Nova* encountered icefloes of fantastic shape: 'Some of the forms [of ice] were almost like huge flowers, whilst but little effort of imagination turned others into the very similitude of animals—for fancy easily runs riot in these regions. The sunbeams played amongst this zoological ice-garden bewitchingly, and I ran to fetch my kinematograph to record the extraordinary scene. But before I could get it ready we had passed out of the region of these wonders. . . .'[19]

The New Year—1911—saw the *Terra Nova* clear of the ice, and Ponting recorded exuberantly: 'Bright sunny weather, an ice-free sea and a fair wind were all that we could desire, and we bowled merrily along with all our canvas pulling and bellying to the breeze. Great swelling billows of cumulus—glorious contrasts of light and shadow—floated in the heavens, or detached themselves into woolly clusters. Such weather made the very drawing of the breath of life a joy. It filled one with a sensation of delight to throw back the arms, expand the chest and, opening wide the lungs, inhale great stimulating draughts of the sweet exhilarating air. It made one thrill and tingle with very gladness to be alive, and to have health and strength and feel the marvel of it all.'[20]

Shortly afterwards, the *Terra Nova* sighted the Great Ice Barrier—the biggest known ice-sheet in the world and extending over an area about the size of France. At the same time, Ponting had his first sight of Mount Terror, a 10,000-ft. mountain which hid the even higher (13,500-ft.) Mount Erebus from view. But he was due for a disappointment: 'Captain Scott had described the Great Ice Barrier to me with great enthusiasm in London; and it had been arranged that, when we reached it, the ship would steam for several miles along its face, so that I might secure photographs and moving-pictures of this eighth wonder of the world. And now it was before us, with the sun shining from an almost cloudless sky, throwing its creviced and caverned precipices into magnificent effects of light and shade; the conditions could not have been more propitious for securing remarkable pictures of priceless educational value. Yet such, it seemed, were the exigencies of our case, owing to the long delay experienced in the pack-ice, that the time could not be spared.

'So, hastily securing such photographs and moving-pictures as were possible, with a heavy heart I then impotently watched the bastioned rampart slowly disappear astern—one of the most remarkable features of the earth, to see which, and in the hope of illustrating it, so that others might see it too, I had come over more than a third of the circumference of the globe.'[21]

This was not to be the only disappointment for Ponting, even though Scott had every reason for wanting to press on or, on occasion, for fearing for his photographer's safety. As the *Terra Nova* made for McMurdo Sound, Ponting wrote: 'Could I have had but one hour ashore amongst the life revealed by my glass, I might have secured such moving-picture marvels that I hesitate to hint of, for fear of being suspected of exaggeration. I pressed to be allowed to have one of the boats for this purpose; but, though in full sympathy with my wishes, Captain Scott considered the danger—from the swell that was breaking on the beach, and of possible attacks from whales—was too great.'[22]

Shortly before the ship entered the Sound, Ponting recorded: 'The towering mass of Erebus now began to rise above the glaciers; and at 11 p.m. I secured my first photograph of the great volcano which was to be so intimately associated with the next year of my life. The mountain was, from this northern aspect, more interesting as a study in vulcanology than remarkable for its beauty. I have seen many volcanoes in many lands, but none that so clearly showed the periods of its life as does Mount Erebus, from the north. The ancient outer crater, a more recent inner crater, and the present active cone were all clearly defined.

'At 1 a.m. we rounded Cape Bird—a forbidding looking promontory of black lava— and entered McMurdo Sound. Erebus now came full into view, presenting a well-balanced contour, with the active, snow-covered cone plumb in the centre of the mountain mass, and the ice-fringed lava skirts of the old, outer crater falling wide on every side. It was a most beautiful and impressive scene.

'The midnight sun was shining with such brilliance that I was able to make focal-plane photographic exposures with an aperture of F11, using a Zeiss Protar lens of 16 inches focus, with a K3 colour screen [filter—H.J.P.A.] in conjunction with an orthochromatic plate. With this combination I secured correctly exposed negatives, with my 7 in. × 5 in. reflex camera—such was the brilliancy of the light at midnight [Plate 52].

'All that night we steamed leisurely along, carefully scrutinising the land, and about 5 a.m. we were passing through loose pack off Cape Royds, where Sir Ernest Shackleton's 1907 Expedition wintered. Through my glass I could see the little hut, nestling in a valley amidst the surrounding volcanic hills, where, in the heart of this godforsaken wilderness of ice and lava, some of our fellow adventurers had lived and done magnificent work two years before. Deep feelings were inspired by the sight of this lone dwelling-place in these ghastly, uninhabited solitudes; and I resolved that this should be the Mecca to which I would make a pilgrimage as soon as chance permitted.

'Having now been watching and working with my cameras for twenty-four consecutive hours, I turned in for an hour's sleep. . . .'[23]

56

The outward trip of the ship was now almost over, and on 4 January 1911 Captain Scott, Dr. Wilson and Lieutenant Evans selected a Cape (dubbed Evans) upon which the winter hut, and thus the headquarters of the Expedition, was to be constructed. The photographer could now begin his land work in earnest.

One important decision had already been taken—and one which was not calculated to endear Ponting to some of his colleagues. He wrote: '. . . Captain Scott, quick to recognise that fine weather meant everything to the success of my work, advised me that it would be as well to take all possible advantage of the exceptionally favourable weather conditions while the ice held, as, once it broke up, subjects now easily accessible would then become impossible of approach. I was to consider myself free to devote myself exclusively to my photographic work, and should not be expected to take any part in unloading the ship. Being thus free from regulations drawn up for the observance of others, I worked almost ceaselessly, for there was no lack of subjects for my cameras.'[24]

This was good sense whilst the ship was being unloaded, but Ponting to some degree appears to have extended this arrangement after the unloading was completed. Frank Debenham, one of the Expedition's geologists, later said that several of the officers 'disliked him for not joining in tasks like snow digging. . . .'[25] Whatever the extent of this, a *quid pro quo* was exacted, for in his photographic expeditions, Ponting was largely on his own even if he asked for help: 'I now decided to get some of my gear ashore, and made several lone trips, hauling some hundreds of pounds of photographic and darkroom equipment, and my personal belongings, on a sledge.'[26]

It is fascinating to compare Ponting with Frank Hurley in this respect. Whereas Ponting, although fully appreciative of his colleagues' skills and attributes, tended to be a 'loner', Hurley was the life and soul of his Antarctic Expeditions. A thorough-going optimist in these early years, ever-ready for a practical joke but equally ever-ready to help others, energetic, strong and rapidly developing into a superb sledging man (as well as an Antarctic cook), Hurley became a first-class explorer in his own right and a positive asset to any group of men whom he joined. Photography was always his main task but he was many other things besides. During the 1911–14 Mawson Expedition to the Antarctic, for example, he was one of the three-man team which made an inspiring attempt to reach the South Magnetic Pole.

Ponting never became an explorer or a team-man in this sense. He remained primarily a single-minded and superb photographer who had been brought to and set down in a spot on the far south of the earth's surface and who then proceeded energetically and comprehensively to bring his skills to illustrating the many aspects of the spot without moving far from his immediate surroundings. And he remained a 'loner' to the end, for he never attended any of the reunions held from 1925 onwards by the survivors of the Expedition.

The Antarctic was not slow to demonstrate the perils of the tasks that Ponting had set himself. He described several such episodes:

'I had noted some fine icebergs frozen into the sea-ice about a mile distant. The morning after our arrival, I was just about to start across the ice to visit these bergs, with a sledge well loaded with photographic apparatus, when eight Killer whales appeared, heading towards the ice, blowing loudly. Since first seeing some of these wolves of the sea off Cape Crozier I had been anxious to secure photographs of them. Captain Scott, who also saw the approaching school, called out to me to try and obtain a picture of them, just as I was snatching up my reflex camera for that purpose. The whales dived under the sea, so, hastily estimating where they would be likely to rise again, I ran to the spot—adjusting the camera as I did so. I had got to within six feet of the edge of the ice—which was about a yard thick—when, to my consternation, it suddenly heaved up under my feet and split into fragments around me; whilst the eight whales, lined up side by side and almost touching each other, burst from under the ice and "spouted".

'The head of one was within two yards of me. I saw its nostrils open, and at such close quarters the release of its pent-up breath was like a blast from an air compressor. The noise of the eight simultaneous blows sounded terrific, and I was enveloped in the warm vapour of the nearest 'spout', which had a strong fishy smell. Fortunately, the shock sent me backwards, instead of precipitating me into the sea, or my Antarctic experiences would have ended somewhat prematurely.

'As the whales rose from under the ice, there was a loud "booming sound"—to use the expression of Captain Scott, who was a witness of the incident—as they struck the ice with their backs. Immediately they had cleared it, with a rapid movement of their flukes [huge tail-fins], they made a tremendous commotion, setting the floe on which I was now isolated rocking so furiously that it was all I could do to keep from falling into the water. Then they turned about with the deliberate intention of attacking me. The ship was within sixty yards, and I heard wild shouts of "Look out!" "Run!" "Jump, man, jump!" "Run, quick!". But I could not run; it was all I could do to keep my feet as I leapt from piece to piece of the rocking ice, with the whales a few yards behind me, snorting and blowing among the ice blocks. I wondered whether I should be able to reach safety before the whales reached me; and I recollect distinctly thinking, if they did get me, how very unpleasant the first bite would feel, but that it would not matter much about the second.

'The broken floes had already started to drift away with the current, and as I reached the last fragment I saw that I could not jump to the firm ice, for the lead was too wide. The whales behind me were making a horrible noise amongst the broken ice, and I stood for a moment hesitating what to do. More frantic shouts of "Jump,

58

man, jump!" reached me from my friends. Just then, by great good luck, the floe on which I stood turned slightly in the current and lessened the distance. I was able to leap across, not, however, a moment too soon. As I reached security and looked back, a huge black and tawny head was pushed out of the water at the spot and rested on the ice, looking around with its little pig-like eyes to see what had become of me. The brute opened his jaws wide, and I saw the terrible teeth which I had so narrowly escaped.

'Thinking they might break the ice again, I ran quickly to my sledge, by which Captain Scott was standing. I shall never forget his expression as I reached it in safety. During the next year I saw that same look on his face several times, when some-one was in danger. It showed how deeply he felt the responsibility for life, which he thought rested so largely on himself. He was deathly pale as he said to me: "My God! That was about the nearest squeak I ever saw!"

'There were two dogs tethered out on the ice near the scene of this incident, and we came to the conclusion that it was an organised attempt by the whales to get the dogs—which they had doubtless taken for seals—into the water. I had happened on the scene at an inopportune moment, and I have no doubt they looked upon me as fair game as well.'[27]

Captain Scott, at the end of his description of this incident in his Journal, stated:

'. . . One after another their huge hideous heads shot vertically into the air through the cracks which they had made. As they reared them to a height of 6 or 8 feet it was possible to see their tawny head markings, their small glistening eyes, and their terrible array of teeth—by far the largest and most terrifying in the world. There cannot be a doubt that they looked up to see what had happened to Ponting and the dogs. The latter were horribly frightened and strained to their chains, whining; the head of one killer must certainly have been within 5 feet of one of the dogs.

'After this, whether they thought the game insignificant, or whether they missed Ponting is uncertain; but the terrifying creatures passed on to other hunting grounds and we were able to rescue the dogs. . . .

'Of course we have known well that killer whales continually skirt the edge of the floes and that they would undoubtedly snap up anyone who was unfortunate enough to fall into the water; but the facts that they could display such deliberate cunning, that they were able to break ice of such thickness (at least $2\frac{1}{2}$ feet), and that they could act in unison, were a revelation to us. It is clear that they are endowed with singular intelligence, and in future we shall treat that intelligence with every respect.'[28]

This was not Ponting's only experience with killer whales. He was to lose a prized

Bausch & Lomb lens next day when they were again the subjects. A little later, whilst photographing some penguins, he wrote:

'. . . I heard a sound behind me, and on looking round I saw a Killer whale—with open jaws, and eight feet of its length out of water—leaning on the ice, surveying me with interest. I didn't wait to pack my things. I almost threw them on to the sledge, and pulled off to a safer distance from the water—half expecting, as I did so, to feel the brute burst the ice under me, as I knew it was not very thick hereabouts'[29] (Plate 68).

This was the period of the midnight sun—and it was the sun that played the leading part in another dangerous experience for the photographer.

'As I neared the bergs, I was perspiring freely from the effort of dragging my sledge; and the yellow goggles, which I wore as protection against snow blindness, became clouded over, so that I could not see. I was just about to stop to wipe them, when I felt the ice sinking under me. I could not see a yard ahead because of my clouded goggles, but I felt the water wet my feet, and I heard a soft hissing sound as the ice gave way around me. I realised instantly that if the heavy sledge, to which I was harnessed, broke through, it would sink like a stone, dragging me down with it. For a moment the impulse was to save myself, by slipping out of the harness, at the expense of all my apparatus. But I went to the frozen South to illustrate its wonders, and without my cameras I was helpless. At all costs, therefore, my precious kit should be saved. I would save it, or go down with it. We would survive or sink together.

'A flood of thought rushed through my brain in those fateful moments. I seemed to visualise the two hundred fathoms of water below me, infested with those devils, and wondered how long it would take the sledge to drag me to the bottom. Would I drown, or would an Orca [killer-whale] snap me up before I got there?

'Though the ice sank under my feet, it did not break; but each step I expected to be my last. The sledge, dragging through the slush, became like lead; and as the water rose above my boots, I was unable to pull it further. Just then, with perspiration dripping from every pore, I felt my feet touch firm ice. With one supreme, final effort, which sapped the last ounce of strength that was left, I got on to it, and managed to drag the sledge on to it too; then I collapsed—and if ever I breathed a fervent prayer of thanks to Heaven, it was that night. I was so completely exhausted that it was quite a long time before my trembling muscles ceased to quake. When finally my knees would hold me up, I took the photograph [Plate 48].

'In adventure one should never take anything too seriously. It is strange how quickly incidents of peril are relegated to the limbo of the past. The moment such

episodes are over—no matter how imminently life itself may have been at stake—they become but reminiscences, to be cast aside, and perhaps seldom or never referred to again, until the pen searches them out from the treasure-house of memory.

'Having recorded with my camera a very beautiful Polar scene, I lay down on the ice—at the edge of the pool where the reflections appear in the picture—to peer into the profundity that I had so nearly become more intimately acquainted with. A great shaft of sunlight pierced the depth like a searchlight, and, by shading my eyes, with my head close to the water, I could see a hundred feet down into the sea, which was all alive with minute creatures. As I watched, a slim, silvery fish darted by, and a seal rushed into the field of view, from the surrounding blackness—not in pursuit of the fish, but fleeing in evident terror. The cause of its terror immediately appeared. The horror hove into view without apparent effort, looking like some grim leviathan of war—a submarine; and a thing of war it really was for the seal. It was a dreaded Killer again, in close pursuit of its prey. It came so close to me that I could distinctly see the evil gleam in its eye, and the whole outline of its sleek and sinister shape. For a single second I lay, transfixed with interest at the sight. Then I remembered, and hurried to a safer place.'[30]

Intense activity during these summer days marked Ponting's life and he was delighted with many of the subjects he found. Scott recorded in his Journal: 'Ponting is enraptured and uses expressions which in anyone else and alluding to any other subject might be deemed extravagant.'[31] And again: 'Ponting is the most delighted of men; he declares this is the most beautiful spot he has ever seen and spends all day and most of the night in what he calls "gathering it in".'[32]

During this period, the photographer took some of his most famous shots—for example, 'A Grotto in an Iceberg' (which in Scott's Journals was entitled 'The Archberg from Within' (Plate 47)). Ponting described it: 'In one of these bergs there was a grotto. This, I decided, should be the object of my first excursion. It was about a mile from the ship, and though a lot of rough and broken ice surrounded it, I was able to get right up to it. A fringe of long icicles hung at the entrance of the grotto, and passing under these I was in the most wonderful place imaginable. From outside, the interior appeared quite white and colourless, but, once inside, it was a lovely symphony of blue and green. I made many photographs in this remarkable place— than which I secured none more beautiful the entire time I was in the South. By almost incredible good luck the entrance to the cavern framed a fine view of the *Terra Nova* lying at the icefoot, a mile away.'[33]

A little later he recorded: 'During those midnight days, when others slept and only the night-watch and I were awake, some of the most memorable of my Antarctic experiences befell me. It was in those "night" hours, too, as the sun paraded around

the southern heavens, that I secured some of the best of my Polar studies. One of these was "The Death of an Iceberg"—which represents a berg in the last stage of decay, from the action of the sun and currents'[34] (Plate 48).

Ponting's Alpine knowledge was of considerable use on occasions—indeed, it probably saved his life at least once: 'One day Captain Scott had accompanied me to see about photographing a heavy cornice which hung from the Barne Glacier, with icicles descending therefrom. But I could not do the work at that time, as the light was not right; the sun was shining full on to the face of the glacier, which for ice photography is useless. One must work half against the light to get correct effects of shadows; I should, therefore, have to return some morning. The cornice was a heavy one; there must have been many tons of overhanging ice, and I saw that there would be a fine picture to be made if I could get my camera *behind* the icicles, and photograph through them. But I considered the danger too great, as there was a large crack in the cornice, and I feared that any movement might precipitate the avalanche which, to me, appeared imminent. I know how the Swiss guides respect overhanging cornices, especially when there are cracks in them. Three years previously, with two guides and two porters, I had narrowly escaped being buried in a falling cornice on the Eiger, so I hesitated to take the risk. Scott, however, scouted the idea of risk, saying that the cornice might last for months.

'We returned home without securing any photographs. Two days later, I proceeded to visit the place again, accompanied by a shipmate. There were neither icicles nor cornice to be seen; instead there was a mass of hundreds of tons of debris where the avalanche had fallen.'[35]

The hut on Cape Evans was completed towards the end of January 1911, and around that time the various sledging parties left on their appointed tasks. It had earlier been decided that Ponting should head the Western Geological Party, but the chief geologist of the Expedition, Australian Griffith Taylor, had been deeply disappointed by the decision. '... Ponting at once disclaimed any right, and announced cheerful agreement with Taylor's leadership; it was a satisfactory arrangement, and shows Ponting in a very pleasant light. I'm sure he's a very nice fellow.'[36] Ponting told Scott he would devote the time that remained before winter to photography on Cape Evans itself and on the neighbouring Cape Royds. 'The western journey would not have enabled me to take my own time over my work, and photography in these regions is too important and difficult to be done in haste. Moreover, I should not have been able to take my heavy kinematograph apparatus and equipment, and Captain Scott was in complete accord with me as to the desirability of securing typical scenery and animal life records, rather than geological details, which Debenham, the most painstaking of my pupils, was fairly competent to deal with.'[37]

62

He worked hard and well, as the photographic record shows. He studied the structure and the creatures of the area in detail—and never lost his photographic way of thinking: 'Each blow of a full-grown Killer whale lasts for a second—it takes exactly sixteen pictures on the kinematograph to illustrate it, and the machine runs at sixteen pictures to the second—but a Rorqual's blast lasts half as long again.'[38]

One major task was to get his darkroom in the hut organised, and when the various parties returned to it to face four months of winter without the sun—the sun setting for 'good' on 22 April 1911—they were amazed at the work he had done. Scott wrote: 'The art of photography has never been so well housed within the Polar regions and rarely without them. Such a palatial chamber for the development of negatives and prints can only be justified by the quality of the work produced in it, and is only justified in our case by the possession of such an artist as Ponting ... my eye took in the neat shelves with their array of cameras, etc., the lead-lined sink and automatic water-tap, the two acetylene gas burners with their shading screens, and the general obviousness of all conveniences of the photographic art. Here, indeed, was encouragement for the best results, and to the photographer be all praise, for it is mainly his hand which has executed the designs which his brain conceived. In this may be clearly seen the advantage of a traveller's experience. Ponting has had to fend for himself under primitive conditions in a new land; the result is a "handyman" with every form of tool, and in any circumstances. Thus, when building operations were to the fore and mechanical labour scarce, Ponting returned to the shell of his apartment with only the raw materials for completing it. In the shortest possible space of time, shelves and tanks were erected, doors hung and windows framed, and all in a workmanlike manner commanding the admiration of all beholders. It was well that speed could be commanded for such work, since the fleeting hours of the summer season had been altogether too few to be spared from the immediate service of photography. Ponting's nervous temperament allowed no waste of time—for him, fine weather meant no sleep; he decided that lost opportunities should be as rare as circumstances would permit.'[39]

The photographer himself described his handiwork with justified and quiet pride: '... during the summer I had built and equipped my laboratory when the weather was too stormy to work outside. It was eight feet long, six feet wide, and eight feet high. After boarding the framework, I covered the walls with ruberoid left over from our building operations, to keep out all light, and lined the room all round with two or three tiers of shelves. On one side I built a bench, covered with ruberoid, and at the end of the bench a thirty-inch lead-lined sink was fitted. On the roof of this room—which was eight feet below the ridge of the roof of the Hut—a thirty-gallon iron tank was fixed, that I had brought for the purpose. A lead pipe, terminating in a swing tap,

connected this tank with the sink—the fall from the tank to the tap being four feet which gave an ample head of water for rinsing plates.

'Under the sink were racks for developing dishes, etc. Various things were also stored under the bench, including the kinematograph developing machine, when not in use; and a small carbide-gas plant which generated my own light, independent of the Hut supply. Every available inch of stowage space was utilised, even the ceiling being covered with racks in which photographic gear was stored. My bed was so arranged that it could be folded up in the daytime against the lower part of the wall on the opposite side of the bench, where it was out of the way.

'To obtain water, I would go out daily and get ice from the little glacier at the foot of Wind Vane Hill, melt it down in a "cooler" on the stove, then mount a ladder and empty the water into the tank, through a funnel. Thus, I always had plenty for photographic purposes, if used with care. The sink drained into a pail, which was emptied when necessary.

'I devoted much care to building and equipping my compartment, and it was not only a comfortable laboratory and living place for me, but it proved useful for other purposes. This room was always kept spotlessly clean and neat, for though I cannot claim excessive orderliness in other respects to be one of my redeeming points, yet in matters photographic untidiness is abhorrent to me.'40

Despite his care and handiwork, however, he had problems: 'I have stated that my darkroom was at the eastern end of the building. Whenever the door was closed—as was necessary when developing, or changing plates—it became exceedingly cold. As no warmth could enter, the temperature would rapidly drop to about 36°F. Foreseeing the likelihood of difficulty in heating my room, I had brought a small oil-stove for that purpose; but I presented this stove to the sailors of the *Terra Nova* as their mess-room in the ship was inadequately heated. For lack of sufficient warmth when the door was closed, the lower part of the wall at the end of my room speedily became a mass of ice, due to warm air condensing on the cold wall. I had to chip this baby glacier away with an ice-axe whenever it became six inches thick, which it did once a week throughout the winter.

'As the galley stove failed sufficiently to heat the ward-room, a coal stove was started in the space between the end of the dining-table and my darkroom. This was a great comfort to me, as several times before this stove was inaugurated my water tank froze. Now, however, we were able to keep the Hut at about 52°F.; we found that any higher temperature was uncomfortable.'41

The developing of movie-film was a continual and dreary chore: 'A great amount of monotonous work is entailed in developing kinematograph film in these latitudes. On account of the difficulty of getting sufficient water, the tank system cannot be used. Therefore the films have to be developed, fixed and washed in strips of fifty feet on a

revolving drum; by which method the necessary quantity of the solutions, or of water, is reduced to the minimum. But it is exceedingly slow. Fifty feet of film lasts for less than a minute on the screen; but to develop, fix and wash that quantity of negative took about an hour and a half. As several thousand feet of film had been exposed in the summer, it took over a hundred hours during the winter to develop and wash the negatives. These were dried by hanging them up in the Hut on frames. In addition, there were many hundreds of glass negatives to be developed; so, as space in the ship had not permitted my bringing an assistant to do all this work, time never hung idly on my hands.'[42]

The disappearance of the sun did not mean the end of taking photographs. Ponting had set his heart on photographing the remnants of the Arch Berg which now resembled a castle. He used magnesium flash-powder and had to have extremely still conditions before it could be ignited otherwise a breath of wind would scatter it: 'On a comparatively mild day in June—that is to say when there was only about 50° of frost, and it was dead calm—I took out my camera, and fired two flashes of 8 grammes of powder, about one hundred feet distant from the part of the berg I desired fully lighted, and one flash for the part I desired to be more or less in shadow. This photograph proved a complete success, and is probably the only example in existence of a magnificent iceberg photographed by artificial light in the depths of a Polar winter [Plate 55].

'That evening, at dinner, Captain Scott related, with much ardour, to us all, and more especially to our meteorologist, how, when he had been walking round Tent Island, he had seen three exceedingly brilliant flashes of lightning to the northward. As such a phenomenon was unprecedented, he wished Simpson to record the fact in his log. I listened with attention, and then asked him what time he had witnessed the manifestation. As the time synchronised with my firing of the flashlights, I was reluctantly compelled to tell him so. He was disappointed to be "done" out of being able to record a remarkable happening, but he enjoyed, as much as anyone, so good a joke against himself.

'It is interesting to note that, at the time, he was about four miles away from where I fired the flashes, and on the far side of an island several hundred feet high. He considered the incident of interest, as illustrating the possibility of signalling at long distances with such a simple contrivance.'[43]

There were other ways of passing the time during the long winter. A programme of evening entertainment was arranged in which Ponting's task was to lecture with slides on the various countries he had visited—lectures which, as was indicated in the previous chapter, were much appreciated. An edition of the *South-Polar Times*, edited by Apsley Cherry-Garrard, was published on Midwinter Day—22 June—and Ponting's anonymous contribution to it was 'The Sleeping Bag':

On the outside grows the furside, on the inside grows the skinside;
So the furside is the outside, and the skinside is the inside;
As the skinside is the inside, and the furside is the outside;
One Side likes the skinside inside, and the furside on the outside;
Others like the skinside outside, and the furside on the inside;
As the skinside is the hard side, and the furside is the soft side.
If you turn the skinside outside, thinking you will side with that side;
Then the soft side, furside's inside, which some argue is the wrong side.
If you turn the furside outside, as you say it grows on that side,
Then your outside's next the skinside, which for comfort's not the right side;
For the skinside is the cold side, and your outside's not your warm side,
And two cold sides coming side-by-side are not right sides one Side decides.
If you decide to side with that Side, turn the outside, furside, inside;
Then the hard side, cold side, skinside's, beyond all question, inside-outside.[44]

As distinct from *In Lotus-Land Japan*, Ponting wrote at considerable length in *The Great White South* on photography. His outline of the problems of the photographer in the Antarctic was of particular interest: 'When working the camera, I would remove both pairs of mitts until my hands began to chill in the woollen gloves; then bury them again in the warm fur, and beat them together until they glowed again. But my fingers often became so numbed that I had to nurse them back to life by thrusting my hands inside my clothing, in contact with the warm flesh. Scott one day told me: "This photographing is the coldest job I have ever struck, as well as the most risky"—the latter because it so often happened that the best subjects were only to be secured in the most dangerous places.

'In summer it was, of course, not necessary to wear so much clothing.

'Photographing in such extremely low zero temperatures necessitates a great deal of care; there are many pitfalls, into all of which I plunged headlong. I had to pay dearly for some of the experience I gained. . . . I found that it was advisable always to leave cameras in their cases *outside* the Hut. There was sometimes a difference of more than one hundred degrees between the exterior and interior temperature. To bring cameras inside was to subject them to such condensation that they became dripping wet as they came into the warm air. If for any reason it was necessary to bring a camera indoors, all this moisture had to be carefully wiped away; and the greatest care had to be taken to see that none got inside a lens. To do so much as breathe upon a lens in the open air was to render that lens useless, for it instantly became covered with a film of ice which could not be removed. It had to be brought into the warm air and thawed off; then wiped dry. Every trace of oil had to be removed from all working parts of kinematograph cameras and focal-plane shutters, as even

66

some "non-freezing" oil (which I bought in Switzerland) froze. Lubricating had to be done with graphite. Several of my colour-filters became uncemented from the expansion and contraction caused by changes of temperature, and were useless; and some of my shutters became so unreliable that I had to discard them and make all exposures by makeshift expedients.

'Great care was required to prevent plates being ruined before use. There was not sufficient room in the Hut to store my entire stock, so the supply in the darkroom was replenished, from time to time, from the stores outside in the snow. Plates had to be brought indoors gradually, in order to prevent unsightly markings. This took two days. I placed them for a day in the vestibule; then left them at least another day in my room, to accustom them to the temperature before opening. No such care was necessary when taking plates into the open air. After exposure, plates could be brought indoors at once, if they were to be developed immediately. The first batch of English plates that I brought indoors and left in a warm place—before learning by experience that care was necessary—were completely ruined by wave-like markings. Even with all possible care markings would frequently appear; but a brand of American plates— to which I am much attached, having found them very reliable, in every conceivable climate, during my travels—remained practically unaffected so long as they received reasonable care. Greater precautions had always to be taken with orthochromatic than with ordinary plates.

'Roll-films and film-packs stood every test magnificently, and yielded splendid results. There can be no question that, taking into consideration the great saving in weight, reliability and extreme convenience, films are pre-eminently suited for travel and exploration photography. Eastman kinematograph film never failed to yield the finest possible results.

'Every film and plate exposed in the South, as well as many thousands of feet of kinematograph film, were developed in the Hut, with the maximum of convenience, by means of "Tabloid Rytol", which I had chosen because of its proved excellence.

'To thread a film into a kinematograph camera, in low temperatures, was an unpleasant job, for it was necessary to use bare fingers whilst doing so. Often when my fingers touched metal they became frost-bitten. Such a frost-bite feels exactly like a burn. Once, thoughtlessly, I held a camera screw for a moment in my mouth. It froze instantly to my lips, and took the skin off when I removed it. On another occasion, my tongue came into contact with the metal part of one of my cameras, whilst moistening my lips as I was focussing. It froze fast instantaneously; and to release myself I had to jerk it away, leaving the skin of the end of my tongue sticking to the camera, and my mouth bled so profusely that I had to gag it with a handkerchief.'[45]

Later he commented: 'I found the Antarctic a very disappointing region for

photography. It was exasperating to find the weather so often thwart one when half-way to some goal—for a journey to a point even a few miles distant could not be undertaken lightly. My camera and kinematograph equipment weighed more than 200 lbs.; and when visiting the point a few miles away it was wise to take camping kit and food for several days, lest a blizzard should descend upon us. Pulling a load of 400 lbs. dead weight, two men could not maintain a greater pace of more than one mile per hour; and if the surface were bad their progress might be much slower. Because of the serious losses to our transport, there was seldom a man available to help me with the photographic work, whereas in fine weather I could have used the services of two constantly. However, notwithstanding the many impediments with which Nature sought to baulk one, it was surprising how much could be accomplished by persistent effort, and by grasping every opportunity she gave whilst in more amicable humour.'[46] It is only fair to observe that for some of these problems, as we have seen, Ponting only had himself to blame.

Whatever he might have thought or said in moments of depression, however, his failures or the failure of his equipment were few and far between. The Lumière brothers had warned him that the colour-plates would not retain their quality for more than a few months—particularly after a journey which would take them through the tropics. The forecast was only too accurate, and Scott noted that 'Ponting has taken some coloured pictures, but the result is not very satisfactory and the plates are much spotted. . . .'[47] Ponting himself reported that he had obtained some interesting records of afterglows with the plates, but nothing was heard of these once he had returned to England.

A more important failure in Ponting's eyes—and certainly in those of Simpson the meteorologist and some of the others—was his inability to photograph the Aurora, though Ponting later explained it to his own satisfaction: 'I was quite unable to secure satisfactory photographs of Aurora, though I had equipped myself for the purpose with the most rapid plates and lenses obtainable, and also with plates specially sensitised to green rays. With exposures of half-a-second, stars of the magnitude of those of the Southern Cross developed out, but no trace of Aurora appeared. A fraction of a second exposure would have been necessary to secure a clear impression of the restless rays; but even exposures of a minute showed no sign of them, though the stars appeared as little streaks. Exposures of five minutes sometimes revealed a nebulous glare, of no scientific interest whatever.

'I knew that photographs of Aurora Borealis had been secured by Professor Störmer in Lapland, with short exposures. When, several years after returning from the Antarctic, I visited the north of Norway in the autumn, I realised the reason of my inability to secure similar results in the Antarctic. The Aurora Borealis that I witnessed in Norway, though not so beautiful in its formations, was more luminous than the

68

Aurora Australis we saw at Ross Island, and it seemingly took a higher spectroscopic line. I think we were perhaps too far south, in 77° 40′, to see the displays at their brightest.'[48]

Four months without the sun and with weather conditions which made any moderately lengthy trip from the hut dangerous is a trial for any man—and in his book Ponting frankly described the effect on himself: 'It was greatly to my disadvantage during this winter season that I am so light a sleeper. The slightest sound made by the night watchman would wake me; and the melancholy droning of the blizzometer pipe outside the wall of my compartment often kept me awake all night, or until sleep came from sheer inability of the brain longer to resist. It was curious how certain thoughts would persistently recur during those wakeful hours. The mind would dwell on waterfalls and rivers in distant, temperate lands; and it seemed incredible, in that world of perpetual ice, that I could actually have seen men squirting water—water that was not frozen—out of great hose pipes, in the dead of night, to cleanse the streets of London.

'I think these long weeks of comparative inactivity in the Hut were more irksome to me than to any of my comrades; for the very nature of my life of continuous travel, in search of the picturesque during the preceding ten years, had made constant change of scene almost a necessity to me. My spirit chafed impatiently for the reappearance of the sun, so as I might get on with the work for which daylight was essential.

'Long walks over the frozen sea when the weather permitted, and a vigorous series of exercises in the open air before turning in, now failed to have the effect of inducing sleep; so, in the absence of Uncle Bill (Dr. Wilson)—who was away at Cape Crozier— I consulted (Surgeon) Atkinson. He suggested a change of muscular effort by excavating holes in the ice for the fish traps; but, though I tried it fairly regularly, this produced no result. I never had a good night's rest until the sun came back, and day and night alternated once more in a properly regulated manner.'[49]

Scott wrote on the same subject in his Journal: 'Ponting is not very fit . . . his nervous temperament is of the quality, to take this wintering experience badly— Atkinson has some difficulty in persuading him to take exercises—he managed only by dragging him out to his own work, digging holes in the ice.'[50]

A man of moods himself, Scott was obviously concerned about Ponting's condition. But he need not have worried, for although Ponting was highly strung, introspective, depressed on occasions by the frustrations and difficulties of his job, and not a good mixer—with all that this implied for himself and others—he did have a dogged determination and stamina sufficient to see him through. And—perhaps surprisingly —he could stand bantering and teasing as well as anybody else.

Thus during a period of intense activity when winter had passed, some of the

people posing for Ponting's cameras were hurt by falls and other mishaps. 'This was the third mishap that had occurred when I was photographing—first Gran's fall when ski-ing; then Clissold's fall from the iceberg, and now Debenham was *hors de combat*. Also, I had had several narrow escapes myself, since my adventure with the Killer whales. The whale incident had, of course, inspired numerous quips about Jonah; and Taylor had invented a new verb, consisting of the first syllable of my name— "to pont", meaning "to pose, until nearly frozen, in all sorts of uncomfortable positions" for my photographs. This latest mishap revived all the former quizzing about the evil eye propensities of my camera, and I was once again the butt for no end of twitting about "the peril of 'ponting' for Ponko"—the latter being my nickname. The more I protested—that I had kinematographed Gran's feat at his own special request; that I had taken every possible precaution to ensure safety when out with Clissold; that Debenham had fallen twenty minutes after I had taken my film, and instanced the scores of occasions on which nothing had occurred to mar the success of my pictures—the more persistently these crimes were fastened onto me.

'But such railleries were always good natured, and everyone in the Hut was subjected to them whenever the slightest occasion presented. No opportunity was missed of poking fun at one another, and everyone hastened to give as good as he received whenever he had a chance of "getting his own back". The saving grace of humour served us in good stead always.'[51] (But there was no doubt that Ponting was a little too 'sober' for some of his younger colleagues, and it may not be too unfair to conjecture that Taylor had the verb 'to pontificate' in mind when he popularised his own verb.)

Although not mentioned in *The Great White South*, Cecil Meares contributed an amusing poem on the 'pont' theme to *The South-Polar Times*:

PONT, PONKO, PONT

I'll sing a little song, about one among our throng,
Whose skill in making pictures is not wanting.
He takes pictures while you wait, 'prices strictly moderate';
I refer, of course, to our Professor Ponting.

 Chorus—
Then pont, Ponko, pont, and long may Ponko pont;
With his finger on the trigger of his 'gadget'.
For whenever he's around, we're sure to hear the sound
Of his high-speed cinematographic ratchet.

70

When we started in the ship he was d——ly sick,
And couldn't make a picture for a day or two ;
But when he got about, we began to hear him shout,
'Please stand still for a moment while I take you.'

When at last we reached the ice, he landed in a trice,
And hurried off to photograph the whales O !
But the 'killers' heard the sound, and quickly turned around,
And nearly made a meal of poor old Ponko.

In the dreary winter night he fixed up his carbide light,
And took us round the world as quick as winkin'.
And his spicy little yarns, about foreign countries' charms,
Were as good as any published in the 'Pink Un'.

Then pont, Ponko, pont, and long may Ponko pont ;
With his finger on the trigger of his 'gadget'.
For whenever he's around, we're sure to hear the sound
Of his high-speed cinematographic ratchet.

One of Ponting's great merits was the regard he had for his colleagues and for their work. Like most of the Polar party, he had the utmost respect and admiration for Captain Scott and also respect and a great deal of affection for Doctor Wilson, or 'Uncle Bill', as he was known to most of the party. Ponting's affection for Wilson was strengthened by the fact that—although the Doctor was a scientist—he was also a fellow artist, and indeed they planned to hold a joint exhibition of photographs and paintings on their return to London.

There is a touch of true pathos in a letter which Ponting wrote to Wilson on 27 October 1912, from London, when, unknown to Ponting, of course, Wilson had already died on the return journey from the Pole. Excitedly describing some of the photographic results of his trip, Ponting commented: 'If any incentive were needed to make my thoughts fly often to you, these weary months that I have been struggling with my results in London, it has been supplied in the numbers of times I have seen your genial, smiling countenance on the screen. The way you played up to that camera of mine is worthy of all the praise your acting gets, and I have heard numerous people say how well you were doing it—somehow or other you always seem to do just the right things, and these little things tell tremendously on the screen. . . . I shall never forget that night when I saw you three gradually disappearing into the distance in that wilderness, and every time I see it in the film I then made on the screen

memory flashes back with lightning wings to that hour. . . . The news that I am anxiously waiting for is to hear that you are all safe and have reached the goal of your hopes, and I shall be glad indeed to know that you are safe back in New Zealand once more.' But while frequently concentrating on Scott and Wilson, Ponting nonetheless often praised other of his colleagues. The naval officers Rennick and Pennell and the Bo'sun Cheetham came in for much comment, as did Lillie, the biologist on the *Terra Nova*, Simpson, the meteorologist, and Nelson, the Expedition's biologist. (Frank Hurley also had the greatest regard for meteorologists in the Antarctic whose unpleasant duty it was to go out into the midwinter conditions at regular intervals to record the readings of their instruments.) There was, however, scarcely one member of the party whom Ponting did not praise at some time or other in his book.

When it came to teaching photography once the sun had returned, Ponting could not do too much for his colleagues. Scott wrote: 'My incursion into photography has brought me in close touch with him [Ponting] and I realise what a very good fellow he is; no pains are too great for him to take to help and instruct others, whilst his enthusiasm for his own work is unlimited.'[52] Scott also later wrote: 'The photography craze is in full swing. Ponting's mastery is ever more impressive, and his pupils improve day by day; nearly all of us have produced good negatives. Debenham and Wright are the most promising but Taylor, Bowers and I are also getting the hang of the tricky exposures.'[53]

Ponting himself was typically more detailed and exacting in describing the work of his pupils: 'It had, from the outset, seemed strange to me that among so many brilliant men no one had more than a superficial knowledge of photography. Indeed, the Western Journey of the previous summer had suffered badly from lack of adequate illustration in consequence. I felt that the results attained in the past could be easily improved upon in the future; so, as there was no lack of cameras, I began to coach Bowers, Debenham, Gran and Wright, as well as Captain Scott. Both Scott and Debenham had some knowledge of photography, but it was too elementary to cope successfully with the difficult problems that would now have to be faced.

'Debenham at once exhibited a capacity for taking pains that was soon productive of the most encouraging results. His retentive memory—aided by a genuine affection for photography, and the recognition that it could be of much value to him in his science—rapidly absorbed all that I was able to impart as to the primary principles, and ere summer came he was fairly expert with his camera; he produced beautiful photographs of really difficult subjects.

'Captain Scott and Bowers applied themselves to the work with extraordinary enthusiasm. Indeed, Scott's zeal outran his capability; he craved to be initiated into the uses of colour-filters and telephoto lenses before he had mastered an exposure meter. I had to express my disapproval of such haste, and firmly declined to discuss

these things until he could repeatedly show me half-a-dozen correctly exposed negatives from as many plates. When he had achieved this result under my guidance, he would sally forth alone with his camera.

'He would come back as pleased as a boy, telling me quite excitedly he had got some splendid things, and together we would begin to develop his plates—six in a dish. When five minutes or more had elapsed and no sign of a latent image appeared on any of them, I knew something was wrong, and a conversation would follow, something in this wise:

"Are you quite sure you did *everything* correctly?"

"My dear fellow" (a great expression this of Scott's), "I'm absolutely *certain* I did. I'm sure I made no mistake."

"Did you put in the plateholder?" "Yes."

"Did you draw the slide?" "Yes."

"Did you set the shutter?" "Yes."

"Did you release the shutter?" "Yes."

"Did you take the cap off the lens?" "Yes."

'Then he would rub his head, in that way he had, and admit: "No! Good heavens! I forgot. I could have sworn I had forgotten nothing."

'He would then fill up his holders again, and be off once more. He fell repeatedly into every pitfall in his haste—with unfamiliar apparatus. One day he would forget to set the shutter, another time he would forget to release it, and each time he would vow not to make the same error again—and then go out and make some other. But I liked him all the more for his human impatience and his mistakes. How often have I not made them all myself, in my own early days with a camera.

'Knowing the importance of the Polar and other journeys being thoroughly illustrated, I spared no effort to communicate every short cut to efficiency that I knew. With such exceptional "pupils", remarkably fine results were soon being produced by all. When Scott was able at length to secure good results with colour-filters, orthochromatic plates and telephoto lenses, his pleasure was very real indeed; for then he knew he was capable of dealing with any subjects he would meet with on the Beardmore Glacier. Finally, he and Bowers were shown how to release the shutter by means of a long thread, so that all who reached the Pole might appear in the group to be made at the goal.'[54]

Ponting's intense enthusiasm for photography and his desire to communicate this enthusiasm to others and to help them is nowhere better shown than in his notes and letters to Debenham, who took over much of the photographic work of the expedition when Ponting left in the spring of 1912:

'In using Seed Plates, be sure and use only 1 tabloid of Rytol and 1 of accelerator

to 4 ounces of water. These plates are double coated and you cannot see through them when developed so you must use this diluted developer and let them go very far and judge by appearance from the face. Let them go until quite dark, except in the deep shadows. . . .

'Make a group of the Polar Party—on Seed Plates . . . and be sure you show what their faces are like. If the light is bad out of doors make it by flashlight in the hut. For such flashlights use Paget 200 [plates] with a ¼″ of [flash] powder—and use F11. That will get it. . . .

'I wish you all possible success and hope you will get good weather to keep the photographic end up. It will probably devolve upon you to develop Capt. Scott's plates.[55] They are Seeds and need the proportions stated above.

'Give the films if developed in tank 1 tabloid of each to 3 ozs. water. If developed by hand use 1 tabloid each to 2 ozs. water. Get them good and dense. . . .'

And a little later: '. . . please let me know how your negs are coming out. I am just as interested in them as in my own, you fellows being my protégés, so to speak . . . I feel confident your own work will be quite equal to mine and if there is to be an Exhibition I should like some of everybody's work to be in it. . . .'

Eventually the sun returned to the south, and on 31 October 1911 the Polar party, led by Captain Scott, and its various support groups, set out on the journey from which five were not to return. Ponting accompanied them for the first few miles and he put his movie-cameras to good use in recording the scene as they departed. But he had much more work to do in the area of Cape Evans and Cape Royds. By means of still and movie photography, the nature of the animal life in the far south could be shown—not merely described—and this was the task to which Ponting applied himself with his usual dedication. If he was not *the* first to use movie-film to record in detail the habits of animals in their natural surroundings (now such an everyday occurrence on our TV screens) then he was certainly amongst the very first. He shot much general coverage of the seals, penguins and skua gulls—but, even more important, on several occasions was able to record certain habits of the animals, and thus to corroborate or correct earlier opinions of the experts.

'When the sea ice became ten feet thick or more—so that there was a good bank of it above the water—the seals found it a difficult matter to get out to sleep. If at the first rush they could project themselves far enough out of water to get their side-flippers on to ice, they could usually work themselves out, after much floundering about. But if these efforts failed, they would proceed to overcome the obstacle by cutting away the ice with their teeth, using both upper and lower incisors and canines in the process. They do not *bite* the ice, but, opening their jaws wide and using the shoulders as a pivot, they swing their heads from side to side, and *saw*, or scrape the ice away. Thus, they scoop out an inclined

trough, equal to their own width, up which, with a tremendous expenditure of effort, they laboriously drag themselves.

'The value of the kinematograph in faithfully recording such animal habits was never better exemplified, during our Expedition, than in this case. Moving-picture films of this remarkable habit—which has been witnessed by only a few observers— were secured, conclusively proving that the process is as described above, and not, as Dr. Wilson thought, and described in *The Voyage of Discovery*, by fixing the teeth of the lower jaw and revolving the upper jaw upon it. I watched many seals thus engaged, and the cutting away of the ice was invariably accomplished by swinging the head from side to side as shown in the films'[56] (Plate 71).

As a result of spending many hours filming skua gulls raiding penguins' nests, Ponting could note: 'The day was a memorable one, for remarkable success attended my efforts. The gulls had now become so accustomed to my presence, that they ignored it; and the next raider was so contemptuous of me—though the camera and I were not ten feet from the nest—that, instead of flying hastily off with the egg which it had snatched up, it stood there, facing me, with the egg in its beak. Subsequently, it, or another gull—as I could not distinguish individuals—repeated the manœuvre twice; and each time stood truculently facing the camera, holding an egg. Both these incidents were also kinematographed. This remarkable habit was thus not only proved by the indisputable evidence of the camera; but the resulting films show clearly the manner in which the gull holds the egg *in* its beak—not *impaled* on it, as reported by some observers.'[57]

The results were not achieved comfortably or painlessly.

'They [skua gulls] would fly towards us from the rear, and, carefully making allowance for speed and distance, discharge a nauseating shower of filth. Photography had to be done despite such discomforts, and though I protected myself with canvas and constant watchfulness, I was more than once the victim of this revolting habit— whilst the air was rent by what sounded to me very much like screams of sardonic laughter. . . .

'When I was recording the final phase of one of the chicks kicking off the last bits of shell, the parents were swooping wildly around me, screaming with rage and fear as they heard the "peeping" of the struggling little ones. Just as I had finished the work and rose from my kneeling position, I received two blows in rapid succession, one on the back of the head and the other in the right eye. As I held both my arms close to my face for protection, two more blows were delivered, one just at the back of the ear, which almost bowled me over. Suffering acutely, I lay on the ground for

an hour or more, my eye streaming with water, and I could see nothing with it. I really thought the eye was done for—as it probably would have been, had I not been wearing a heavy tweed hat with a wide brim. The joint of the gull's wing struck the brim of the hat, and beat it down against the eye; but for that wide brim I should certainly have received the blow full in the eye, and probably have lost it.

'The infuriated birds made no further attempt to molest me as I lay on the ground, nor did they attack the camera either—seemingly comprehending that it was an inanimate thing that could do them no injury. Had they not attacked me, no harm would have resulted to the chick, for I had just finished the picture; but by the time I had recovered sufficiently to take the camera away, the chick was frozen stiff, the parents had forsaken it and were nowhere to be seen. My eye was weak for many days afterwards; but fortunately it had suffered no permanent damage, and it ultimately got all right again.'[58]

And again (not without sympathy for the animals):

'Though Weddell seals are harmless creatures, seldom showing fight except in defence of their young, yet I discovered more than once that it was as well to treat them with respect. A ten-foot bull is eight feet or more in girth, and would weigh from 900 to 1,000 lbs. One day, I came across one of these big fellows among the ice-blocks at West Beach—a sandy stretch of shore at the end of our cape, much frequented by seals as a convenient sheltered spot for a snooze. I tried to persuade him, by poking him with a stick, to rear up his head into a favourable position for a portrait. Having worked him into a fine pose—with head and shoulders well arched back, staring at me open-mouthed, and flippers extended—I was focussing him on the ground-glass, with my eyes in the hood of my reflex camera, when, just as I was about to release the shutter, he suddenly evinced the most determined objections to the proceedings. Lunging forward open-mouthed, with a loud bellow, he seized me by the shin and sent me flying backwards. With several hundredweight behind it, the blow might well have broken my leg; but fortunately I was caught off my balance, and the fall saved me. Having sent me sprawling, he retreated, apparently as scared as I was—regarding me suspiciously along his backbone. I limped slowly back to the Hut in a good deal of pain, and could feel the warm blood trickling down my leg, until my foot seemed to slip about in my boot each time I stepped. On arriving at the Hut, I unfastened my clothing as quickly as possible, fully prepared to find my leg in a horrible state; but to my surprise there was hardly any haemorrhage. There were four teeth-cuts on my shin, a red bruise, and a mere spot of blood; that was all. My thick clothing had no doubt saved me from worse injury. It was a curious instance of the power of imagination, for I had felt convinced the wound was bleeding freely.

76

These seals have clean, healthy mouths, and no trouble ensued from the bite; I dressed it antiseptically and it healed up rapidly. After this adventure I treated these big Weddell seals with more deference than hitherto; it was obvious that one of them enraged might easily break a man's leg with its jaws: they could also do so with a rapid blow of the heavy tail-flippers, which are no mean weapons either. In this case I had certainly invited, and, no doubt, from the seal's point of view, deserved the punishment I received.'[59]

In full measure, Ponting had the seemingly limitless resources of patience and the ability to overcome long, tiring periods of failure that is the characteristic of all good nature photographers. 'I spent many hours in trying to kinematograph this habit, but in vain. On each occasion when—after standing still and silent as a statue for long periods—I began to turn the handle, as the mother was about to regurgitate, the moment I stirred she was frightened and stopped at once. Though I tried every manner of ruse—including keeping my hand moving as though working the camera, until I was compelled to stop from fatigue—I never succeeded in recording this interesting trait by moving-pictures. It was the clicking of the camera that defeated me. I think, however, the coveted record would have been secured, but for an unfortunate incident. By dint of stalking one mother and her chick for nearly twenty consecutive hours, I had got them thoroughly accustomed to my presence and the camera; but whilst I went to take a few hours' sleep, someone killed the mother. When I returned to continue my vigil, she was lying dead on the ground, not twenty yards away; and another gull had doubtless carried off the unprotected chick, for it was no longer to be seen. Fortunately, however, I had already made a 'still' photograph of the mother disgorging for the chick; it was the only study of the kind I ever succeeded in getting [Plate 73]. I vowed inwardly that when I returned home I would endeavour to have a noiseless kinematograph made, before I tried to secure moving pictures of animals or birds at close quarters again.'[60] On other occasions, however, the ruse of keeping his hand moving as though working the movie-camera paid off—for example in securing the sequences of a gull robbing a penguin's nest.

Whilst he concentrated on photographing the animals and birds around Cape Evans, Ponting did not completely ignore scenic photography. Indeed, he fulfilled his ambition of photographing the Western Mountains across the McMurdo Sound—and his detailed description of this is a guide both to his technique and application.

'Higher mountains I have seen—higher by far—but in all the world I know of none more serenely beautiful than those fifty miles of snowy heights in tempest-swept Victoria Land, as seen from Ross Island, across the frozen sea.

'Scott told me that a panoramic telephotograph of the range would be of lasting

value to geography. I knew it would also be a remarkable feat of photography. I had soon realised the difficult nature of the task, however, for in those first sunny summer days the radiation from the sea had been so great that the quivering air rendered telephotography of distant objects impossible. One day in the autumn I had, however, succeeded in telephotographing the Queen of the range, Mt. Lister, over 13,000 ft. high and seventy miles away, during a brief lull in the wind [Plate 76]. But, for the coveted panorama I had to wait until the weather became colder; and when it did so, the few days on which the mountains appeared clearly were so windy that the feat was equally impracticable.

'An equivalent focus of nearly six feet would have to be used—six magnifications of an eleven inch lens, which took the extreme limit of the extension of my camera. A six-times colour-filter would be necessary in conjunction with an orthochromatic plate, and a medium diaphragm. Photographic enthusiasts will understand that to attempt to use such a combination on a windy day would be to court certain failure. Moreover, it was necessary that the picture should be taken from as great height as possible; for the tendency of telephotography is to annihilate perspective, and from sea-level the intervening icebergs would appear to be close to the mountains, some of which were about ninety miles away. I should therefore have to get above the highest of them. This increased the difficulty, for the wind was invariably stronger on high ground. I selected a position on the Erebus moraine, above the Ramp, where, in the lee of the debris-cone, there would be, to some extent, shelter from the prevailing wind, if any, and an uninterrupted prospect from an altitude of about 250 feet.

'To accomplish the feat had become for the time being the principal aim of my existence, and I had kept a watchful eye on the weather, in the hope that, if but for one single hour, the elements might prove propitious. But, to my disappointment, the winter had crept upon us without any chance having occurred to obtain the object of my desire. . . . On the rare occasions when the wind was at rest and the mountains visible, the radiation from the ice was now as bad as formerly it had been from the open water. It was impossible to focus. As it was now midsummer again, I began to fear I might never get the coveted picture; for, once the ice broke up, the character of the scene would be completely changed. A frozen sea was essential.

'But early in January there came a day when the visibility was perfect, and only a light breeze, sufficient to eliminate all radiation, was blowing. I decided that the chance of a lifetime had come; so, "packing" my things up to the Ramp, I set the camera on a heavy, rigid tripod in the shelter of my debris-cone. All the peaks stood out distinctly in the marvellously clear air; but the sea edge of the glaciers—at the base of the foothills, 40 miles across the Sound—was invisible, as it was below the horizon.

'After carefully checking from calculations, I exposed a double series of 7×5 plates

on the panorama, telephotographing the entire range from end to end; and I had the satisfaction of developing, an hour later, twelve beautiful negatives of one of the longest-distance panoramic telephotographs ever secured.'[61]

Herbert Ponting's fame in Antarctic photography has tended to rest on his scenic work of the kind described immediately above. However, his animal photography was of a similarly high order. The black-and-white prints were not only technically perfect but also contained great life and activity—nowhere more so than in the shots of skua gulls stealing penguins' eggs and of Weddell seals fighting. In his movie-photography of the animals and birds of the south, he was—as have already been noted—a trail-blazer (Plate 69).

In mid-January 1912, the *Terra Nova* returned to McMurdo Sound, leaving again with some of the Expedition members for New Zealand in mid-March, arriving there early in April. Herbert Ponting—as planned—was one of this party and he had in front of him an intensive period of work in preparing the results of his photographic labours in Antarctica. He became run down towards the end of 1912—probably as a result both of his time in the Antarctic and the subsequent work—and it was on holiday in Switzerland that he learned of the death of the Polar party. 'In February, 1913, when at Wengen, I received a cablegram from the Central News, stating: "Captain Scott and entire Polar party perished whilst returning from the South Pole."

'Completely dazed by such terrible and wholly unexpected news, I could not believe it and cabled for confirmation. A few hours later I received a further wire: "Regret to state information is authentic. Entire Polar party perished."[62]

The practical results on Ponting of the death of Scott and his colleagues—in particular, the way in which he dedicated himself to providing the most perfect photographic record possible of the Expedition to the exclusion of everything else and with unfortunate results for himself—is dealt with later. But it is appropriate here to evaluate his Polar work. To those not emotionally involved with Antarctica as a result of visiting it, the virtues in Ponting's photography are obvious—the artistic mastery of composition generally, allied to a technical mastery of exposure and development which yielded a tonal range achieved by very few men then and in the subsequent half-century. To the scenic grandeur of the Antarctic landscape—sometimes beautiful, sometimes cruel—he added records of its fauna which until then had been seen only in artists' impressions or described in words. So much cannot be disputed. But best of all, perhaps, is the evaluation of those who have also been to the 'farthest south'.

Scott wrote in April 1911: 'Of the many admirable points in this work perhaps the most notable are Ponting's eye for a picture and the mastery he has acquired of ice subjects; the composition of most of his pictures is extraordinarily good, he seems to know by instinct the exact value of foreground and middle distance and of the intro-

duction of "life", whilst with more technical skill in the manipulation of screens and exposures he emphasises the subtle shadows of the snow and reproduces its wondrously transparent texture. He is an artist in love with his work, and it was good to hear his enthusiasm for results of the past and plans for the future.'[63]

On 22 June 1911—Midwinter Day—Scott wrote again: 'By the end of dinner a very cheerful spirit prevailed, and the room was cleared for Ponting and his lantern . . . [he] had cleverly chosen this opportunity to display a series of slides made from his own local negatives. I have never so fully realised [the value of] his work as on seeing these beautiful pictures; they so easily outclass anything of their kind previously taken in these regions. Our audience cheered vociferously.'

Three months later Scott was writing again: 'Ponting would have been a great asset to our party if only on account of his lectures, but his value as pictorial recorder of events becomes daily more apparent. No expedition has ever been illustrated so extensively, and the only difficulty will be to select from the countless subjects that have been recorded by his camera—and yet not a single subject is treated with haste; the first picture is rarely counted good enough, and in some cases five or six plates are exposed before our very critical artist is satisfied.'[64]

Ponting would have probably appreciated Dr. Wilson's criticism even more: '[his] work is perfectly admirable . . . I have never seen more beautiful pictures than some he has taken here of ice and Mt. Erebus and seals. . . . I hope he will make a great success of them . . . he has deserved it. . . .'[65]

Frank Hurley, who visited England during the First World War at the conclusion of the Shackleton Expedition, met Ponting. Ponting's pictures, according to Hurley '. . . were the acme of photographic perfection'[66]—an opinion of significance coming from a photographer who had then done, and was yet to do still more, excellent work in the Antarctic. Ponting (who gave the Australian a copy of *In Lotus-Land Japan* with the inscription, 'In tribute to a brother artist of the trail') was, Hurley wrote, looked upon 'as being the leader in Antarctic photography'.[66] Indeed, it is a measure of Ponting's skill and achievement that—so far as black-and-white still photography is concerned—it can be strongly argued that Hurley's evaluation is true today.

In his movie-work, Ponting was trail-blazing with equipment and materials which were primitive by today's standards. Also, he was unable to shoot colour photography of any merit because of the inadequate colour materials of the time. But in black-and-white still photography, there has been only one photographer whose work has approached and possibly equalled Ponting's in its originality and technical excellence— the Swiss photographer Emil Schulthess, who visited the Antarctic during the International Geophysical Year of 1957–8.[67] Compared with the photographic genius displayed by these two men, all other photographers in the Antarctic—with the single exception of Frank Hurley—have been but honest workmen achieving varying degrees of success.

80

1. *The Great White South*, pp. 2–3. Happily, much of Ponting's Antarctic story is contained in this book. This chapter relies extensively upon that account.
2. Dr. Jean Charcot: *The Voyage of 'The Why Not?'* Translated by Philip Walsh. Hodder & Stoughton, 1911.
3. Frank Legg & Toni Hurley: *Once More on My Adventure* (The Life of Frank Hurley), p. 24. Ure Smith of Sidney, 1968.
4. *The Weekly Press*, 23 November 1910.
5. *The Photographic Journal*, March 1935.
6. *The Great White South*, p. 169.
7. *The Lancashire Daily Post*, 23 November 1910.
8. 1 March 1935. (As its name implied, the developer was in tablet form. This was a most convenient means of ensuring that a given amount of water had the required amount of chemical.)
9. 3 June 1910.
10. *The Great White South*, p. 7.
11. Ibid., p. 12.
12. *Scott's Last Expedition*, Vol. 1, p. 10. Smith, Elder, 1913.
13. *The Great White South*, p. 15.
14. Ibid., p. 29.
15. Ibid., pp. 35–6.
16. Ibid., pp. 39–40.
17. Ibid., pp. 40–1.
18. Ibid., pp. 41–2.
19. Ibid., pp. 50–1.
20. Ibid., pp. 51–2.
21. Ibid., p. 55.
22. Ibid., p. 57.
23. Ibid., pp. 58–9.
24. Ibid., p. 63.
25. Letter to the author, 20 April 1964.
26. *The Great White South*, p. 77.
27. Ibid., pp. 63–5.
28. *Scott's Last Expedition*, Vol. 1, pp. 95–6.
29. *The Great White South*, p. 69.
30. Ibid., pp. 70–1.
31. *Scott's Last Expedition*, Vol. 1, p. 91.
32. Ibid., p. 129.
33. *The Great White South*, p. 67.
34. Ibid., p. 69.
35. Ibid., pp. 80–1.
36. *Scott's Last Expedition*, Vol. 1, p. 20.
37. *The Great White South*, pp. 83–4.
38. Ibid., p. 87.
39. *Scott's Last Expedition*, Vol. 1, pp. 233–4.
40. *The Great White South*, pp. 124–5.
41. Ibid., p. 127.
42. Ibid., p. 151.
43. Ibid., pp. 136–7.
44. Ibid., p. 140.
45. Ibid., pp. 168–70.
46. Ibid., p. 189.
47. *Scott's Last Expedition*, Vol. 1, p. 249.
48. *The Great White South*, p. 133.

49. Ibid., pp. 149–50.
50. *Scott's Last Expedition*, Vol. 1, p. 355.
51. *The Great White South*, pp. 180–1.
52. *Scott's Last Expedition*, Vol. 1, pp. 417–18.
53. Ibid., p. 422.
54. *The Great White South*, pp. 165–7.
55. It was indeed Debenham who later developed the two rolls of film which had been exposed by the Polar party—and which had lain on the snow for eight months until the rescue party found the tent in which Scott, Bowers and Wilson had died.
56. *The Great White South*, pp. 203–4.
57. Ibid., p. 243.
58. Ibid., pp. 217–19.
59. Ibid., pp. 210–11.
60. Ibid., pp. 220–1.
61. Ibid., pp. 194–6.
62. Ibid., pp. 290–1.
63. *Scott's Last Expedition*, Vol. 1, pp. 234–5.
64. *Scott's Last Expedition*, Vol. 1, p. 406.
65. Letter to Mr. and Mrs. R. Smith, 29 October 1911.
66. *Once More on My Adventure*, p. 83.
67. Emil Schulthess: *Antarctica. A Photographic Survey*. Collins, 1961.

5:Antarctic aftermath

To the outside world, the events following the death of Captain Scott and his colleagues and the return of the Expedition to London in the middle of 1913 must have seemed tragically simple. The King presented each member of the Expedition staff with a Silver Polar Medal and the other members of the Expedition with a bronze replica. The staff also received silver medals from the Royal Geographical Society 'For Polar Exploration'. Promotion and medals were won by a number of the naval contingent, and—most important of all—about £75,000 were eventually contributed by the public to a fund to meet the expenses of the Expedition. In due course, a statue of Captain Scott—executed by his wife—was raised in London.

Up to the outbreak of the Great War in 1914 Herbert Ponting lectured for several months—the presentation taking the form of a novel mixture of films, lantern slides and commentary by the photographer himself. In May 1914 he introduced a showing of the film at Buckingham Palace before King George V, the other members of the Royal Family, the King and Queen of Denmark and hundreds of other guests. The King presented Ponting with a diamond scarf-pin as a memento and expressed the hope that: 'It might be possible for every British boy to see the pictures —as the story of the Scott Expedition could not be known too widely among the youth of the nation, for it would help to promote the spirit of adventure that had made the Empire.' An exhibition of two hundred of Ponting's photographs was held at the Fine Art Society of London in 1913, and he staged various shows throughout the war, often in aid of charity. In 1915 a set of the films was sent to France, and the Senior Chaplain to the Forces wrote to Ponting: 'I cannot tell you what a tremendous delight your films are to thousands of our troops. The splendid story of Captain Scott is just the thing to cheer and encourage out here. . . . The thrilling story of Oates' self-sacrifice, to try and give his friends a chance of "getting through", is one that appeals so at the present time. The intensity of its appeal is realised by the subdued hush and quiet that pervades the massed audience of troops while it is being told. We all feel we have inherited from Oates and his comrades a legacy and heritage of inestimable value in seeing through our present work. We all thank you with very grateful hearts.'

The photographer himself offered his services to both the War Office and the Foreign Office for use in the war, but was told that the lectures he was giving were of

great value, and that he should continue with them. (He was also suffering from severe sciatica which must also have presented problems.) His family, however, suffered, as did most during those years, and in February 1917 he wrote to Lady Scott: 'Only a few weeks ago two of my favourite cousins were killed within 2 weeks of each other; another was killed last year; another—a Colonel in the Engineers—is a prisoner in Germany; and my sister's husband is home with shrapnel in his thigh.'

Beneath the surface of these apparently straightforward events, however, there was considerable confusion and also bad feeling over vital aspects of the photographic coverage of the Expedition. The attempt to analyse this unfortunate business accurately is difficult, since only Ponting's views and opinions have survived in any extensive form. But he was a man who knew his photographic markets well and, since he also criticised himself harshly for certain omissions, his description in its essentials may not be far from the truth.

The trouble stemmed from the absence of any fully comprehensive agreement between Ponting and Scott on the later exploitation of the photographic results of the Expedition. Ponting later admitted that this was a serious mistake on his part, particularly as previously this had been a standard practice upon which he had always insisted. Compare this with Frank Hurley's action just before Shackleton was due to leave on the dangerous trip in the *James Caird* to South Georgia in April 1916. He persuaded Shackleton to sign the following letter in his diary:

'. . . In the event of my not surviving the boat journey to South Georgia, I here instruct Frank Hurley to take complete charge & responsibility for exploitation of all films & photographic reproductions of all films & negatives taken on this Expedition the aforesaid films & negatives to become the property of Frank Hurley after due exploitation, in which, the moneys to be paid to my executors will be according to the contract made at the start of the expedition. The exploitation expires after a lapse of eighteen months from date of first public display. . . .

E. H. Shackleton.'[1]

The cinematographic exploitation presented no problem. In the so-called Gaumont agreement of 1910, it had been agreed that 40 per cent of the proceeds from the exploitation of the film should go to the expedition; 40 per cent to the Gaumont Company and 20 per cent to Ponting. Gaumont showed the film in 1913 and, after a later modification to the agreement, Ponting bought all rights to it in 1914 for over £5,000.

But major ambiguity existed on the exploitation of the still photography. Ponting appears to have thought that, as a result of personal agreements between himself and

84

Scott, the matter ought to have been straightforward. He claimed that in the period of exploitation whilst the Expedition was still in the South and around the time of its return to England, Scott had requested his agent in London to consult with Ponting on all Press matters. The photographer also claimed that it was part of the 'man-to-man' arrangement with Scott that 'the results of my work shall become my property after two years or sooner once the Expedition was free from debt'. Only Scott and Wilson had the right of lecturing to and using his work.

While it was partly Ponting's own fault and he no doubt exaggerated the problems, it is easy to sympathise with him on what followed, for he lived by his photography. From London in the autumn of 1912 he sent letters to both Captain Scott and Dr. Wilson—who, unknown to him, of course, had already tragically died on the trip back from the Pole. To Wilson on 27 October, he wrote:

'So far as I am concerned all the work, which I strove all I could to make as complete a record of the Expedition as possible, has been robbed of its main interest by a most absurd arrangement which Reginald J. Smith has made with the *Strand Magazine*, whereby that miserable periodical, for the sum of £2,000, has sole rights to all my work and a 20,000-word story from Scott. I have for years been a contributor to the finest papers of the world, and my main object in joining the Expedition was that my work might continue to appear in these papers. I have been incensed beyond measure by this arrangement, which gives all my results to such rags as the *Daily Mirror* and the *Strand*.

'Had I known that the arrangements for dealing with my results would have been changed without my knowledge in this manner, the chief inducement for me to join the show would have been lacking, and I should, of course, not have gone. . . . I estimate that the Expedition has lost some thousands of pounds by this most foolish arrangement . . . I have had to give a few yarns to the papers apropos of the photographic side of things to help boost the films a bit . . . I tried to get a yarn into the papers—the *Graphic* would have used it—about the Polar party. It was simply an estimate of them from the personal standpoint, but that pettifogging old woman Reg J. Smith forbade it, and I have been impotent to do anything and help keep up the popular interest in the Expedition.'

To Scott on 4 November he wrote:

'I do think that you should have let me know that you were leaving matters in such a condition that a change of plans, such as has occurred, was possible. I should certainly not have agreed to the suppression of my results in this manner, had I had any idea that anything of the kind was likely to occur.

'One cannot at my age, and with my responsibilities, give up important commissions, to go on an undertaking on which the conditions are largely a matter between man and man, and then find that these conditions are not observed, without making a very rigorous protest against the injustice of it.

'I think that I made a very great mistake on going on this enterprise without a full and complete Agreement, such as I have had with every firm with whom I have previously dealt, and I certainly think you should have let me know in full, as I thought I did, of your arrangements for dealing with my work. . . . I come home to find that my work has been dealt with in a manner totally different from that for which I agreed to do it.'

The Reginald Smith to whom Ponting so scathingly referred here was a close friend of both the Scotts and the Wilsons. He was head of the House of Smith, Elder (a publishing company), and had been closely connected with both Scott and Wilson in publishing the account of the 'Discovery' Expedition of 1901–4. Smith would only have had the interests of Scott and his colleagues at heart and thought he was acting wisely. In addition, it was not unknown for Ponting to over-estimate somewhat the value of his efforts, at least in later years. Be that as it may, in the photographer's view the inadequate exploitation of the Expedition's photography and story extended beyond the Atlantic. He later wrote to Frank Debenham:

'In March 1913 I was sent . . . to New York to endeavour to make arrangements for the showing of the Scott film in America. . . . Whilst there I went to see the Editor of the *New York World*, to whom Sir Ernest Shackleton had given me a letter of introduction, and he immediately made me a magnificent offer to syndicate the Pole pictures throughout the country, and also to publish in the Sunday editions of his paper and every other paper in the country that would take it, a story which I agreed to write. This story was to take up, with the pictures, two whole pages of the *Sunday World*, etc., for two consecutive Sundays. For the story I was to be paid by the *World* $100 per page, plus a substantial sum for the pictures. That would have been about £100. In addition to this I was to be paid the entire proceeds of any syndicate receipts for the pictures and 75 per cent of the receipts for the story.

'The story and pictures were accepted by the *World*'s associate newspapers in every State . . . the proceeds would amount to well over $10,000. . . . I was delighted beyond words to have made such a splendid deal, whereby the Expedition funds would profit so handsomely. I immediately cabled what I had done to Meares, who was looking after things at this end during my absence.

'A few hours later my cup of joy was turned to one of awful bitterness, for I

received . . . a cable from Meares, stating: "All American rights sold to *New York American*. Any illustrations published in *World* infringe contract."

'I was compelled to go to the *World* immediately, and tell them that the whole thing was off. They were incensed, and I was made to look like an utter fool. . . . But that is not all. Under the fine arrangement I had made with the *World* the Expedition would have profited by a sum of at least £2,000. I found later that [the agent] acting over my head, and without consulting me, had sold the rights to not only the Pole pictures, but lots of others also, to the *New York American* . . . for *one hundred pounds*.

'Not only that, but had the *World* published the pictures with my story, the advertisement throughout the States would have meant thousands of pounds more to the value of the film.

'Had I not thought to send that cable to Meares, and had he not immediately reported my cable to the *Daily Mirror*, there would have been an action against the Expedition, or against the *Daily Mirror*, for tremendous damages. . . .

'It makes me feel sick when I think of the way Scott muddled up publicity matters. . . .'

This was not the only result of the ambiguous situation. Commander Evans went on a lecture-tour when he returned with the Expedition—using photographs to which, according to Ponting, he had no right and which affected the takings of the photographer's own presentations. Ponting was not to forgive Evans for this for a long time, and indeed at one stage was contemplating legal action. Also, Ponting had to write to a number of his Polar colleagues telling them that they could not have copies of his photographs for lecture purposes. There was a particularly revealing exchange of letters in which Ponting explained at great length and with typical seriousness to Apsley Cherry-Garrard why he could not use the photographs—and an equally typical, disarming and jaunty response from Cherry-Garrard, beginning: 'Dear Old Ponko—I am sorry my slides have caused you worry. . . .'

Ponting was genuinely hurt by the impression held by a few members of the Expedition that he had made a large amount of money out of it. He raised the matter with Frank Debenham as late as 1933 and Debenham sympathetically replied:

'There were one or two members of the expedition who were persistently unable to realise that you were bound by contracts which might or might not favour you, that Scott had a perfectly free hand in making these contracts, and that what you stood to gain out of the expedition was not a question of salary like some of the scientists, but an enhancement of your reputation. In a word, that you, more than anyone else, stood or fell according to your results.

'One knew all the members acknowledged your splendid work, and most of them

benefited greatly by that work. Yet I can recollect that some, forgetting all the risk and personal expense on your part, did hint that there was pots of money in the film, etc. (as there would have been but for the War). Nevertheless, these hints were long ago and I thought that most of the Expedition knew the rights of the matter.'

This is indeed one of the aspects of the situation at that time which can be commented upon with some conviction—that in the period from 1912 to his death, Herbert Ponting's work to preserve the memory of Scott and his Polar colleagues at best yielded very little profit to him and at worst caused a heavy loss. The amount of money which the Expedition derived from the photographic work is difficult to estimate now, although on one occasion Ponting calculated it to be around £12,000. Even then, he felt that Amundsen's success and the existence of Hurley's film of the Shackleton Expedition kept the figure lower than it would otherwise have been. (In a letter to Lady Scott in 1917, he wrote that when he purchased the film from the Gaumont Company it was showing at only one picture palace and that it was taking 30s. per week.)

His expenses were high. During the 1914 lectures they totalled around £800 per week and his second series of lectures in 1917 at the Philharmonic Hall in London failed. 'Unfortunately I am confronted with the necessity of closing down. Yesterday we only took in £5 0s. 10d. and the expenses are nearly £300 weekly, out of which £100 is for rent, and a recent audit of the books shows that only on two weeks since I opened, has there been any profit, and the nett loss is now over £1,200, and in this loss figure, there is nothing whatever included as pay for myself. . . . In the meantime, I am struggling on. Since Xmas I have had to close six nights as no one came, and last week we took in, all told, a little over £100. However, I am happy in the certain knowledge that I am doing some good.'

His ideal was that 'the nation' should take possession of the film and still negatives. He felt that if this happened, and 'it were known that the Government had acquired the films, the whole Kinema would clamour for them. . . . America wants them but I want England to want them too. . . .' He was to comment time and time again in the years ahead to his various correspondents about the large sums of money which he had been offered from the United States. If he could be criticised for anything, it was for the single-minded and fanatical manner in which year after year he continued proposing schemes for the display and presentation of his Polar work—and investing large suns of money in this—when it was clear to others that the world was interested in other things and that the heroism of 1912 had been absorbed by the carnage and heroism of the Great War.

But with all the financial failures, and whatever the personal failures, Ponting brought enjoyment and thrills to thousands with his lectures. Children in particular

88

were enthralled. The various forms of the films which were shown received tremendous praise, even allowing for the emotional attitude of the time—'They are easily the most remarkable films that have ever been shown in England' (*Daily Mail*); 'The story is an epic in the history of ENGLISHMEN. There is nothing like this film in the world. They are not pictures, but LIFE. . . .' (*Pall Mall Gazette*); 'It is almost impossible to credit that these wonderful moving-pictures were obtained under circumstances and conditions seldom paralleled in the whole history of photography' (*The Sketch*); 'For intrinsic interest no moving-pictures ever produced since the invention of photography can compare with these. No history of the Expedition, however brilliantly written, could possibly enable us to realise what Polar exploration means as do these living pictures' (*Daily Telegraph*); 'One of the greatest achievements of the Kinematograph to-date has been to make Captain Scott's Expedition imperishable. The story of Scott's death will, of course, be told as long as the English language is spoken, but it is wonderful to think also that 100 or 500 years hence future generations will be able to see this pictorial record and gaze upon Scott and his comrades trudging over the ice to glorious death. It is to be hoped that Mr. Ponting's own share in obtaining this record for posterity will not be overlooked' (*The Times*); 'To see Mr. Ponting's historic film, and to hear his brilliant lecture is to realise what being an Englishman *should* mean. Some people talk of a subsidised theatre. This should be a subsidised film. Nay, more than that, people should be made to see it' (*Daily Mirror*); 'There is nothing in the Theatres of London to approach this drama. There is no comedy so amusing, no play so poignant, no tragedy so heart-rending as this tale in pictures' (*Sunday Times*); 'Critics of the "film" can be certain that there is one film at present being shown which can have only a good effect on the British boy: Mr. Herbert G. Ponting's *With Scott in the Antarctic*. Any boy should be inspired to be "an English gentleman" when he has seen the moving history of that band of heroes, and no school lesson on the subject could teach so much' (*Daily Mail*).

Ponting's book *The Great White South* was first published in October 1921[2] and was undoubtedly the single most successful result of his time in the South. In 1930, he wrote to a friend: 'If only I could use my pen as well as I can use my camera . . . how happy I should be.' But, in fact, the book was infinitely better than his earlier *In Lotus-Land Japan*, and, with the exception of the occasional purple patch, his narrative ability was of a higher order. The *British Journal of Photography* in June 1912 had prophesied that the book when it came would be 'the most important proof of the immense value of photography in exploration which has hitherto been forthcoming'. When the book actually appeared the *British Journal* called it: 'The most eloquent tribute to his artistic and technical skill as a photographer under outdoor conditions such as no other man has been called upon to endure.'

A few weeks before his death in 1935, Ponting wrote proudly to a friend: '*The*

Great White South is still going very strong. The prints are getting worn now. I must revise it a little, put in a few new plates and get the publishers to make a fuss about the next—eleventh—edition. The book is now entering its 14th year, but every few weeks I seem to get a letter of approval about it. Had two last week from unknown people. One, a schoolmaster in Anglesey, tells me he has been reading the book to his boys and that "they are all absolutely thrilled with it". I am so glad because it was just written for boys, as stated in the foreword. I have a file of many notes and letters about it from schoolmasters and one wrote me that he is going to be responsible for 50 copies going to fresh centres of interest. So that is encouraging for a 14 year old book. I am proposing to the publishers to forgo all royalties in future, so that still better value in illustrations and text can be given to buyers.' (Still the great interest in photographic excellence!) That the book went through at least 14 printings—the last as late as 1950—was testimony to its quality.

Antarctica held great interest for Ponting until the end of his life—and it is not surprising that three of his most frequent correspondents were Frank Debenham, the Reverend Gordon Hayes and Mrs. D. Irving-Bell. Frank Debenham, it will be remembered, was a geologist on the 1910–13 Expedition. After the war he taught at Cambridge, eventually becoming a professor and head of the Scott Polar Research Institute when he founded it in the 1920s. The correspondence between the two was usually originated by the photographer, who seemed to be in need of the quiet sympathy that Debenham was prepared to give, although the latter obviously felt that Ponting was far too serious about things.

The Reverend Gordon Hayes, whose parish was in Worcestershire, was a scholar of polar exploration, and in the late 1920s and early 1930s published several histories on the subject. He and Ponting met from time to time in the 1930s—sometimes in the company of Mrs. Irving-Bell and her husband Ronald—and had long heart-to-heart talks. Mrs. Irving-Bell assisted Hayes in research and preparation and, as a result of contact also with some of those involved in polar exploration and in other work on the subject, understandably became extremely knowledgable on it. She first contacted Ponting in 1917 when, as a young girl—Miss Russell-Gregg—she wrote to him at the Philharmonic Hall in London asking for his autograph. This was duly supplied on a cut-out of a penguin. It was not long, once they had started to correspond, before Ponting was 'Ponko' to both the Reverend Hayes and Mrs. Irving-Bell, and that the latter was 'Squibs' to Ponting.

No chance was ever lost by the photographer to put the record straight on Antarctica so far as he saw it. Hence, in 1919, when the then Captain Evans was introduced at a lecture as Scott's 'right-hand man' in the Antarctic, Ponting wrote immediately to *The Times* stating that whereas Evans was 'nominally second in command' of the Expedition, the right-hand man in every sense of that phrase was

Scott's old friend and former comrade, Dr. E. A. Wilson. In this attitude, he apparently received support from Atkinson, Cherry-Garrard, and Mrs. Wilson herself.

We have already seen that Ponting had little reason to be friendly towards Evans. But he could never bear enmity for very long and wrote in the middle of 1926 that he and Evans had 'buried the hatchet': 'Life is too uncertain and short to harbour ill-feeling for ever . . . I feel happier to know it is ended. I do so dislike anything of that kind.' (It was also possible that Ponting thought that Evans's rise to high rank in the Navy could be of use to him—for example, in adopting for general use within the Senior Service the projector he was then developing.)

The B.B.C. occasionally asked the photographer to make broadcasts and this gave him much pleasure, although he was quick to pass any requests on subjects about which he considered he knew too little to Frank Debenham in Cambridge. His last 'performance' was a few weeks before he died, and this one especially delighted him, for it was to mark the housing of the Scott Polar Research Institute in a new building in Cambridge. On 18 November 1934 he wrote to Hayes: 'On Wednesday the B.B.C. rang me up and asked me if I would give a broadcast about the opening. I immediately replied that as I was ill I could not do so. Then I thought: they may have some difficulty in getting anyone to do it instead at such a late date. (You see they know me and I gave an Empire Broadcast about the Antarctic in September.) So I wrote again, and said that if they had any difficulty they could use by proxy the story which I enclosed. I sent a copy of it to Debenham, and on the morning of the 16th at 10 a.m. I received a wire from Deb. stating: "Heartily approve draft of broadcast." So my story about the Institute was broadcast for me by proxy by one of the announcers. Wasn't that funny?'

He was always generous in his praise of new achievements in the South. When the American Richard E. Byrd, during his expedition to Antarctica in 1929, flew to the Pole and back, Ponting issued a statement to the newspapers. He received a cable from Byrd at the Pole, dated 17 December 1929: 'I send you my sincere appreciation for your radio [message] and my gratitude for the very generous statement you made to the newspapers which was sent down to me. All the inhabitants of "Little America" have an admiration for your Antarctica work and join with me in kindest regards. Richard Byrd.'

This enthusiasm was infectious when he wrote to 'Squibs' in April 1934: 'I came back just in time to listen in to the Broadcast from Little America. There seemed to be an awful blizzard raging, and the atmospherics were very bad, but it was wonderful to hear anything at all when one considers the distance. To me it was a miracle to be sitting comfortably in my room, and hearing voices from within a few hundred miles from the South Pole. I have not got over it yet. This is certainly an age of marvels.

They are just getting into the long winter night. On April 22nd they will see the last of the sun for four months! They talked about 60 below now. But that is nothing to what they will get two months hence. It was nice of them to all sing the British Grenadiers, and God Save the King. It was impressive coming straight in from the Cinema over the way—from the Great Ice Barrier, and Scott's Grave, to hear men talking *from* the Barrier. To me it was almost poignant. I shall *never* forget it. Think of it! Listening in my own room here in London, with Barrier pictures all around me, *to voices from the actual Barrier itself.* Could anything *possibly* be more wonderful? No siree!, as the Yanks say. And to think of Byrd *all alone* out there in the *middle* of the Barrier, 123 miles away! There's grit. . . .

'I have the greatest possible admiration for these Americans. What they did before was done with the maximum of efficiency. They did marvellous work, and I never tire of reading about the Byrd Expedition. True, they had two men to do every one man's work, but that shows how thoroughly they were equipped for the job. And they did it, and did it all with wonderful thoroughness. Whenever I hear anyone belittling their achievements, it gets my "dander up". Those fellows are full size men doing full size men's jobs.'

Commenting with professional knowledge on the film which was made about the 1929 Byrd expedition, he wrote to Debenham in 1930: 'They had studio cameramen who regarded all the explorers as film actors, with consequent loss to the interest of the film . . . [but] . . . I thought that Byrd's finner whale scenes were altogether marvellous. Gee! don't I wish that I could have had such wonderful chances as that. The whole expedition seems to have been carried out most efficiently in every way. . . . The aeroplane is wonderful for reconnaissance. . . .'

So far as his own work was concerned, he never once lost sight of the idea of having his motion-picture film (now under the title of *The Great White Silence*) taken over 'by the nation'. Towards the end of the 1920s his plans benefited from the support of such people as the by then Rear-Admiral Evans and another Antarctic scholar, the Reverend George Seaver. Something of a public relations campaign was launched and the famous *People* columnist, Hannen Swaffer, joined the fight: 'It is easy now to sit in comfortable seats in a kinema, and watch the visualisation of it all. You do not realise, as you look, that nobody has yet thought it worthwhile to acquire this film record for the nation for ever. On the other hand, Americans have for some time been desirous of negotiating for the World rights to the negatives. But Mr. Ponting has, so far, resisted them, knowing that this country has the prior right. And the entire photographic records could be acquired for much less than the cost of the British rights alone of a single American comedy film! . . . [Captain Scott and his four companions] . . . died in such a way that their last hours will remain forever an imperishable glory of our race. For with the sole exception of the death of Nelson in

92

the hour of victory, there has been nothing so dramatic, nothing that will abide so long. . . .

'I wonder why the British nation does not think it worthwhile to acquire this film as a national possession. For it is the greatest epic of our race, the photographed story of an expedition which will never be forgotten, as long as man lives on the earth.'

Ponting wanted between £20,000 and £25,000 for the movie negatives, and when in February 1929 the Duke of York received the film—together with copies of still negatives—on behalf of the British Empire Film Institute to inaugurate an Empire Library of British Films, all seemed well. But it was not to be. On 8 January 1930 Ponting wrote to Debenham: 'The actual facts are that the British Empire Film Institute has made an appalling mess of the matter since they acquired it. And if I had known what an impotent lot they were nothing would have induced me to yield to their inducements to me to assign the negatives to them.

'To begin with I have not received more than about half the agreed purchase price, and then I found that the concern had not a single penny to exploit the films with. And I advanced them the sum of £600 with which to get it started. This money they simply frittered away and lost it all, and then they tried to get me to advance more. This I refused to do, as they had degraded the film by showing it in a few country cinemas and even in company with comedy films. They never gave the promised London season, and I let them have it on the express promise that it would not only have a London season as an entertainment on its own, similarly as I used to show it at my lectures, but that it would be shown all over the Empire to keep that great memory fresh in the public mind. They refused to take my advice about the manner to use it to get the best results, and now they simply do not know what to do, and they are doing nothing to carry their promises into effect. The sum I have so far received is not sufficient to cover the money I paid Gaumont to purchase their rights in 1914. . . .

'It now looks as though I should not get another penny and I am utterly disgusted with the concern. It was a foregone conclusion that they could make no money out of the way they tried to exploit the film, for they know nothing about film exploitation. They are now in debt, and blame the failure for their miserable, impotent efforts on the film itself, saying that "Such films are out of fashion". Could such a film ever go "out of fashion"? . . .The Film Institute ought to be forced to carry out their published intention of a year ago when the negatives were assigned by me to the Nation on receiving one quarter of the purchase price. . . . The thing is nothing short of a national scandal. . . .'

His intense dislike of the cinematographic industry and film people—whom he had

once described as 'a lot of selfish, conceited incapable invertebrates . . . Charlatans, of colossal conceit and incredible incapability'—received a further stimulus.

Ponting could not see that the lack of commercial success of the film might be due to the product itself—to the product being unsuitable for the times in which it was being shown. With characteristic determination he commenced yet another remake. This one (costing around £10,000) took three years, and—with sound-track, animation and a brilliant use of stills—was issued in 1933 as *90 Degrees South*. Both the time taken to remake the film and its cost was far higher than planned, and Ponting drove himself into the ground on the project, which undoubtedly accelerated his death. In letter after letter he wrote that he could not come to a dinner or accept an invitation to visit because of the work which the film was demanding. The animation sequences were exacting and the addition of a sound-track meant that the film had to be adapted to run at twenty-four frames per second instead of the silent speed of sixteen frames. The money was advanced by a friend but Ponting undertook to repay it all.

In one of his more optimistic moods he wrote to the Reverend Hayes on 14 July 1931: 'I have now got the whole story ready for recording, when the film itself is finished. This story fills over 70 typed pages, and every single word has had to be timed with a stop-watch and then fitted to what is going on on the screen. It has meant rehearsing over and over again, but the ultimate result is going to be satisfactory, I feel confident. All the problems are being overcome one by one—and they are many—and a beautiful series of relief maps is being made. These will make everything absolutely clear to the most uninitiated and will very greatly add to the interest of the story. It is all working out splendidly, but what a job it has all been. The making of an entirely new film would be an easy matter compared with this reconstructing of an old one. The whole tempo of the film has had to be altered to meet modern methods and to make room for the sound-track has necessitated pushing all the composition over to one side. But the ultimate result is great.'

The film was well received by the critics. A notice in *The Cinema* commented on the 'fine photography which bears up well despite the film's age, the very clear recording of the informative commentary, intelligent use of diagrams, drawings and stills', and paid tribute to the 'sheer narrative drama of Ponting's commentary'—a feature which can still be appreciated by those viewing the film today in 1971. Another comment, in an unidentified publication in 1933, was that 'there is one film in London which has by no means received the support which it richly deserves'.

But once again it was not a commercial success. Ponting criticised the exhibitors for not advertising the film sufficiently. He wrote to a friend: 'As far as I am concerned there is no question of any financial gain. There is small chance that I shall ever see a single penny. I may have to be content with what I feel in my heart—that I have

94

loyally carried out a duty to the memory of those in the Barrier ice. I have done my utmost, but it has about ruined me, for I am run down physically as well as cleaned out financially.' And again: 'I am dropping out of photography for good, as I am so sick of the sort of people one has to rub shoulders with in the film business . . . I have lost more money over trying to keep the Scott film going than I care to think about, and often wish I had never packed up a career with brilliant prospects in order to go on it. But I console myself with the knowledge that many people have learnt about the Antarctic from my photographic work.' Up to the time of his final illness, Ponting saw the film in a number of cinemas around London—agitating all the while as he complained of incorrect printing, or of cuts in the dialogue, or of frames missing.

This concentration on the Expedition meant that Ponting did little new and creative photography. In 1918 he took his cameras to Spitzbergen as a member of an expedition which examined the island's potentiality as a source of mineral wealth—in which he had an interest as a shareholder in the Northern Exploration Company. In later years his photography was limited to experiments with the equipment which he had developed and to taking colour-portraits of his various girl-friends. (One girl—whose nickname was the 'Prima Donna' since she was a singer—was a favourite subject.) None of this photography was at all distinguished.

During these years he lived very comfortably at 44 Oxford Mansion, just off Oxford Circus. The mansion was a block of bachelor service flats, of high class and 'desirable'. Maids did the housework and there was a resident cook. The rent was around £170 per annum for Ponting—a not inconsiderable amount for those days. There was a very large lounge—which he sometimes used for a studio—a bathroom and a bedroom.

Ponting occasionally entertained at the flat, though he more frequently took people out to dinner in Soho or accepted their invitations to dinner. If it had not been for his almost complete lack of success elsewhere, it would have been a most pleasant and comfortable middle-class existence. Mrs. Irving-Bell, writing sometime in the 1930s, recorded one particular episode: 'After tea we [she and her husband Ronald] went along to see Ponko, and with him dashed to a quick meal at Gattis. Dear Ponko! He had to be in evening kit because later on he was to show his famous film to Admiral Evans and distinguished company as "Evans of the Broke" was leaving in a few days for Africa. I made Ponko tuck his table-napkin into his collar like a German as I was in such a state of nerves about his spotless white front being ruined by the hurriedly eaten dinner. "Like this?" he asked, just as if he were at nursery tea. At last all was well, and the lily-white shirt was saved. We dashed along to the Royal Society of Arts to hear a lecture on modern whaling in the Antarctic by Captain H. R. Salvesen. He talked for an hour before showing any film so Ponko went off to sleep. When the film came it was no good but I must admit I was terribly interested in it all.

95

Those great factory ships in the Antarctic are amazing but no whale would share this view.'

The photographer could relax—and it was most frequently when talking or writing to women. At these times he could be quite debonair and light-hearted. Towards the end of 1932 he sent a hand-written letter to Mrs. Irving-Bell, upon which he had dropped some ink-blots. He wrote: 'Big damnation! and Sunday morning too! This is the sort of thing this disgusting pen always does when I try to write a letter instead of typing it. But when I take it back and complain, it never does it. It is always on its very best behaviour and the pretty brunette, with the big dark eyes, listens with those little shell-pink ears of hers to my tale of woe, and regards me with compassion not unmingled with a sort of contempt, as she hands it back to me; but she refrains from saying what I know she is thinking to herself: "There is nothing the matter with the pen." And there isn't—in the shop, but it backslides again as soon as I get it home. Incidentally she is the sort of girl who ought to be on films, and, if I only had the nerve, I ought to lean on the counter (in that engaging manner of film actors) and forgetting my own worry, gaze into her dark eyes and say: "Are Ye doing anything this evening, baby. What about a show, and a nice little supper?" If *only* I *had* that enviable nerve! However, it's obvious I shall have to go there again isn't it? Perhaps I'll buck up!'

'Squibs' had obviously sent along a book of poems, for Ponting continued: 'It was awfully sweet of you and so delightfully original—like the author. It was kind of you to send it to me and I've read them all and love them and perhaps those I like most are "Blue Sky Days" and "Lido" and "Little Island Nights"—because these paint the sort of pictures that are so dear to my own memory. And, like you, I have often felt contemptuous pity for those who have eyes for nothing along the highways of this lovely country but the pubs.'

On another occasion he wrote to Mrs. Irving-Bell: 'Your very kind present of the clotted cream and the plums arrived safely today, in excellent condition. And I am going to have a real gorge for dinner this evening—peaches and clotted cream! Gee! I've just got some nice fresh peaches for the occasion. And I'll get the plums cooked for tomorrow. It really was most awfully kind of you to send these nice things to me. And you may be sure that you sent them to the right place for real appreciation. Fortunately really excellent peaches are wonderfully cheap in London just now. I used to grow peaches during my ranching days in California, and I used to try my hand in those days at making clotted cream, too. It wasn't half bad. The only thing about me is that whenever I get near anything of this kind I never know when to stop. I like to gorge! And I do gorge! When I get a present like this.'

He could also write light-heartedly to the Padre. When Hayes was apparently contemplating writing something on Napoleon, Ponting commented: 'You're

amazing! Who comes next? What about Cleopatra as a real change—to get right away from stern he-men and icebergs for a while!' On another occasion he wrote warmly: 'I greatly enjoyed our evening together and especially to find what a wonder you are at the piano; I can imagine you with an organ! You certainly are a wonderful chap. It's a mystery to me how you can keep up in so many things. It takes me all my time to keep up in one thing.'

At other times, the tone of his letters took a more serious turn—for example, concerning religion. In almost all his writing—whether in articles, books or letters— Ponting gave little inkling of his religious beliefs. When he did, it was often linked with strong feelings of nationalism. In *The Great White South* he referred to the cross, which had been raised on a promontory in memory of one of the members of the Discovery Expedition. He wrote: 'This farmost symbol of the Christian faith on earth, gleaming golden in the evening sunlight against the leaden southern sky, seemed like some guardian angel at the threshold of the Forbidden Land beyond— reminding those who would venture further that in the midst of life they are in death, yet holding out the hope of Life Eternal.

'I saw nothing more inspiring in The Great White South—nor have I seen in all the world besides—than that simplest and most sacred of emblems on that snow-clad hill, raised in honour of the seaman of the British Navy, who, in this remote corner of the world, died in the performance of his duty.'[3]

In a letter to Hayes, in July 1930, although it was all too brief, he gave an account of his religious faith: 'I wonder if you read young Randolph Churchill's article in the *Sunday Dispatch* of July 13th. You ought to if you have not. To my mind it is almost insufferable, though there are some points in it. It seems to me priggish in the extreme. This youngster would seem to be of the opinion that everyone must bow to the selfish demands of certain young people of the present day, and that even the teachings of Christ should be so modified as to conform with the ideas of boys who have little more than just left school. The Christian religion is, to him, something that is to be changed from generation to generation, so as to permit more and more license in the individual. He classes religion in the same category as economics, medicine and psycho-analysis.

'I am afraid I am not in any sense a "religious" man, but I have marvelled at the glory of God's work in many remote parts of the world, and they have left me with a deep reverence for the Creator and for religion, and above all for the Christian religion, that is perhaps not less sincere than that of others who profess more than I. Moreover, I love the Bible, especially the New Testament, and frequently read it. Therefore the spectacle of this youth challenging the highest dignitaries of the Church, and demanding that the Bishops should fall into line with the ideas of modern boys, who can know little of life and nothing of the world, and give them a message of

97

sympathy, and to relax "the medieval morality which the Church still imposes", is, to me, nauseating. There are some vigorous replies to the article in today's *Dispatch*.'

Later he wrote sympathetically to another friend: 'It is wonderful that you are able to realise comfort from spiritualism. I am not a disbeliever. I am sure it is a tremendous reality to those who have been able to study it and obtained some inner knowledge. I have never had any time or opportunity to try and obtain such knowledge.'

In recording the events of the last ten years or so of Ponting's life it is all too easy to develop a dislike for him founded on his continual complaints about the activities of others who, in his view, were preventing his plans from succeeding; to lose patience with his general lack of balance; to develop a disbelief of the many huge offers allegedly made by Americans for the Scott negatives and of the many invitations apparently made to him to start his travels once again—by the *National Geographic Magazine* for example—but which were never taken up; to feel no sympathy for his later complaint that he was wrong to go to the Antarctic and that it was the 'greatest error' of his life; and to smile somewhat cruelly at the spectacle of the photographer touring the cinemas, watching his film and criticising the exhibitors or the projectionists or both.

But in all this there is one fact that should not be forgotten. While in the earlier years in particular he hoped and expected that his labours would be well rewarded financially—an ill-founded hope as it proved to be—the way in which he dedicated himself to attempting to perpetuate Scott's memory ultimately became a supreme act of selflessness and one in which he never thought twice about driving himself on, even though seriously ill.

'My work for the expedition is now done. I cannot do more. I must try to do something to retrieve the years I have devoted to it. But it is not easy, at my age. It has left me just about ruined.' This, sadly, was only too true.

1. Alfred Lansing: *Endurance*, p. 199. Hodder & Stoughton, 1959.
2. It was also in the early 1920s that Ponting became a Fellow of the Royal Photographic Society and a Fellow of the Zoological Society.
3. *The Great White South*, pp. 184–5.

6: Business failures to the end

THROUGHOUT the more than twenty years of struggling—and failing—to see the Antarctic photographic and cinematographic record established in a manner which he thought befitting to the memory of Scott and his colleagues, Herbert Ponting also continued to prove himself an entirely unsuccessful businessman. When in 1926 he told Frank Debenham that 'my only pleasure and joy is in creating things, not selling them', he should have appreciated the wisdom of his own words and acted accordingly. Ponting's father possessed (as we have seen) and his son Dick possesses today financial skills of a high order—but such skills were noticeably lacking in Herbert's own case. Just how far this was due to a failing to appreciate the lack of potential or adequacy in the products with which he was associated; to an arrogance which assumed that what he thought was desirable should be thought so by others in the market-place; or to the ineptitude of business colleagues is difficult to say. Most probably it was a mixture of all three.

Towards the end of the Great War, Ponting invested money in a mushroom farm somewhere in the south-west of England. This was managed by a partner and supplies were despatched each day to Covent Garden. Little is known about this episode—other than, like the fruit farm in California, it failed within a comparatively short time. He also invested in the Northern Exploration Company (largely concerned with the exploitation of Spitzbergen minerals) and apparently lost heavily.

Around 1918 he became a director of a company called Chromatic Film Printers Limited, which had its headquarters at Kensington Square, London W.8. As its name suggests, much of the work was concerned with photographic colour reproduction but the company was also developing a film projector—and it was this that attracted Ponting's interest. (He never showed any great interest in colour photography.) His belief in the educational value of the movies was profound and it was natural that he should turn his attention to the commercial development of such a system in schools and the home. But C.F.P. failed in 1921 and the photographer claimed in a letter to a friend that he had lost at least £1,000 of his own money. 'I am doing all I can . . . for the sake of those who put up their money on the strength of my connection as a Director with the enterprise.' The projector had turned out to be a 'perfect abortion' in Ponting's view but he had his own ideas about an ideal projector and promptly began to develop them.

For this, Ponting—not a technical man—needed the services of an engineer, and he found one in George Ford, an employee of Chromatic Film Printers. Ford had already displayed his skill years before in the development of a 'talking pictures' device in a Glasgow picture-palace. A Londoner by birth, Ford came back south in August 1915, to continue working on Government munitions. He and his wife-to-be, Jeanne, first met the photographer during the war when they attended the film and lecture presentation on the Antarctic Expedition. Ford subsequently went to work for C.F.P., and when the projector project failed, Ponting turned to him to refine his own ideas for a new projector and to organise the production of the prototypes. The result was the 'Kinatome' Projector (Plate 9).

A brochure issued at the time described specifications which are worth quoting because, in a number of ways, the machine could be regarded as ahead of its time.

'In standard practice to prepare a motion picture film for projection it is necessary to place a reel of film on a spindle; then unwind the end of the film; thread it over a sprocket and under a pair of pressure rollers; then through a gate; over another sprocket and under two more pressure rollers, and finally attach it to the take-up reel.

'These operations, inseparable from every projector constructed on the lines of accepted standard practice, take time. If the operator be inexpert they may take several minutes; whilst irreparable damage is not infrequently done to the delicate surface of the film by careless handling. . . .

'The Kinatome completely obviates all these troublesome operations, for it is self-threading and self-registering. All that is necessary is to place the film case in the machine, and the film is instantly ready for projection. It may be stopped at any desired moment for viewing any individual picture of a series at leisure with perfect safety—a feature of great value in the school.

'Kinatome films are jointless. They are printed on continuous strips. This is a very great advantage, as it avoids the breaking of the film at joints, which is a source of frequent annoyance and delay with all films put together in sections.

'Each Kinatome film is enclosed in a fireproof metal film case holding the equivalent of 300 feet of standard size film—which lasts for five minutes at the normal rate of running. There is no threading of the film by hand. The film case is simply placed in the Kinatome, and the film automatically comes into position for instant projection onto the screen.

'With other so-called "portable projectors" it is necessary, after a film has been shown, to remove the spool of film from the machine and rewind it on a separate machine before it can be shown again. But with the Kinatome the film is rewound *in situ* in the projector. A reverse lever instantly sets a geared up rewind mechanism in motion, and the five-minute film is rewound, in its case, in 20 seconds. It is then

100

ready for immediate projection again. Kinatome films are never removed from their protecting cases. The film case is also a rewinder and fireproof storage case combined.

'The Kinatome is entirely self contained in a case measuring $12'' \times 9'' \times 16''$, which holds the entire projecting mechanism, optical and lighting systems, motor and ventilating fan. The Kinatome weighs but 16 lb. No other projector approaches it for compactness, lightness, portability, simplicity and efficiency.

'Though the Kinatome may be operated by hand, if preferred, it is intended to be driven by means of its specially designed motor, which makes the projection of the films entirely automatic. In projecting Kinatome motion pictures there is nothing to do but place the film case in position and the Kinatome does the rest.

'The width of the film used in the Kinatome is one third of the width of standard sized film, and each picture is one half the height of the standard size picture. But in standard practice one third of the total width of the film is taken up by the margin necessary for the perforations. This margin is consequently wasted as regards its relation to the actual size of the projected picture.

'By reason, however, of the ingenious system of perforation adopted for Kinatome films, no margin is necessary. The whole width of the film is used. Thus, though the actual size of the Kinatome film picture is about one fourth that of the standard size film picture, it is obtained at only one sixth of the cost. . . .

'Thus, the Kinatome offers to film producers an additional source of revenue, for, after their productions have run their life at the picture theatres, suitable films will, by its means, be assured of a fresh lease of life in the home and the school. Fresh subjects are being filmed every day, and it needs little imagination to foresee that an entirely new industry may immediately spring up for the production of films for use in the home and the school.'

The projector must have seemed promising. It was compact, simple to use (a cartridge-type loading in fact), exposed the film to the minimum of rough usage and in all seemed to meet the requirements demanded of a good educational and home entertainment projection system. But the final sections of the above quotation indicate what was probably a major snag. Although starting from standard 35-mm. film, the finished film gauge was a 'bastard' one of between 11 and 12 millimetres. And quite apart from the introduction of another gauge (and any other problems associated with its mechanical efficiency or reliability), the system had to be adopted by film-makers to stand any chance of success. There is no indication that it was and the hopes were thus not fulfilled.

The fate of the 'Kinatome' may be implied from Ponting's letters. In August 1925 he wrote to Frank Debenham that he had put his last shilling into the projector. Some Americans were enthusiastic about it, however, and he said that he had entered into

a manufacturing and exploiting agreement with them. Some £20,000 had been spent in perfecting it and he had also taken out more than twenty patents. By December of 1925, he was talking of £30,000 having been invested in the projector and claiming that the idea had 'everywhere met with tremendous enthusiasm in America'. In August 1929 he described his American associates as having spent $250,000 on the invention and he said that it was likely to be taken up by one of the largest electrical companies in the U.S.

Over the same period he told Jeanne and George Ford that the projector had been running marvellously at various exhibitions and that it was going to bring them all in many thousands of pounds. Just before Christmas 1925 he wrote to them: 'The good times seem to be drawing near now.' How much—or rather how little—it did bring in is difficult to establish. In the absence of records we have no idea of what money Ponting may or may not have received himself.

During these years the Fords were extremely hard-pressed—and both suffered a good deal from ill-health. For some periods of their acquaintance, Ponting paid George Ford a weekly wage. At other times, however, he sent small sums of money to them at odd intervals to help out—frequently referring to the money as a 'little on account'. Ford appears to have been as bad a businessman as Ponting, failing to come to a firm agreement with the photographer on the basis of his employment and the rewards for his labours—although this may be understandable in an inventor. But despite the lack of success of their various ventures, the relationship was a close one throughout and both had a great respect for each other.

The second and last development with which the two were associated was the most well known—the Variable Controllable Distortagraph (Plate 10). In the Press reports describing this system in the late 1920s and early 1930s it was always described as Herbert Ponting's own invention. (Ponting wrote to Frank Debenham in 1929: 'I have also perfected a process for filming and photographing in caricature which is I should think the funniest thing ever done in photography!') He certainly patented it and on some occasions described himself as a 'co-inventor' with George Ford. It seems certain, however, that the technical concept and detailed design work of this (and other similar projects) was Ford's and that he undertook the project at Ponting's request.

Jeanne Ford later described the origin of the Distortagraph. Her husband had been working on the creation of 'distortions' since the First World War. On one of Ponting's trips to Brighton to see them—the Fords had been forced to move down to the south coast because of George's health—they strolled through a hall of distorting mirrors which Ponting thought were screamingly funny. Ford told him of his work and Ponting was full of encouragement. Eventually Ford was in a position to produce some distorted photographs and again Ponting was vastly amused. Jeanne Ford

102

remembered the occasion well since Ponting laughing was such an unusual sight ('I didn't think he could laugh!'). The eventual result of Ponting's interest was the Variable Controllable Distortagraph. It comprised a lens unit—crossed cylindrical lenses that could be revolved or slid apart—which, with modifications, could be used on the camera to produce 'original' distortions, caricature or modifications in the resulting film or as a projection printer to distort 'straight' film already shot. Distorted motion pictures of still photographs and its use in automatic portraiture machines were also envisaged.

Ponting was convinced that the Distortagraph was better than anything which had gone before, and that it had a great future in the motion-picture industry. A descriptive leaflet stated: 'For dreams, visions, monsters, delirium, magic, nightmares, earthquakes, psychic effects, fairy tales, ghost scenes, what a drunken man sees, and in hundreds of other different ways, this process will enable producers to realise their ideas in a manner which has never hitherto been possible. The Distortagraph will be the means by which innumerable new film effects will be produced.'

Unfortunately for him and for George Ford, his hopes were once again unfulfilled. There is no record of the Distortagraph having been adopted within the motion picture industry—though Ponting had particular hopes of its being used in a filmed version of *Alice in Wonderland*. To judge from the still photographs—which is perhaps unfair since the unit was primarily intended for movie work—the reason for this failure could have been that the result was just not funny or horrific enough. The invention, however, certainly received a great deal of publicity in the Press at the time, and caricatures of, for example, Charlie Chaplin, Lloyd George and Stanley Baldwin were frequently to be seen (Plate 11). The *British Journal of Photography* of 23 March 1934 seemed enthusiastic about its possibilities in automatic portraiture and the writer speculated on the production of six coin-in-the-slot caricatures for one shilling.

Whatever the precise reason for the unit not being taken up, Herbert Ponting's anger at the film industry—described in the previous chapter—received a further boost.

George Ford went on with his engineering and inventive work—a wide-screen system being the most notable—right up until his death at the age of sixty-seven in 1945. But none of this was in association with Ponting. Indeed, the man whom Ponting brought back with him from Australia at the end of the Antarctic trip as movie specialist and assistant—Frederick Gent—actively advised Ford not to let Ponting have anything to do with his inventions.

Gent was in many ways similar to the Fords—nowhere more so than in his religious faith—and continued to be a good friend long after Ponting died. Over this distance of years, Gent is a somewhat shadowy figure. A movie salesman and technician of

English birth who was working in New South Wales when he met Ponting, he was the photographer's assistant until about 1932, when they had a fierce row and Ponting dismissed him. By this time Ponting was already having frequent bouts of ill-health and was exhausted by the remaking of his Antarctic film (though Gent had done much of the technical work involved). There seems little doubt that Gent was the innocent party in the argument and that Ponting regretted dismissing him thereafter. Another and younger assistant was taken on—C. H. Dickason—but although he was delighted to be offered a post by so famous a photographer as Ponting, his experience at that time could not possibly have matched that of the older technician Gent.

As for the Fords and Ponting, they knew each other for approaching twenty years, and a cross word never passed between them, even though there were plenty of occasions when the lack of success could have caused them. It appears clear from the reconstruction of Ponting's life after his trip to Antarctica that the Fords fulfilled for him a psychological need. Whatever name he had established for himself, he was an extremely *lonely* man who had acquaintances by the hundred, but who could accept or give little in the way of genuinely close friendship or intimacy. (A friendly relationship with his eldest sister Edith could not greatly reduce this loneliness.) As the years went on, his health began to fail and the nomadic life of the successful photographic period became but a memory. He became increasingly introverted. He still had great enthusiasm for his various projects, but the lack of success ultimately took its toll. He became embittered and very unhappy. The lack of any distinct sense of humour and his inability to laugh enabled the bitterness to develop unchecked.

In the Fords over the years, Ponting found some solace. They were clearly a couple who were deeply in love with each other and were dedicated to one another—a couple who gave much to those around them and demanded little. They were frequently ill and just as frequently very poor—but they had humour, love, a religious faith and were an inspiration to others. No matter how hard fate was to him, George Ford came bouncing back for more with his lively questioning mind and with a whimsical, faraway smile on his lips. Ponting probably took some strength from them, because in them he saw the form of relationship which he had never had—or had possessed briefly and then turned his back on. He loved to call on them, to have Jeanne Ford call him 'Uncle Ponko', to talk about flowers and the design of furnishings with her, to bring them presents of food or tonic wines when they were sick, to let them have a gramophone and to loan them his precious Caruso records. They were two of the extremely limited number of people with whom he talked about his marriage. It was to George Ford—in a moment of great sadness—that he made the comment about the possibility of passing his own son in Oxford Street and not knowing him.

Whereas Ponting slowly lost hope, George Ford still held on to his. They kept in

contact till the very end. A few hours before Ponting died he told Ford: 'Nobody wants you when you are old and ill.' That was the essential difference between the two men: Ford *was* wanted when he was old and ill. There is no doubt, too, who had the greatest satisfaction and happiness from life.

But this is to look ahead somewhat. Ponting had one more business failure to come yet—and this was associated with his interest in motoring. Some time towards the end of the 1920s, T. B. McLeroth—a retired army captain and engineer—had developed an inner-tube which was initially named after him, but later, when Ponting had joined McLeroth in the project, was called 'The Ponco Inner Tube'. Various properties—including greater resistance to skidding—were claimed for a tyre incorporating the tube, but the principal claim was that the tube was unburstable. A technical journal of the time described the idea as 'highly ingenious'—and went on: 'The tube is divided by flexible rubber walls into separate compartments. Each compartment communicates by means of a small feed-tube with a circumferential air passage which in turn communicates with the valve. In the event of a burst occurring in any of the compartments the escape of air from that compartment causes pressure on the adjacent walls, which are thereby forced together, expelling the remaining air and nipping the small feed-tube, thus shutting off the damaged compartment from the remaining compartments.'[1]

The tube was a classic example of the manner in which Ponting took up a project—with a boundless enthusiasm which was touching but absolutely uncritical. To the Reverend Gordon Hayes he wrote at the end of 1933: 'You will be glad to know that the Inner Tube seems likely to get going soon. I have rich and influential people looking into it, and they are enormously wealthy. This is the biggest thing in the world today. I wish I could tell you what has happened about it, but it would take too long for a letter. . . . This thing is going to develop into something worth millions. And as I am handling the whole thing, I hope to get a bit of it all.' In March 1934, he wrote to Hayes on the same subject: 'Still nothing definite fixed about the tube. What a difficult thing it is to finance even so fine a thing as this, which shows on the figures examined by an accountant, over 100 per cent yearly profit. But negotiations are in progress and I hope will soon result in something.' And again, in May: 'I shall have some things to tell you, for the Tube gets more and more interesting. I regard that as my long suit now. But it is not off the slips yet. We expect it won't be long now. You will be interested to know that the greatest possible interest is being taken in it in more than one of the most influential circles.'

In November 1934, he wrote to Mrs. Irving-Bell: '. . . it looks like coming through all right, and if it goes as we have every reason to hope that it will go, then we shall all be on easy street. You see we have not only the wonderful Tube, but we hope to control a new rubber material for floor covering which is absolutely the last word.

And with all the advantages of its being rubber, it can be retailed at the price of linoleum—3s. 9d. per yard. It is the sort of thing that will sell to anyone at a glance. Enclosed, is a sample.' Somewhat later, he and McLeroth won a legal case in defence of their title to the tyre.

But failure was near yet again, and in another letter to Hayes—in November 1934— Ponting wrote most revealingly: 'So called "businessmen"—or men who call them-selves "businessmen"—are frequently complete fools at business. I know this to my sorrow. Money being their God, all they can see is the £ or the $. There is nothing else in their philosophy. Imagination they have *none*. And imagination (*properly applied*, mind!) is one of the *greatest* things on earth. It necessarily precedes every-thing. It even transcends thought, though these two greatest of all things go hand in hand; for no amount of thought is productive without imagination. And, imagination has been the parent of progress ever since the evolution of the human brain. It has certainly been the parent of this marvellous Inner Tube—which, in addition to all its wonderful properties, will save thousands of lives yearly. I saw instantly its great possibilities and potentialities immediately it was brought to my notice nearly three years ago, and at once decided to throw my whole weight and means into making it a success, disregarding the advice of those who pretended to know a lot, but who were just lacking in *imagination*. They are only suitable for routine work.'

Imagination of course is splendid, but has to be allied with technical quality in the product and business know-how. McLeroth was far more sober in his judgment, and in a letter written in February 1935, just after Ponting had died, said: 'I hope to have my tube going very shortly, that is, if what I hear is correct, one can never tell, I am taking nothing for granted till I see the *cash* on the table and agreements signed.'

A number of promotional schemes were launched—including the attempt to get motor-racing drivers interested in testing it. But London Transport was the main target, and it was London Transport tests that revealed the tube's shortcomings. The extra weight of the tube increased petrol consumption and also affected steering. Most important of all, however—when a compartment was punctured and the bus continued on its way, the flexing of the tyre tore the cell or compartment tube out and air flowed out from the rest of the tyre through the puncture hole, as it would do in the usual way. As if that were not enough, the device was of little or no use in limiting the effects of a puncture through the *wall* of the tyre as distinct from the tread.

Ponting's hopes for the tube were still not entirely quenched when he had to take to his bed for what was to prove his last illness. Periods of ill-health had increased quite markedly around the time he passed his sixtieth year in 1930. He had experienced bouts of bronchitis quite frequently for many years, but what he and his doctor assumed to be bad attacks of indigestion began to come more often in the early 1930s. There is some reason to believe that he had become a diabetic and he had compulsive

bouts of eating sweet foods. Whether in company or on his own, he developed the unfortunate habit of dropping off to sleep at unpredictable times, and around the end of 1934 he became so ill that he had three doctors in attendance. He wrote to Frank Debenham on 13 November that the possibility of a malignancy had been disposed of and that nervous dyspepsia due to low blood-pressure was thought to be the problem. A few days later he told Debenham that the real culprit had been identified —his heart.

In a letter written at 4 a.m. on 20 December 1934 to 'Squibs', he referred to his unfortunate lapse in falling asleep whilst on a visit to her home with the Reverend Gordon Hayes, and went on: 'I was done in to the last ounce. Had very low blood-pressure, a pulse of 160, and hardly strength to stand. I refused point-blank to go into a nursing home. I had some once and never again if I can help it! But I've been quite comfortable and happy here, and *well* looked after, feeding on digitalis and such things and now having strychnine injections and massage as the final courses to a diet that commenced with X-rays, barium meals, etc. . . . I might have been boxed up if I hadn't obeyed doctor's orders for absolute rest, so I'm feeling quite happy I'm still on deck.'

He carried on his correspondence with such friends as Debenham, Hayes and Mrs. Irving-Bell almost to the very end. On 6 February 1935, however, his assistant typed a letter to the Reverend Hayes: 'Mr. Ponting has asked me to let you know that it will not be possible for him to see you, as arranged, Friday or for several days to come. Unfortunately Mr. Ponting is much more seriously ill now than when he wrote you last. During the past two or three days his condition has been very grave, and his doctor says he must not talk more than is absolutely necessary, as being weak, even the effort of talking exhausts him. I telephoned to Mrs. Irving-Bell this evening, and she requested that I should inform you of this.' Herbert Ponting died early the next day.

The death-certificate gave the causes of death as coronary thrombosis, arterio-sclerosis and chronic myocarditis. The funeral service took place at Golders Green Crematorium on 12 February 1935, and his ashes were dispersed in the Garden of Remembrance at the Crematorium.

The photographer's failures were reflected in the events following on his death. On 13 November 1934 he had written in a nearly illegible pencilled scrawl to Frank Debenham at the Scott Polar Research Institute: '. . . I want to arrange that in the event of my death at any time, the ownership of all my Antarctic negatives shall rest in the Polar Institute. I want this to be clear . . . I must get my solicitor to make out a legal document embodying this.' He failed to do so even though his heart was obviously set on the idea, and after his death the material was eventually secured by an enterprising commercial agency.

In Ponting's will, apart from a bequest to his son and daughter, he left a legacy not to exceed £2,000 net and an annuity of £500 per annum to a Miss Beatrice Gibbs— all to be paid from the proceeds of his agreement with McLeroth on the inner tube. In fact, the net value of the estate totalled no more than £377 1s. 4d. and considerable debts came to light—for example, money was owed both to the landlords at Oxford Mansion and to his doctor. Weeks went by in legal argument as to whether the court should administer the Estate, although McLeroth, who was acting as one of the administrators, argued that the Estate was by no means insolvent if it were handled properly. In an attempt to raise additional money, a sale of Ponting's pictures and photographic equipment was held at 47 Oxford Mansion in July 1935.

All in all, it was a supremely sad but absolutely predictable end.

1. *The India-Rubber Journal*, 22 November 1930.

Postscript

HERBERT Ponting was one of those rare creatures who prided himself on his great technical competence in photography and yet at the same time regarded himself not as a 'photographer' but as a 'camera artist'—and it was as the latter that he was recorded in the roll of the Antarctic Expedition of 1910–13.

As distinct from those other photographers who were—and are—noted more for their philosophising on photography rather than for their practical results, Ponting scarcely wrote one word on his philosophy of photography. A camera magazine put it well in 1925, however, when it commented: 'He is at once a pictorialist and a recorder of truth—an uncompromising champion of the school of "straight" photography.' He well knew the effects which could be obtained by the manipulation of equipment and sensitised materials—none better. But if he belonged to a 'school' it was among those photographers who almost without exception used very small apertures to achieve extreme depth of field in their photographs. It is difficult to find one photograph in which he chose to make use of the technique of 'differential focus' whereby parts of a picture are deliberately thrown out of focus.

There is no record that Ponting had any formal art education—and indeed his photography was self-taught. But he did have an instinctive feel for composition and lighting. Out of the many comments upon his work, there are a few which it can be assumed with some confidence he greatly cherished—for example, when the magazine *Colour* wrote that 'Many of Mr. Ponting's pictures possess qualities which are only looked for in the work of great painters'; when the art critic of the *Daily News* observed: 'Mr. Ponting has now succeeded in obtaining for photography all the acknowledgments which previously were reserved for the drama, painting and literature'; and when Sir John Lavery, R.A., said, after looking at a Ponting portfolio: 'If I were to have painted any of these scenes, I would not have altered either the composition or the lighting of any of them in any way whatsoever.'

It is important to realise, however, that Ponting was not striving to imitate the painter. In using his great technical photographic skill to record a scene, he strove after what he considered 'felt' right and represented its mood. If there were close similarities between certain aspects of this interpretation and that of a painter, then this was gratifying, but there was no evidence that Ponting would have changed his attitude if things had been completely otherwise.

Although he made a great name for himself with his Japanese studies, many of them—and in particular the views of gardens and portraits of women—were unimaginative, uninspired and very ordinary. He was essentially a photographer of the world of nature—and of men contending with nature in its various forms. Thus, in his pre-Antarctic photography, he obtained by far his best results in mountain photography.

It was precisely because of these attributes that Ponting was an inspired choice for the Antarctic assignment. In that continent he found nature at both its most beautiful and terrifying, with man driven to the limits of his endurance. Nature provided the stimulus to his great talents—and also the many dangers and difficulties which lay in the way of the successful completion of his work. These he accepted willingly and with characteristic determination, bravery and technical skill which could be matched by few other men. The result is there for all to see—and it has yet to be surpassed. That this is the case is classic proof of the great value of a 'seeing eye' above all else, for Ponting's equipment and materials were frequently primitive compared with today's standards.

And what of the man? His good qualities were numerous. He was generous, touchingly enthusiastic and quick to appreciate the merit in others. He had a profound love for his own country but an equally profound appreciation of the attributes of other nations. He was brave himself and respected bravery in others. Above all he was loyal—to a fault. He was capable of immense application and of displaying great stamina. He was stubborn in achieving the goals he had set himself, and his patience was limitless. And, in the word of the time in which he lived, he was a 'gentleman'.

The seeds of his weakness were in those good qualities. He was too serious and inflexible. He was highly strung and incapable of making close and intimate friendships from which he could derive as well as give strength. Although he made superficial acquaintances easily and had the agreeable social manners of a member of the upper middle class, he was at heart a 'loner'. He had a quite erroneous belief in his business acumen which led to failure after failure. He was quite incapable of realising and analysing his own faults, and the failure of any of his projects was always attributed to the errors or plots of others, or to their inability to see the truth which had been revealed to him so clearly.

Even his dedication and application became a weakness when he completely failed to see that the world had little use for the manner in which he planned to perpetuate the memory of the Polar party—a memory, anyhow, which he had already assured many years before. His personal deficiencies fed upon one another and he died a financially poor, spiritually lonely and embittered man.

But, he had had his grand visions. In an earlier year, he had written about Polar exploration: 'These brave fellows who have risked all for an ideal are human beings

like you and I, even though they could not resist the call of the wild that had entered into their souls and bade them venture forth for the glory of their country.

'There will doubtless be the usual cry: "What's the good of it all?" Those who ask that question never will understand why it is that some are willing to give up everything and risk hardship, danger, and even death for an ideal.

'But every explorer knows what their motive is. It is innate love of adventure combined with desire for achievement and the wish to add something to the sum of knowledge. These are the qualities that have actuated all our own great Empire-builders in the past, and they are the qualities for which this country has always been pre-eminent, for British explorers have ever been pioneers in the Polar regions.' Sentiments which are perhaps out-of-date today—but what does that matter?

And, as Apsley Cherry-Garrard said in his obituary of Ponting: 'He came to do a job, did it and did it well. Here in these pictures is beauty linked to tragedy—one of the great tragedies—and the beauty is inconceivable for it is endless and runs to eternity.'

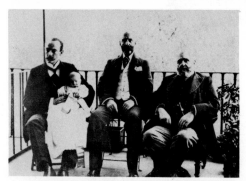

3

4a

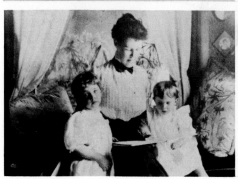

5

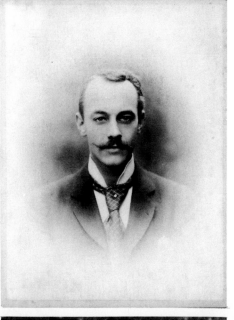

2

4b

THE BACKGROUND

THE PONTINGS

2 Ponting as a young man—probably in the early 1890s

3 The 'four generations' photograph of 1899. From right to left: Herbert's grandfather, Henry; his father, Francis William; and Herbert with his son 'Dicky' in his arms

4a Gathering of the family in 1919 for the funeral of Mary Ponting, Herbert's mother. From right to left: Herbert, his sisters Mildred and Alice, brother Ernest, father, sisters Ruth (behind) and Edith, and brothers Sydenham and Frank

4b Herbert's mother, Mary Ponting, in 1916

5 Ponting's wife Mary with daughter Mildred and son 'Dicky'—about 1903

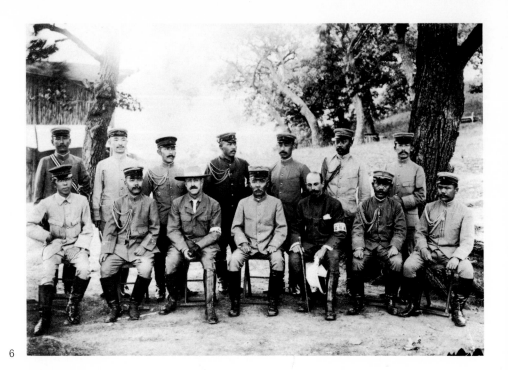

6

MAN AT WORK

6 *Above:* Ponting (third from right, front row)
 with General Kuroki's staff during the
 Russo–Japanese War

7 *Opposite:* Ponting brings up a climbing

partner in the Alps

8 *Following page:* The precarious position
 Ponting adopted to take movie sequences
 of the bow of the *Terra Nova* ramming the ice

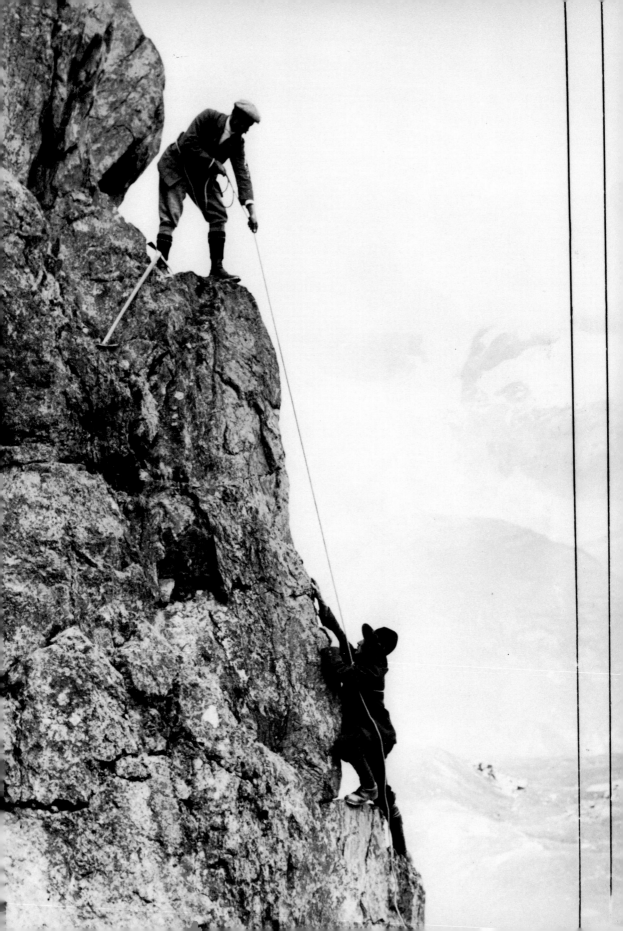

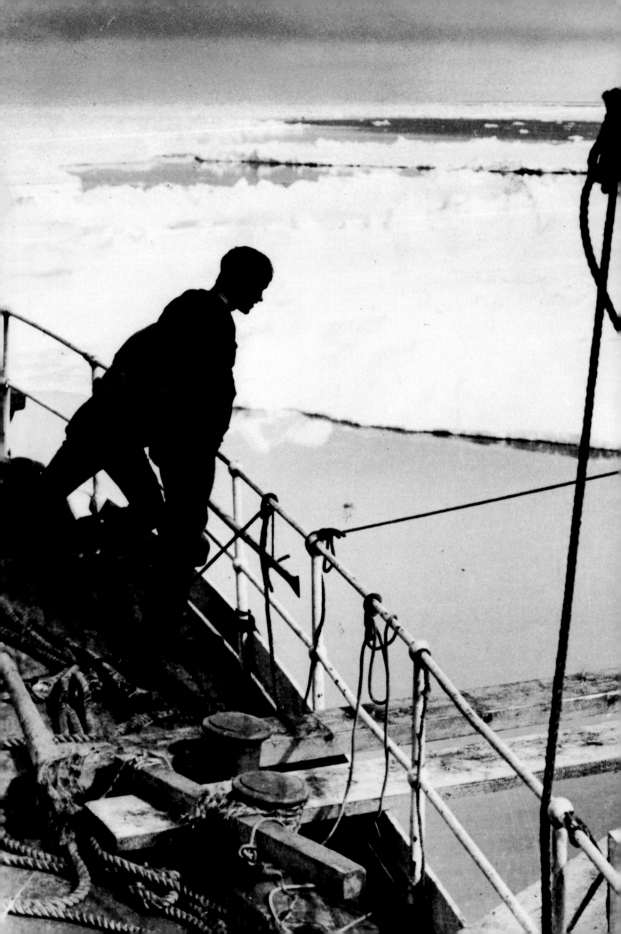

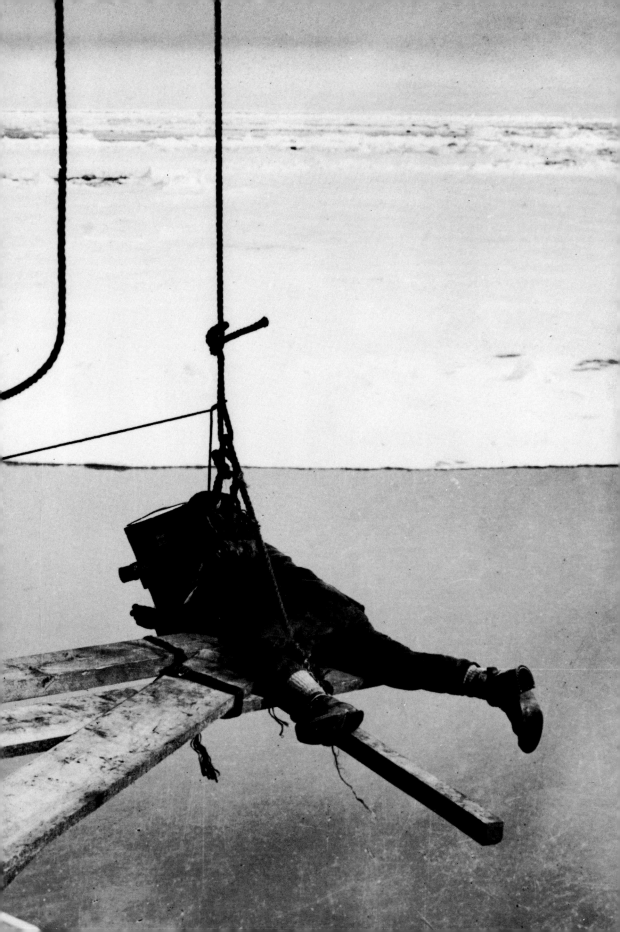

9

10

11

a

b

c

9 The interior of the Kinatome projector

10 The Variable Controllable Distortagraph unit on a Newman–Sinclair movie camera

11 Some of the V.C.D. results : (a) Herbert Ponting (straight photograph) ; (b) same shot by the V.C.D. ; (c) a V.C.D. rendering of Charlie Chaplin

12 *Opposite:* George Ford, the inventor and engineer behind the development of Ponting's Kinatome projector and Variable Controllable Distortagraph

PHOTOGRAPHER OF THE WORLD

U.S.A., 1900

13 *Following page:* Mules at a Californian Round-up

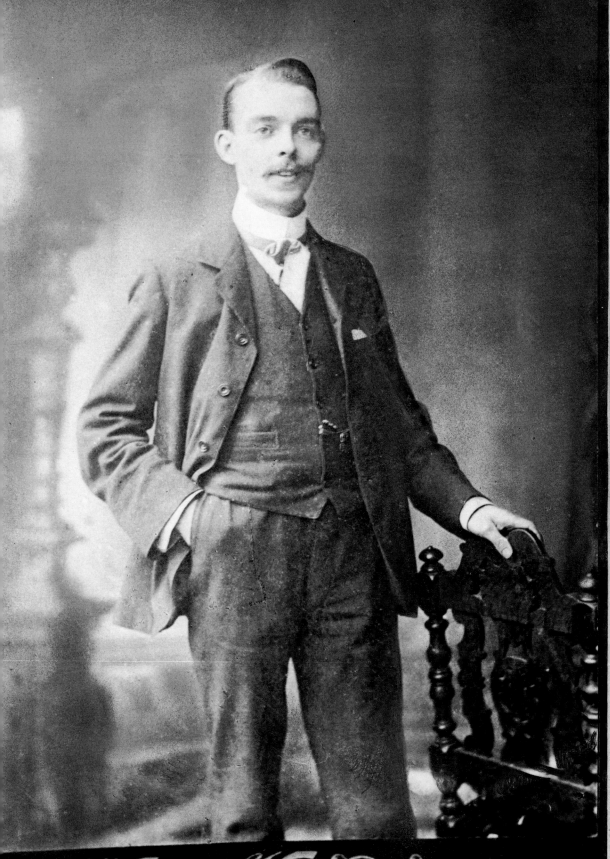

H. Wallace Keir 29. PLUMSTEAD Rᵈ

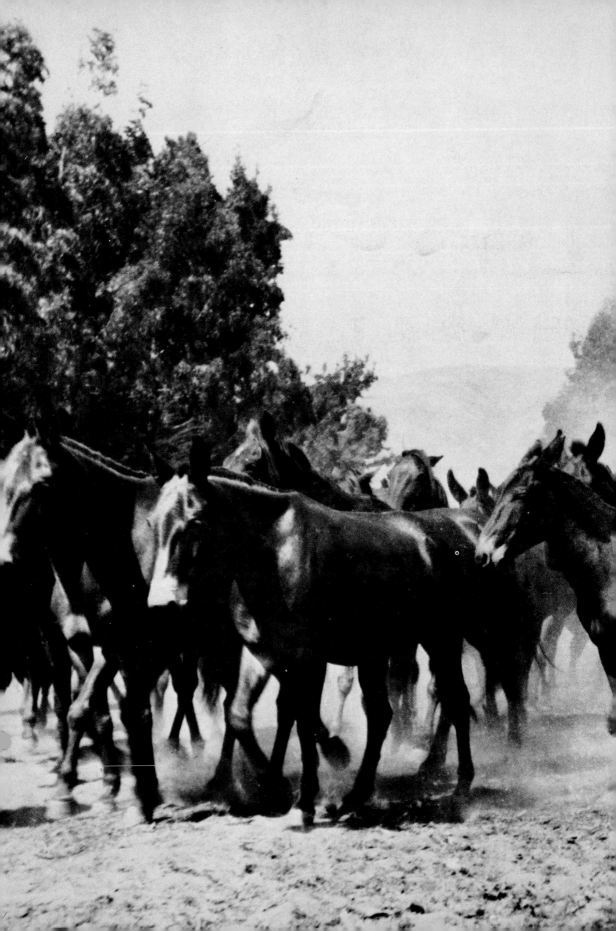

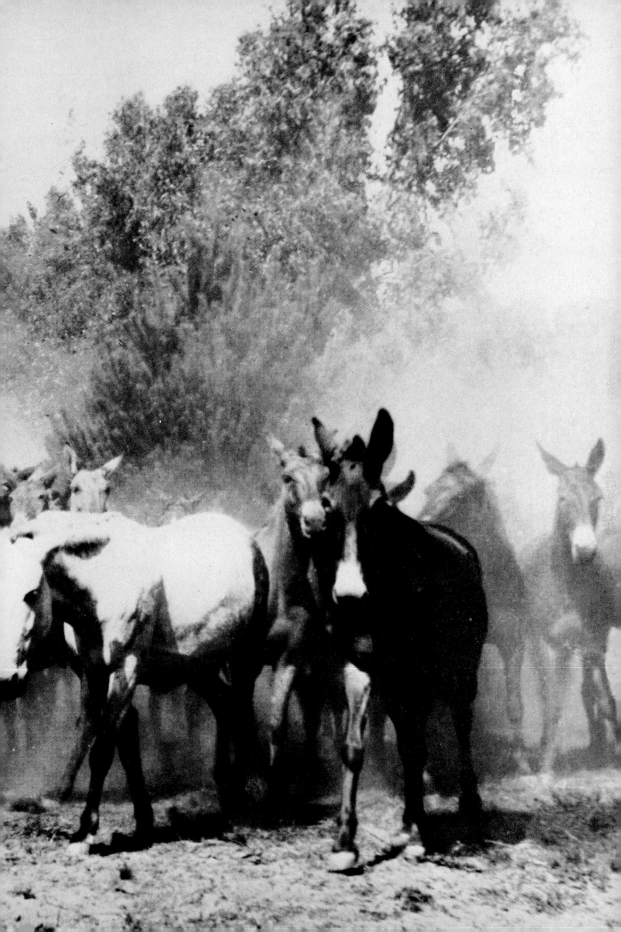

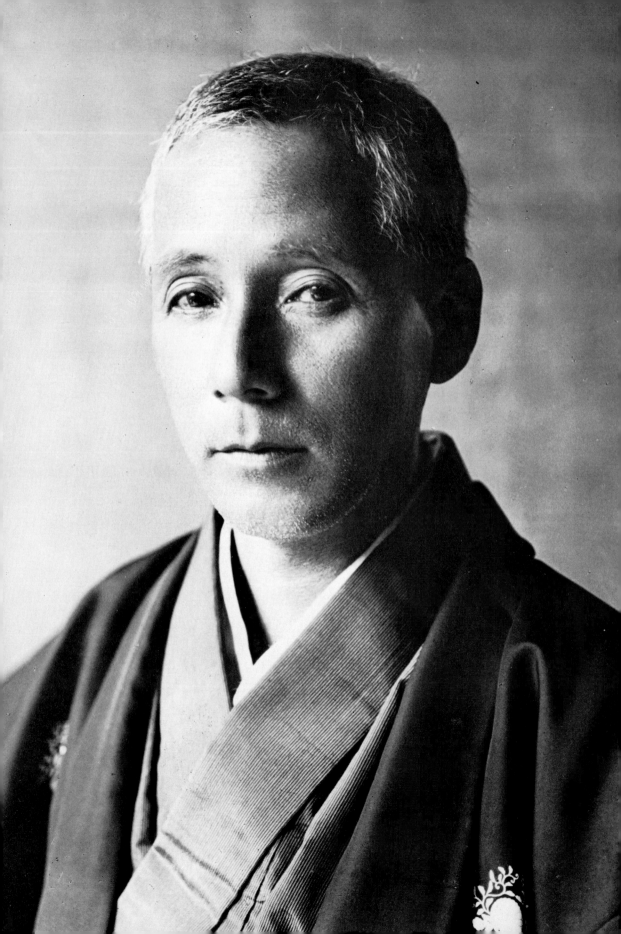

JAPAN, 1902–5

14 (*opposite*) Mr Namikawa

15 Marquis Oyama at Mukden

16 A Shinto priest

17 Marquis Hirobumi Ito

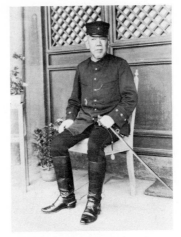

15

16

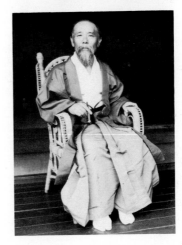

17

18

19

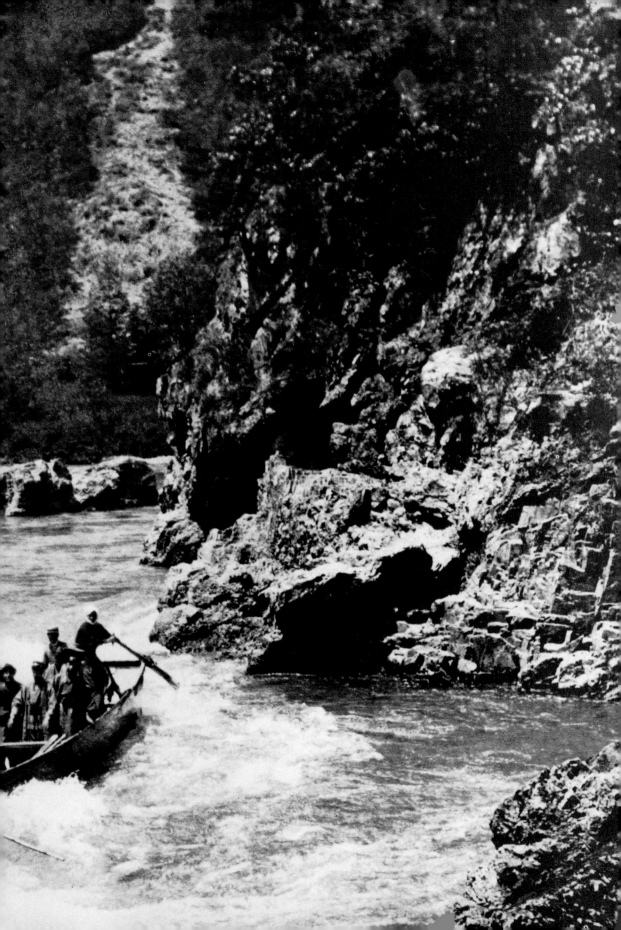

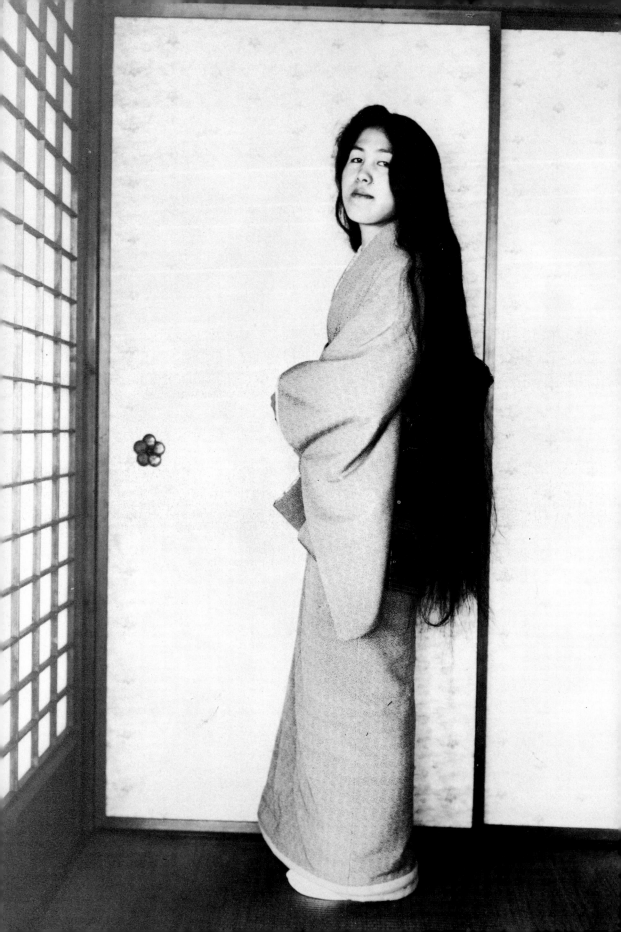

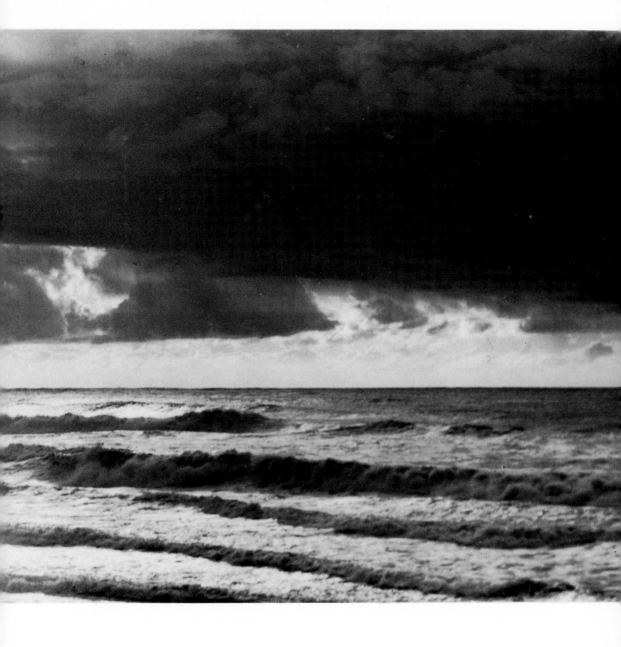

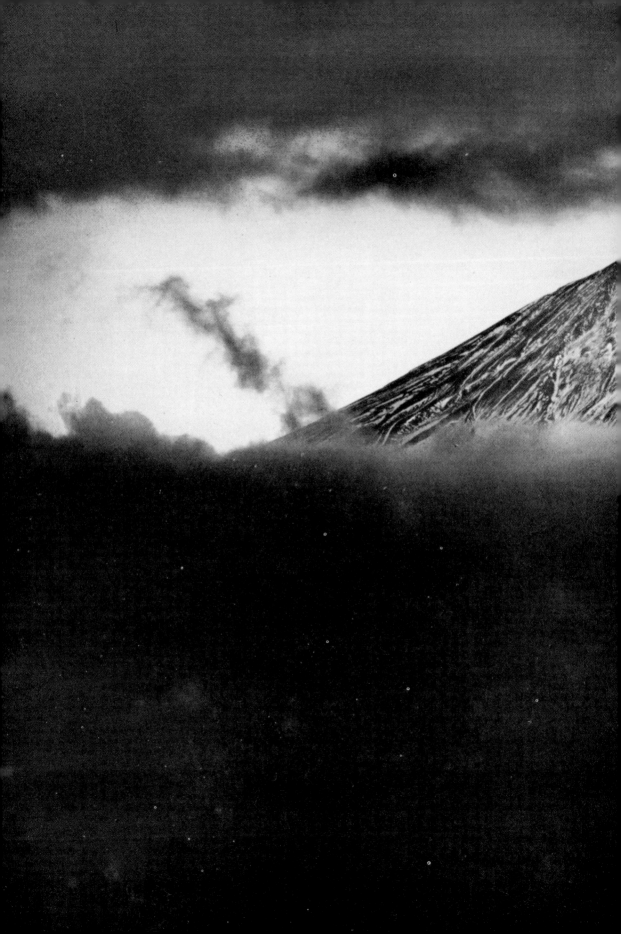

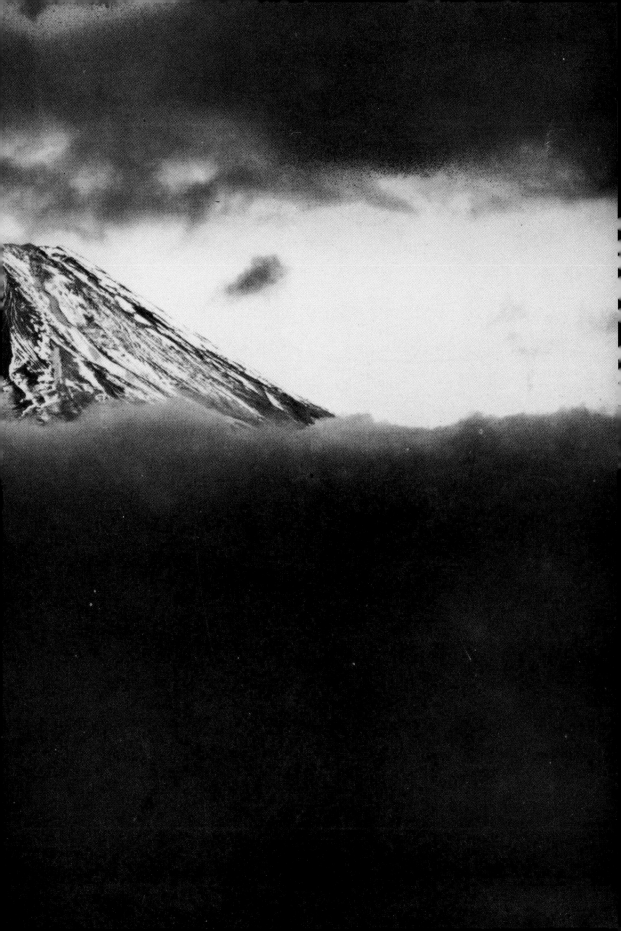

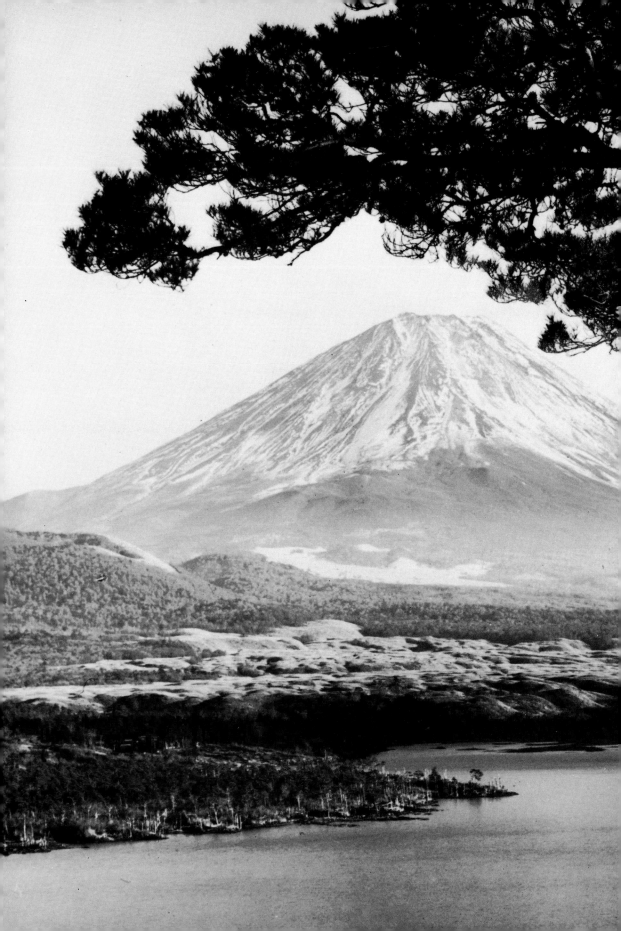

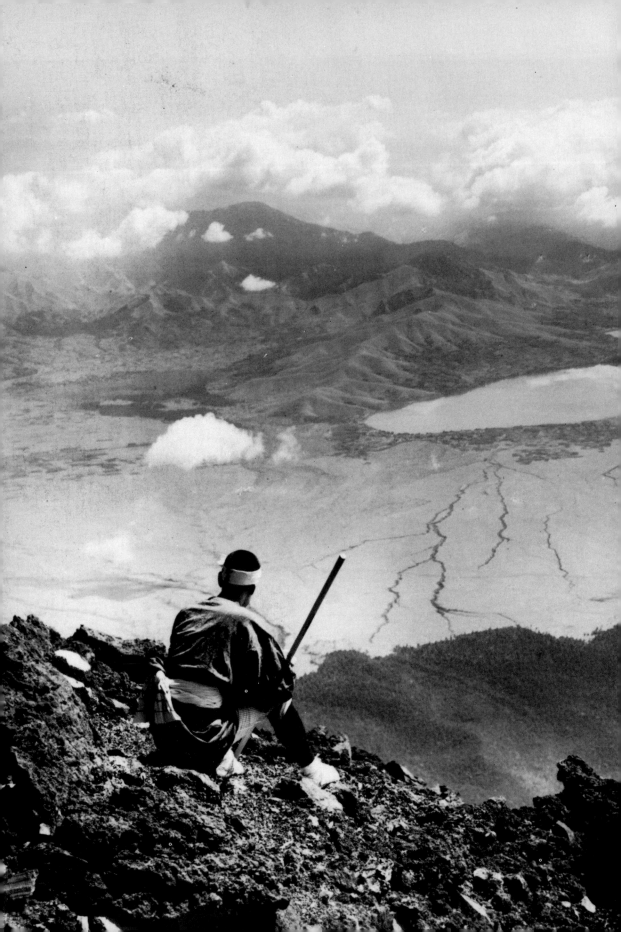

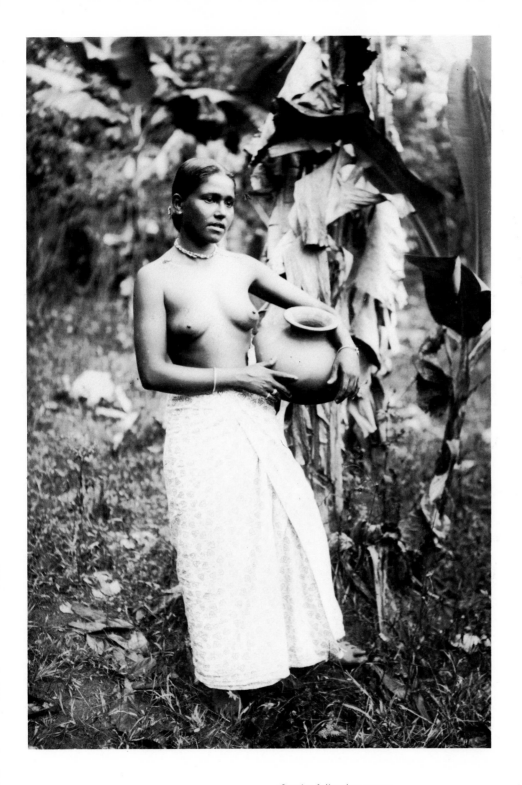

31 *Above:* Girl of Ceylon

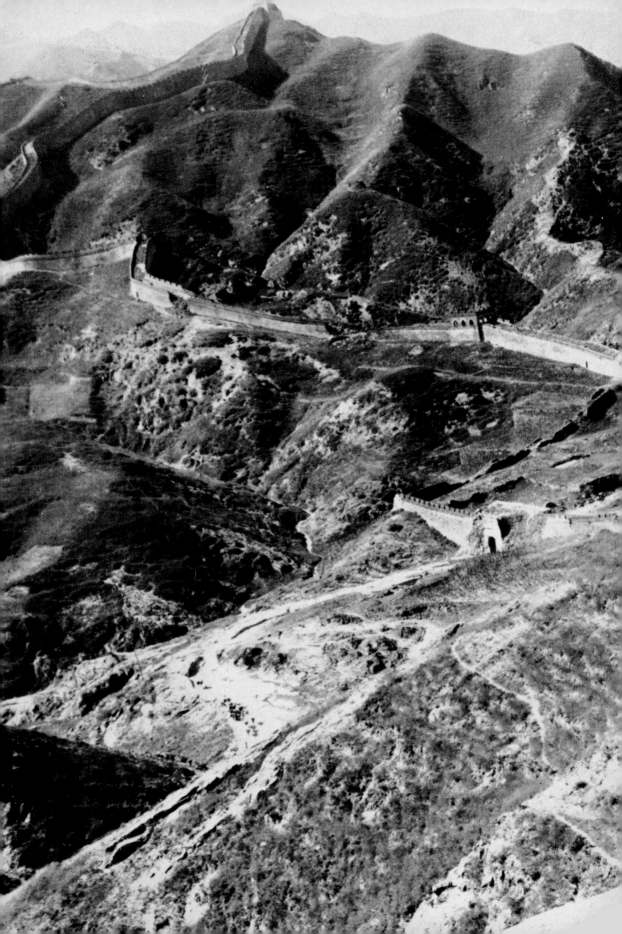

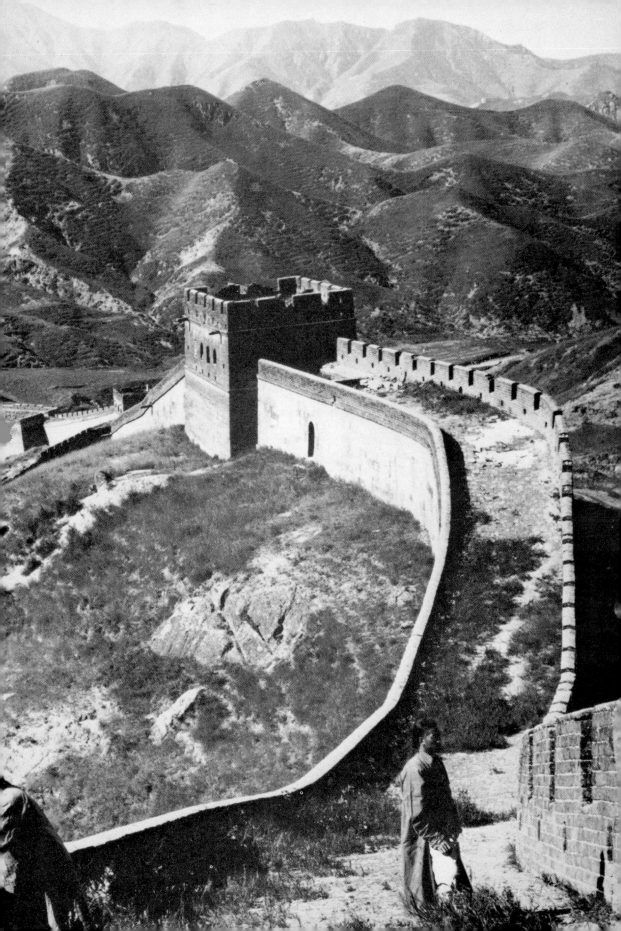

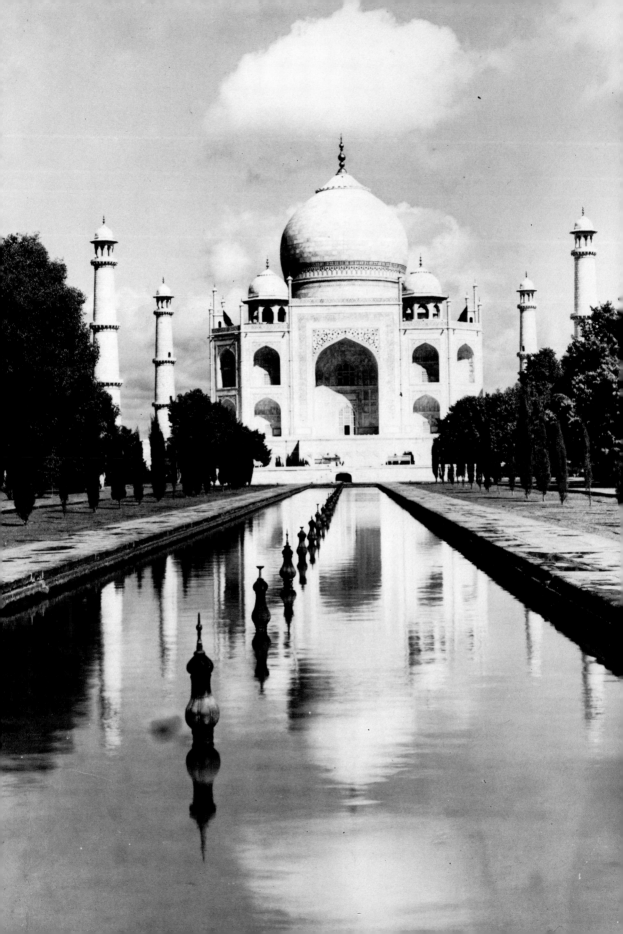

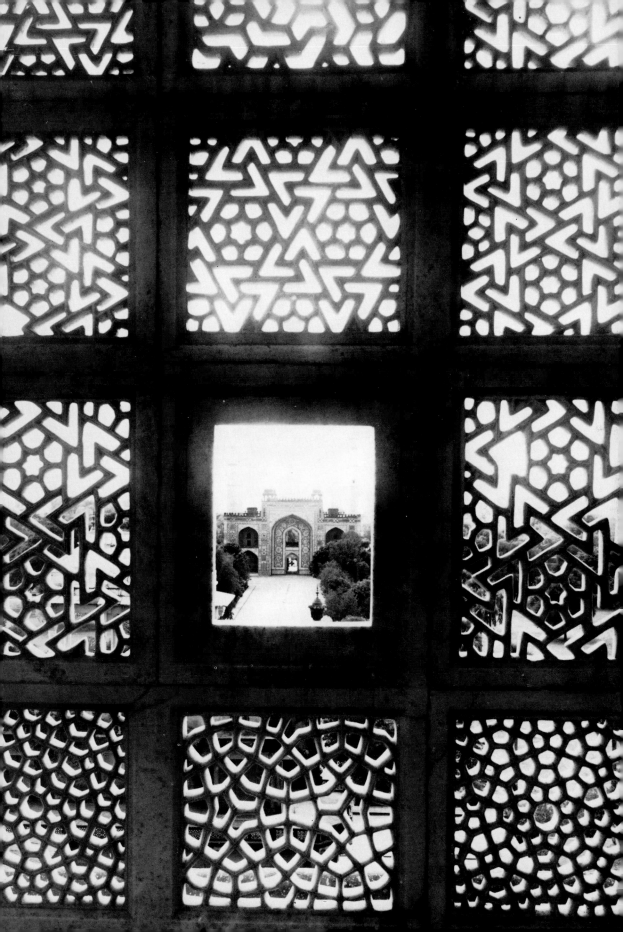

35 Inlaid marble screen, Taj Mahal

36 The Burning ghat, Benares

37 A 70-foot leap into the sacred tank, Delhi

38 Alligators on the banks of an Indian lake

39 Kanchenjunga massif : 50-mile telephoto from Darjeeling

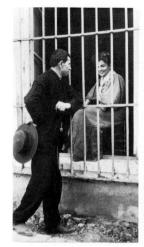

40

41

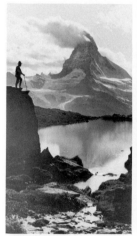

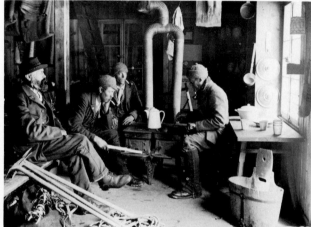

43

42

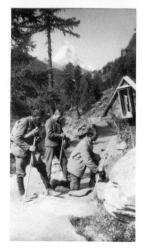

44

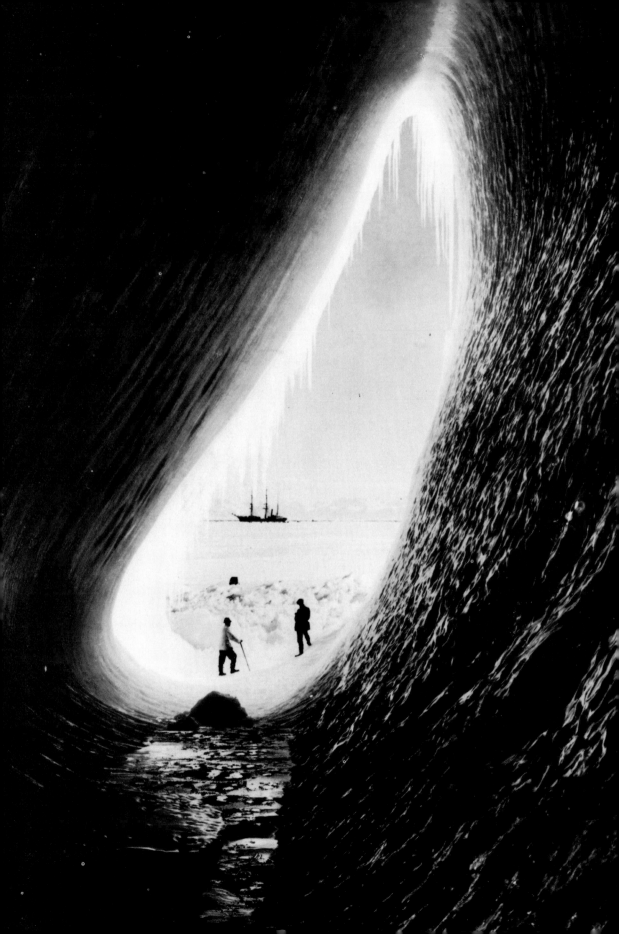

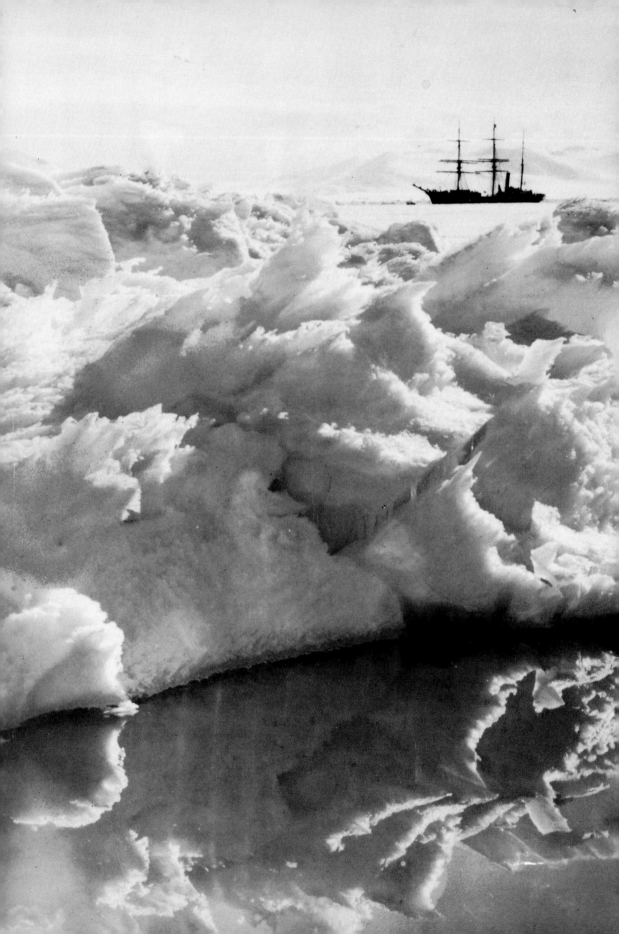

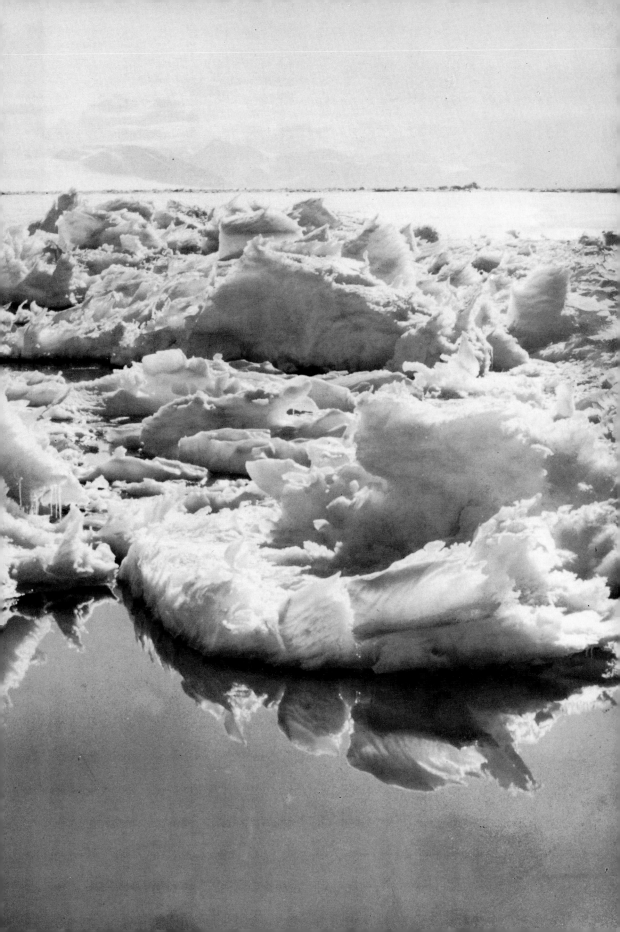

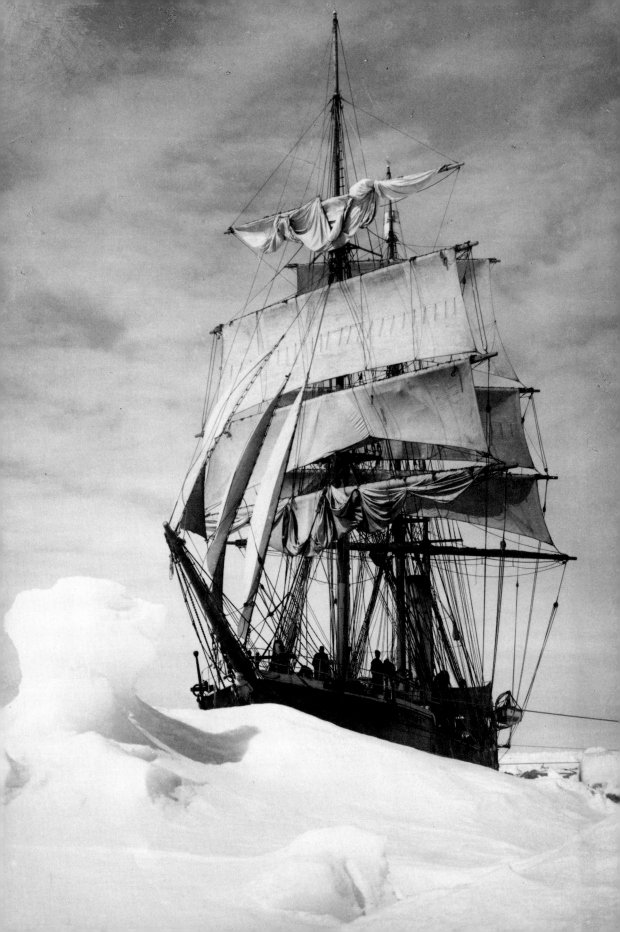

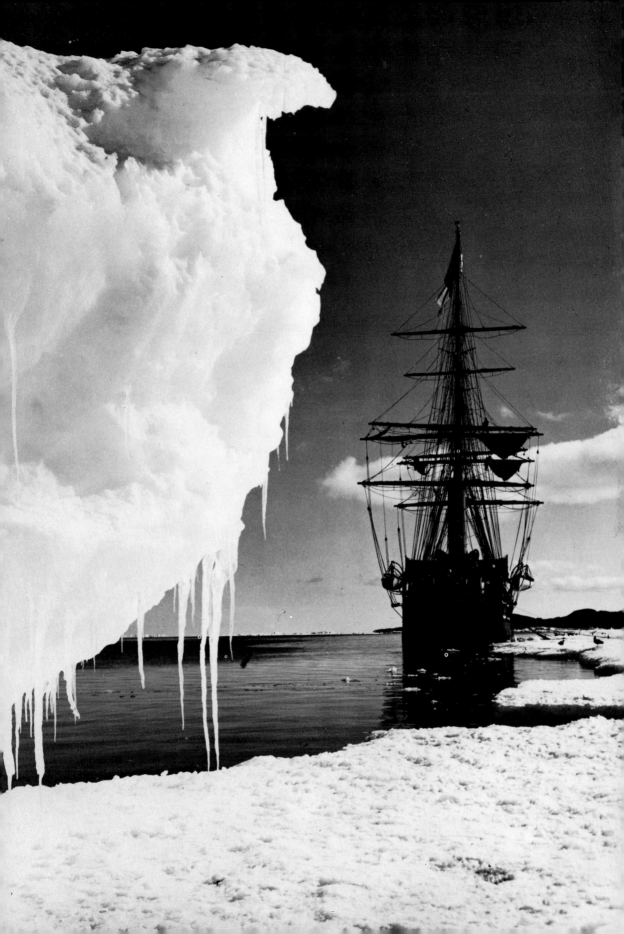

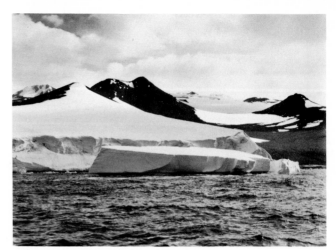

51

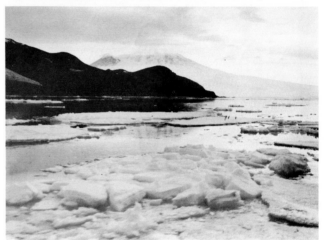

52

53

51 Glacier breaking away, Cape Crozier
 penguin rookery

52 Mount Erebus, 1.15 a.m.

53 Frost smoke off Glacier Tongue

54

55

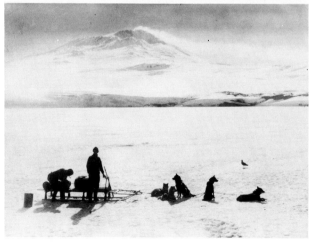

56

54 Weathered Kenyte boulder—'The
 Antarcticosaurus ?'

55 Castle Berg by flashlight

56 Smoke cloud from Mount Erebus

On the following pages

57 Berg in the pack : Debenham and Taylor in
 foreground (telephoto)

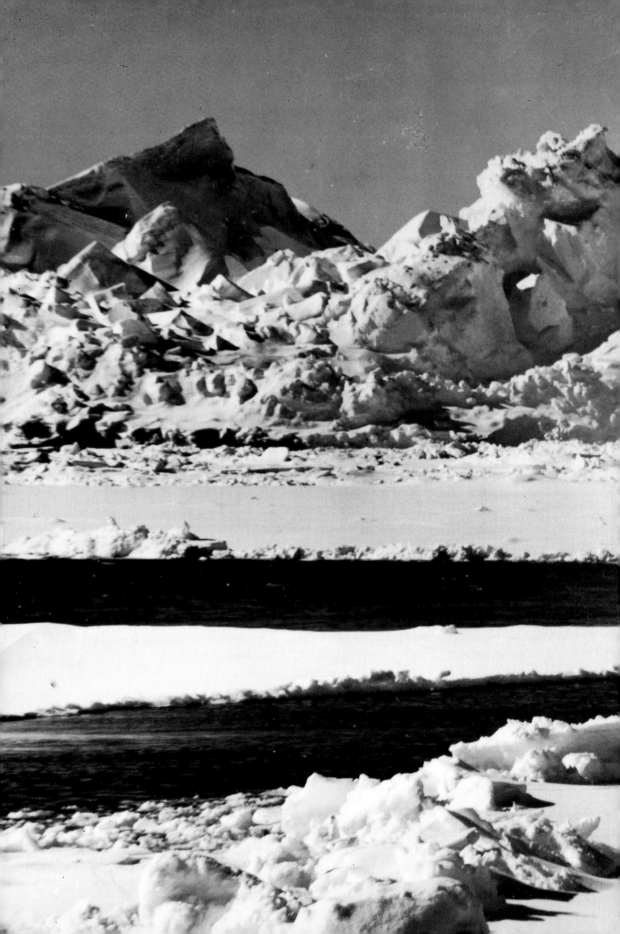

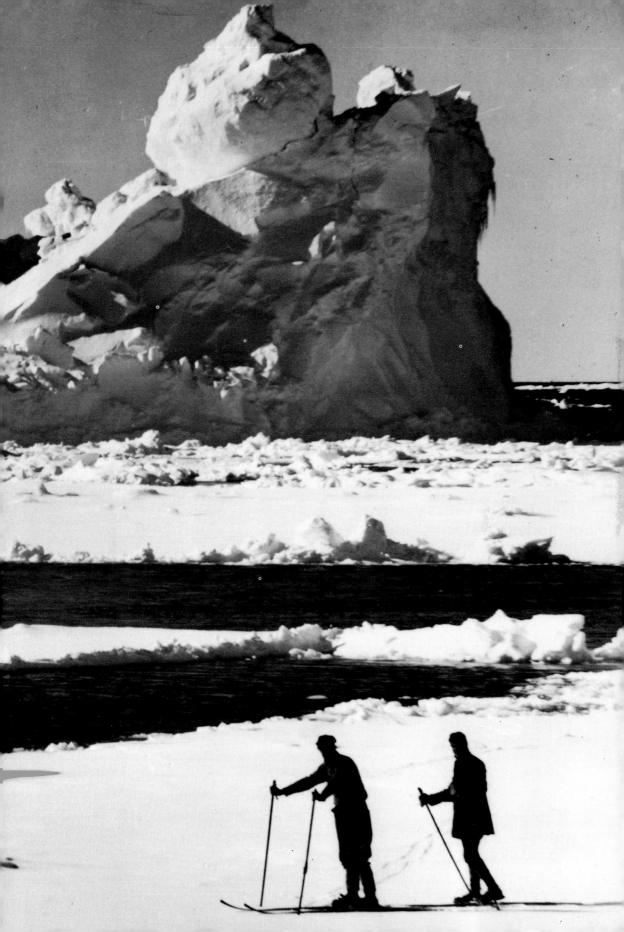

58

60

59

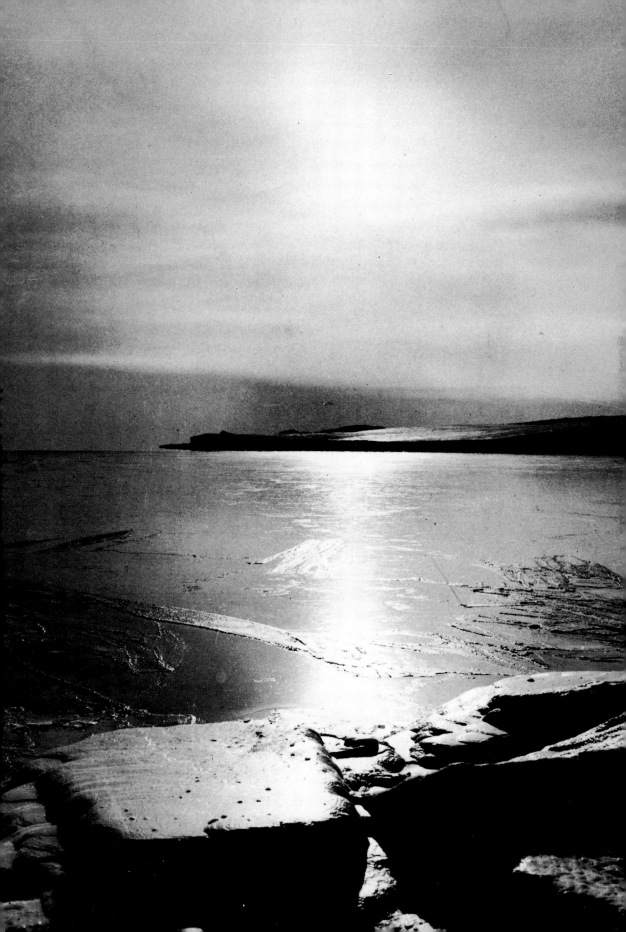

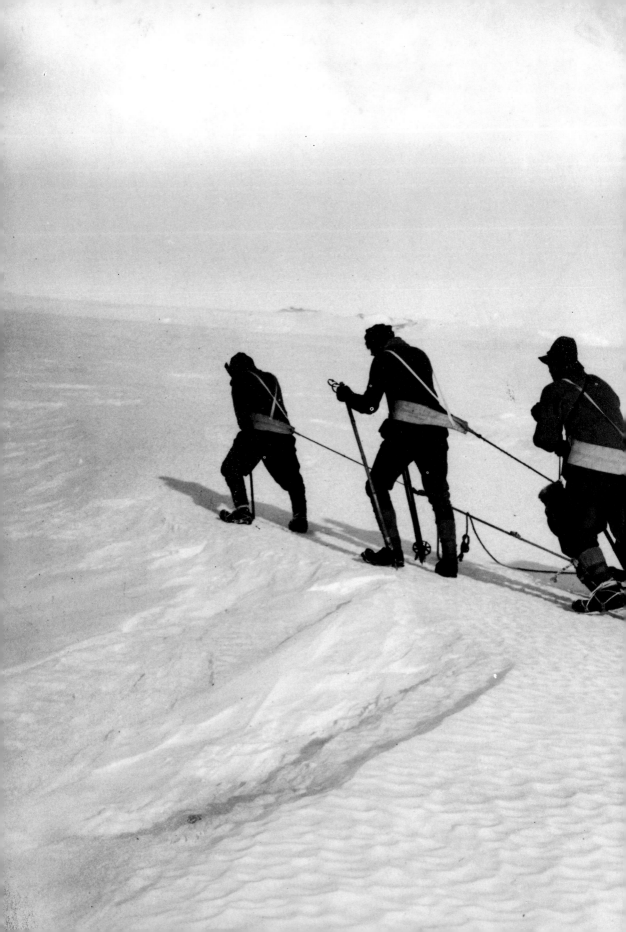

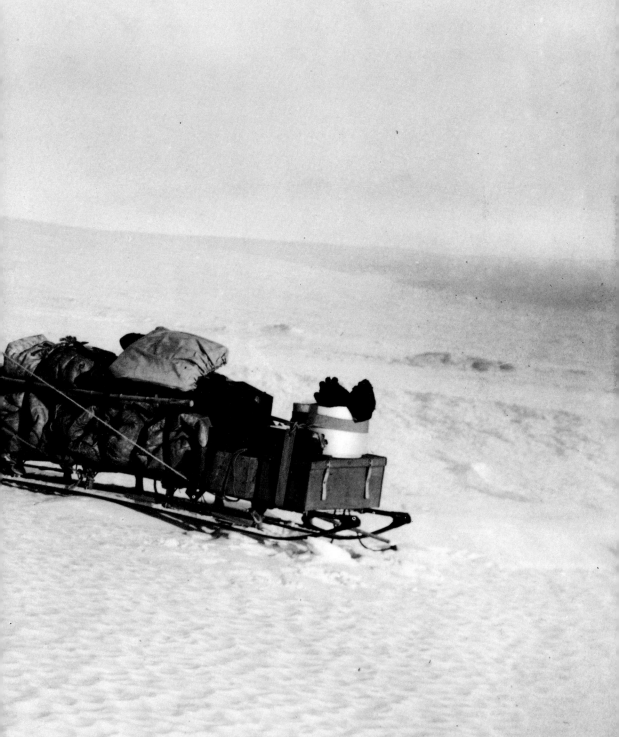

63

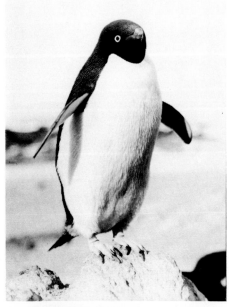

65

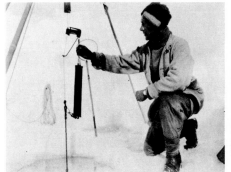

64

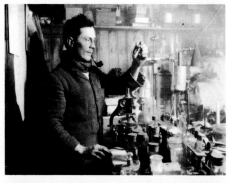

66

67

63 Sledgedog Wolk

64 Nelson with the reversing thermometer

65 An Adélie—attitude study

66 Dr. Atkinson in his laboratory

67 Stacking patent fuel

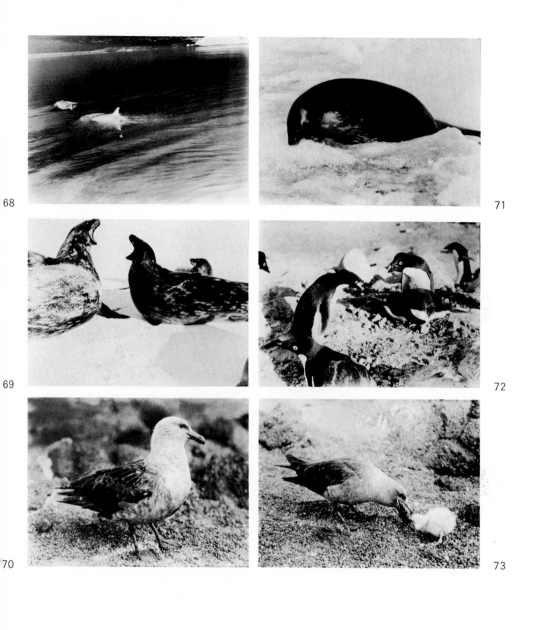

68 71

69 72

70 73

68 Killer whales off Barne Glacier

69 Weddell seals fighting (from movie negative) *On the following pages*

70 Skua

71 Seal 'sawing' the ice (from movie negative) 74 Lieut. Henry R. Bowers

72 Heated argument 75 Dr E. A. Wilson

74 76 Mount Lister (telephoto)

73 Skua disgorging food for its young 77 Captain Robert F. Scott

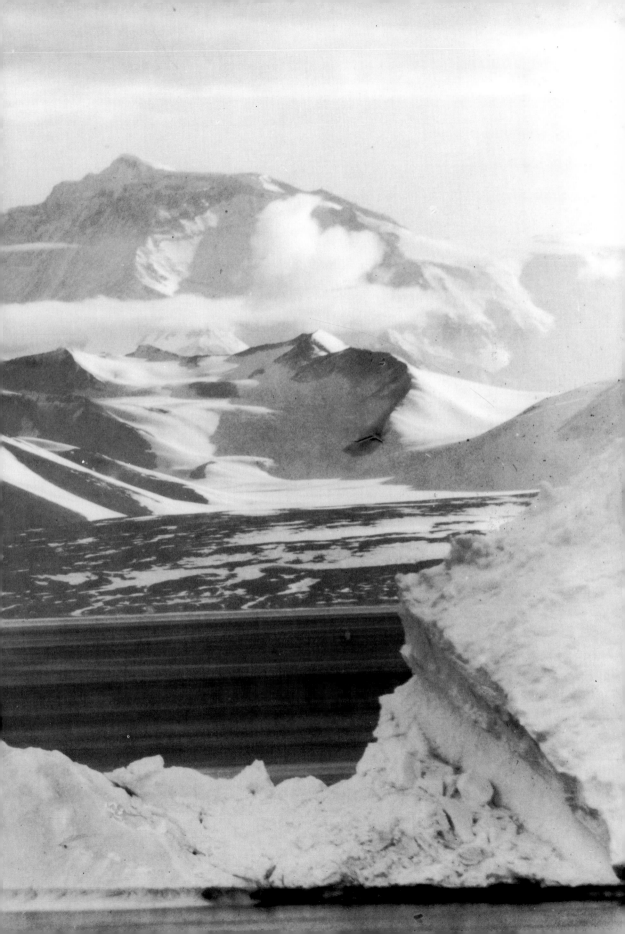

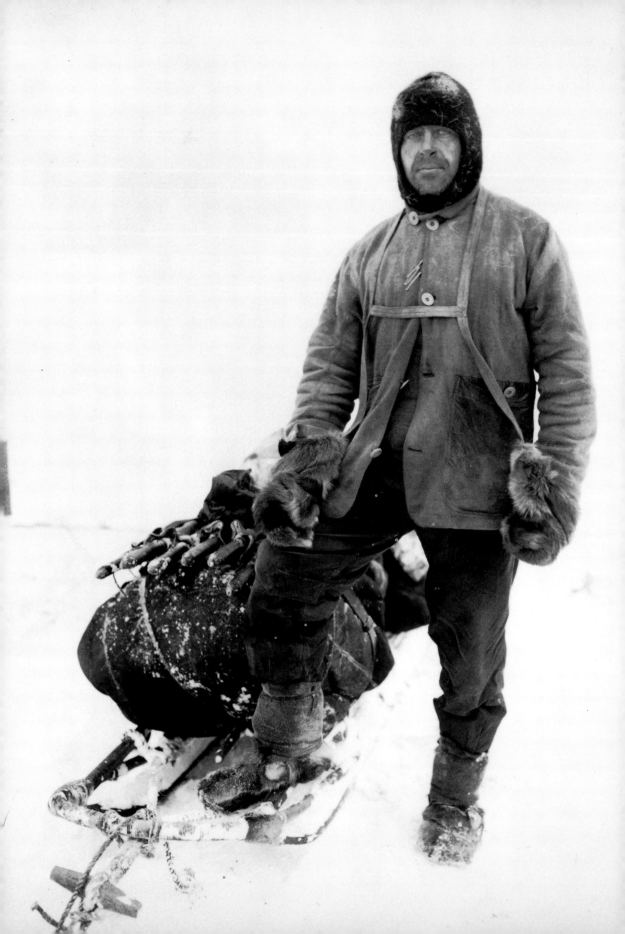

Index